A CAPITAL VIEW

A Capital View

THE ART *of* EDINBURGH

ONE HUNDRED ARTWORKS
FROM THE CITY COLLECTION

———

ALYSSA JEAN POPIEL

BIRLINN

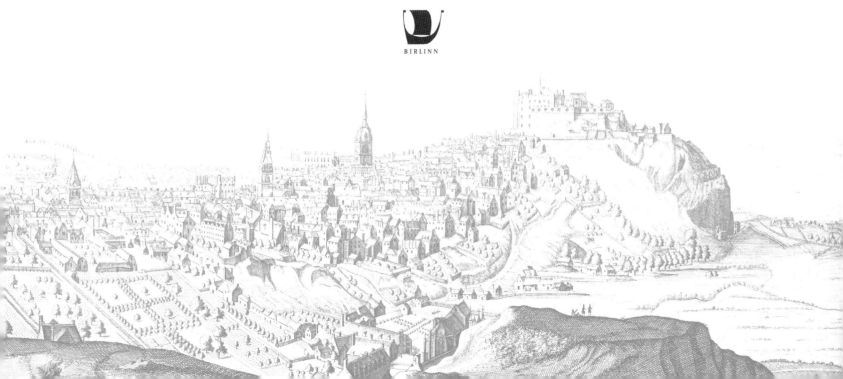

For my parents – I love you

Written in Cadell's studio on Charlotte Square

First published in Great Britain in 2014 by
Birlinn Ltd
West Newington House
10 Newington Road
Edinburgh
EH9 1QS

www.birlinn.co.uk

Hardback ISBN: 978 1 78027 196 5
Paperback ISBN: 978 1 78027 254 2

British Library Cataloguing-in-Publication Data
A catalogue record for this book is available on request
from the British Library

Designed by James Hutcheson
Typeset by Mark Blackadder

The Publisher acknowledges investment from
Creative Scotland towards the publication of this volume

Printed and bound in Poland

Contents

The Artworks

Letter of Introduction

ON BEHALF OF THE CITY OF EDINBURGH COUNCIL, it gives me great pleasure to introduce this new book devoted to the art and history of our magnificent city.

This timely and significant publication celebrates the breadth and diversity of the city's art collection. Indeed what is displayed in the pages which follow is only a very small glimpse of the total collection, which numbers almost 5,000 paintings, drawing, prints and sculpture. This growing collection, which has been officially 'recognised' as being of national importance by the Scottish Government, spans many centuries and includes works by the great majority of Scotland's leading artists.

This has been an ambitious initiative and I would like to congratulate Alyssa Popiel for her initial suggestion to staff at the City Art Centre, and for her determination and zeal, and the hours of research that she has put into the project. She has uncovered lots of new information about many of the works inside, and she has assembled the results of her studies into entries that make fascinating reading and which bring many aspects of the city's development and colourful history to life.

My thanks also go to Birlinn publishers, for responding so enthusiastically to the book proposal, and for working closely throughout the process with Alyssa and staff from the city's museums and galleries to produce this marvellous volume.

COUNCILLOR RICHARD LEWIS
Convener of Culture and Sport Committee
The City of Edinburgh Council

The Dream

I saw the infant city strew the ground,

Beneath the shadows of her guardian rock,

And often spread her timorous arm around,

As oft were lost again in flame and smoke,

But phoenix-like aye from the ashes woke,

Her tavers of nobler mould; what fortune wills

The arm of tyranny may not revoke.

I saw her soon enthroned on many hills,

The queen of cities fair, whose fame the world fills.

GEORGE MEIKLE KEMP

Author's Preface

> I was born and brought up in Edinburgh, which
> to me is the most romantic city in the world.
> JAMES FERRIER PRYDE (1866–1941)

EDINBURGH IS ONE OF EUROPE'S MOST HISTORIC, VIBRANT AND BEAUTIFUL CITIES – a place of celebration, with world class galleries and museums on the doorstop. Returning after many years, I have missed the art, views, architecture, and shopping below a castle, and I treasure childhood memories of trips to exhibitions, Festival fireworks, picnics at the Botanics and antique fairs at the Assembly Rooms. Exquisite artworks are strewn across the city, and at university I first encountered Pictish symbols, the portraits of Sir Henry Raeburn, the angels of Phoebe Traquair and the calotypes of Hill and Adamson. Always stirred by the surroundings, I never tire of walking from the hidden closes of the Royal Mile down to the splendour of the New Town. I agree with Pryde – Edinburgh is an exceptional and exciting city to call home.

The royal custodian of a rich and important history, Edinburgh has long inspired the nation's artists. This panoramic view of Edinburgh consists of selected works from the City Collection. Unique in being owned by the people of Edinburgh, the collection remains one of the oldest and significant of Scottish art.

Courtesy of some of Scotland's finest artists, embark on this windswept tour from the seventeenth century to the present day and rediscover the city in this dynamic and collaborative portrait. From Old to New, witness the transformation of the city from a medieval burgh to a Georgian gem and familiarise yourself with characters, key events and famous landmarks by seeing the city through the eyes of the artists. Step back in time; let me take you on a journey around this magnificent city – a city of architecture, history, science, philosophy and literature, but, above all else, a city of art.

Rest and Be Thankful

ALYSSA JEAN ROBERTSON-POPIEL
March 2014

The Artworks

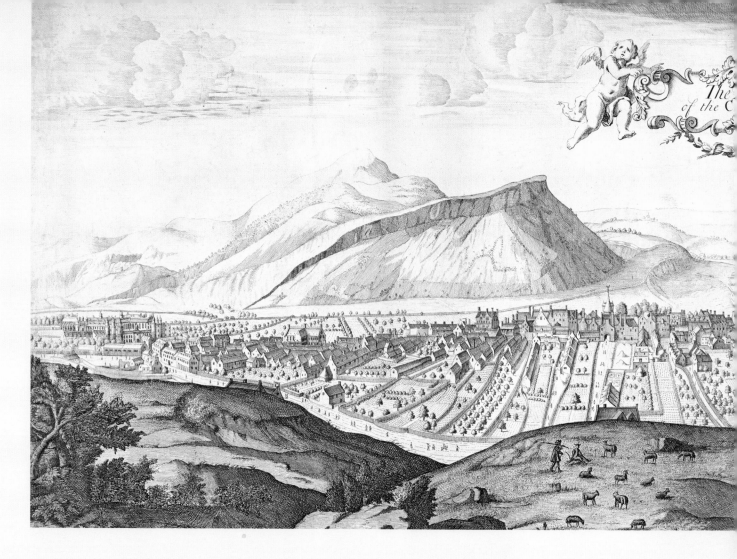

The North Prospect of the City of Edenburgh

JOHN ABRAHAM SLEZER (C.1650–1717)

EDINBURGH, ROYAL CAPITAL OF SCOTLAND, arose below the shadow of its ancient fort, Dun Eidyn. Defended by hill and sea, the medieval burgh flourished within its protective walls. Defined by its unique setting, over the centuries historic Edinburgh has cast the finest views. From the Calton Craigs this is one of the earliest artistic impressions of the city, a detailed journey from the Castle down the ancient ridge of the Royal Mile to Holyrood Palace. This early prospect of civic pride and architectural achievement is one of the treasured prints to be found among the pages of one of Scotland's great historical books, Slezer's *Theatrum Scotiae*.

An important military figure, John Slezer was master of the army at Edinburgh Castle. Travelling across Scotland as 'Surveyor of his Majesties Stores and Magazines', he embarked upon an artistic project to record Scotland's towns, ruins and castles. Despite brief imprisonment in the Canongate Tolbooth for his Jacobite support of James II, Captain Slezer was granted royal approval for printing in 1693. 'Curiously Engraven on COPPER PLATES', Slezer's drawings were accompanied by text by the Cartographer Royal for Scotland, Sir Robert Sibbald.

West View of the City of Edinburgh

PAUL SANDBY (1731–1809)

SPECTATORS ADMIRE THE VIEW OF THE CASTLE ROCK from the fields and farmlands to the west. Behind the Castle, clinging to the Old Ridge, the lofty heights of the Royal Mile overlook the farm houses below. This startling image of the West End in 1753 was caught by one of Britain's most influential landscapists, Paul Sandby.

Working for the Board of Ordnance at the Tower of London, young Sandby was sent to Scotland as Chief Draughtsman for Roy's *Military Survey of Scotland* in 1747. This was the Government's first comprehensive map of the nation following the threat of the Jacobite Rebellion. With a copy of *Theatrum Scotiae* in his back pocket, Sandby began sketching and painting the first picturesque views of Scotland during his extensive surveys. Sandby's skills flourished within the artistic circles in Edinburgh, a renowned centre of publishing and printing. With his companion, the future architect Robert Adam, Sandby loved to wander around the capital sketching the stunning views, landmarks, characters and ruins. Returning to London, he was appointed drawing master at the Royal Military Academy at Woolwich and became a founding member of the Royal Academy. As Britain's outstanding topographical artist, Sandby revived an interest in the picturesque appeal of the British landscape. An unrivalled watercolourist and innovative printmaker, with wit and humour, he was also famed for his satirical drawings of contemporary scenes. It was Sandby's early links to Edinburgh that would influence a future generation of Scottish artists.

This is one of his most interesting Edinburgh views, in which he draws our attention to the historic landmark of Heriot's Hospital, beyond the Castle. Built by William Wallace, royal master mason, in 1728, this magnificent Renaissance palace was the lasting legacy of Edinburgh goldsmith George Heriot. Royal jeweller to James VI, 'Jinglin' Geordie' was one of Edinburgh's richest men. Dying an affluent member of the royal court in London in 1624, he bequeathed his fortune to his home city for the foundation of a school for 'puir orphans and fatherless children of decayed burgesses and freemen of the said burgh'.

The views of the West End have changed considerably since Sandby's Edinburgh days, but Heriot's School still commands the High Riggs below the Castle.

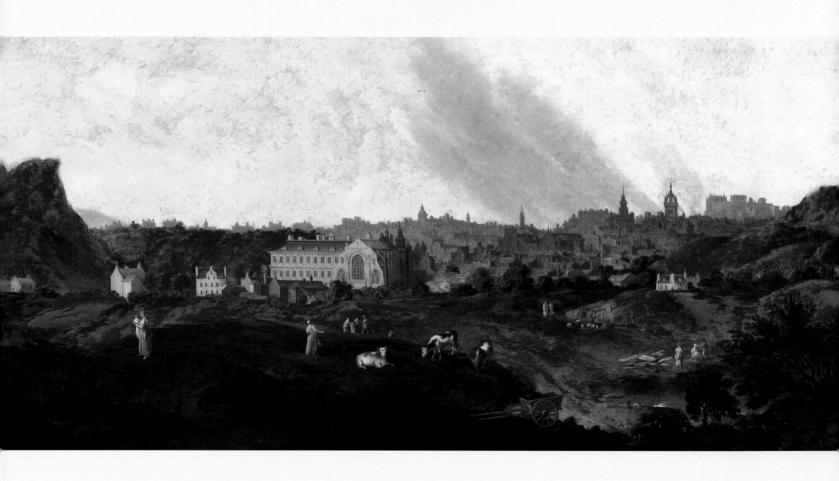

Oil on canvas, 108.2 × 229.1cm

1759

Presented by Captain Ramsay of White Hill, 1922

(Once in possession of John Clerk of Eldin)

A View of Edinburgh, 1759

WILLIAM DELACOUR (D. 1767)

AN HISTORIC PORTRAIT, looking back to 1759, Delacour's impression of Edinburgh survives as the earliest major painting of the city. From the parklands of Holyrood, this classically inspired view stretches up through the town past the spires of the High Street towards Edinburgh Castle. Centre stage stands the Stuart royal residence, the Palace of Holyroodhouse, with its Augustinian Abbey founded by David I in 1128. Painted after his recent move to the capital, this accomplished prospect would secure Delacour the most influential artistic position in the city.

In 1760, the Board of Trustees for Fisheries, Manufacturers and Improvements in Scotland founded an industrial art academy to support the wool and linen trade. Having set up an art academy in Dublin, Delacour was chosen as the first master of the Trustees' Academy School of Art. Responsible for educating students destined for manufacture, Delacour was instructed to teach the 'art of drawing and the principles of design, and for diffusing a beautiful and elegant style of composition in all those manufactures and works which require to be figured, ornamented or decorated'. In London Delacour had previously built a considerable reputation as an interior decorator, theatre designer, portraitist, designer, drawing master, printmaker and art supplier. From his premises at the Golden Head in Katherine Street, Delacour sold his popular *Books of Ornament* (1741–47), impressive catalogues of rococo designs and motifs demonstrating his technical mastery.

When he settled in Edinburgh, Delacour quickly surpassed the long-established Norie firm of interior decorators. His Italianate landscapes and capricci were brushed upon the walls of fashionable mansions. His original decorations still cover the walls of Old Moray House in the Canongate. Demonstrating his skills in theatre and interior design, this ambitious prospect is a reminder that the Scottish school of landscape painting originated on the walls of the decorative painters. Delacour lived on the Royal Mile, down one of its dark and ancient closes, Toderick's Wynd. When he died, his paintings and blocks for grinding colours were sold at auction, the precious belongings of one of the city's most respected artists.

Through this window to the past, Delacour cleverly reminds us that this pastoral scene is not as idyllic as it may at first appear. Auld Reekie indeed, a mass of smog hovers above a town in desperate need of improvement. Crippled by lack of investment and victim to disastrous fires and disease, the decrepit tenements now overlooked the stagnant Nor' Loch. Seeking a solution, Lord Provost George Drummond turned around and looked to the prospect of the north.

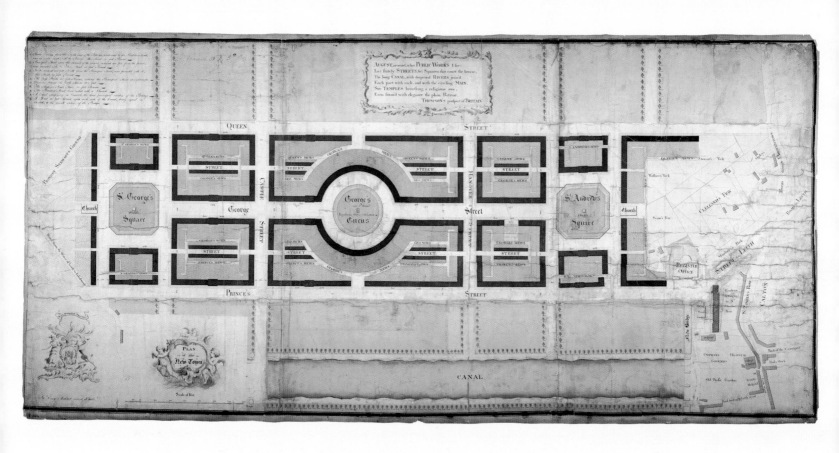

Ink on parchment, 66.7 × 127.5 cm

1767

Submitted to the City of Edinburgh in competition, 1767

Plan for the New Town of Edinburgh, 1767

JAMES CRAIG (1739–1795)

FIRED WITH THE SPIRIT OF THE ENLIGHTENMENT, in 1766 the City Council declared a competition for the design of an ambitious building scheme for the farmlands to the north of the city. To relieve the congestion of overcrowded streets, the city magistrates decided to build a New Town. The Council chose plan No. 4, an expression of Georgian grandeur and elegance, the design of a young unknown Edinburgh architect, Mr James Craig.

A civic treasure of the City Collection, this is one of Craig's original designs for the New Town. Proposing a classic continental model with ornamental statues and gardens, this is Craig's preferred 'Circus Plan', showing an ornamental garden dividing George Street, complete with its equestrian statue of George III. This document reveals that the first phase of building comprised only three streets, named in honour of the Hanoverian royal family. At the request of George III, Giles Street was changed to Princes Street after his two sons, George IV and the Duke of York. The dividing streets later took the names of the Rose and Thistle, after the national emblems. This plan also shows the potential sites of buildings such as the Theatre Royal, Register House and the Physician's Hall. Within the opposing grand squares stand the churches of St Andrew's and St George's. The Nor' Loch has transformed into a tree-lined canal with picturesque temples. In promotion of his patriotism, Craig includes a cartouche quoting the *Prospect of Britain* by his uncle, the acclaimed poet James Thomson. For his winning designs, Craig was awarded the status of Burgess and Guild Brother and presented with a gold medal and the freedom of the city in a silver box. It was a great achievement that should have propelled him to architectural heights.

Construction of the New Town began with St Andrew Square, but Craig's vision was not built according to plan. Having sneaked a peep at this design, Sir Laurence Dundas bought the intended plot for St Andrew's Church as the future site of his Palladian mansion; Dundas House still stands as one of the original buildings of the New Town. The grand townhouses with their astounding views and pleasure gardens quickly enticed the wealthy residents from across the valley. The only building to be built by Craig was the Physician's Hall on George Street. Never making the move to his New Town, Craig remained in an overcrowded tenement in the West Bow, banished to obscurity. With lack of patronage and commissions, in 1782 Craig was forced to sell his precious gold medal and silver box to Sir William Forbes. His only extant building is Old Observatory House on the Calton Hill, built as the city's first observatory for Thomas Short, an optician from Leith.

A masterpiece of the Enlightenment, the design of the New Town was Craig's crowning achievement. Assuming its dual character, Edinburgh would forever be famed for its Georgian architecture. To rival the view of the stars from the roof of the observatory, Craig was proud of the magnificent prospect he created from Old to New Town. James Boswell was quite right to introduce him to Dr Johnson as the 'ingenious architect of the New Town'.

Edinburgh with Salisbury Crags, Arthur's Seat and the Wrytes' Houses, from the South West

JOHN CLERK OF ELDIN (1728–1812)

ON THE BRUNTSFIELD LINKS, the forgotten Wrychtishousis stands prominent in this picturesque panoramic view of the city. The oldest of the city's mansions, this architectural curiosity emblazoned with inscriptions and heraldry was the historic seat of the Napiers of Wrychtishousis. One of the rare views of his hometown, this exquisite etching was created by John Clerk of Eldin, one of the leading figures of Edinburgh's Enlightenment and one of Scotland's most important early printmakers.

The gifted son of Sir John Clerk of Penicuik, John Clerk lived in his own estate of Eldin, where he managed the Pendreich coalfields near Lasswade, Midlothian. Along with balancing many business interests and writing influential works such as his *Essay on Naval Tactics* of 1790, the amateur artist spent his spare time experimenting with the novel technique of etching. Encouraged by Paul Sandby and his father's collection of European master prints, Clerk created a series of over 100 picturesque views of the Scottish landscape between 1770 and 1790. Sets of his etchings were sold at Thomas Philipe's print shop, and his delicate views featuring castles, ruins and epic views presented the first romantic tour of Scotland. In recognition of his talent, in 1786 a collection of his etchings was presented by David Steuart Erskine, 11th Earl of Buchan (Founder of the Society of Antiquaries of Scotland, 1780), to King George III.

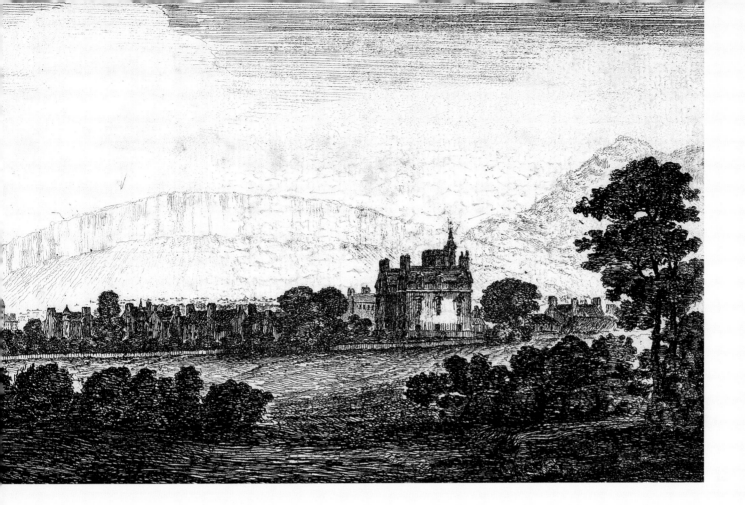

Etching on paper, 13.3 × 38.5cm

1770s

(Reprinted in *A Series of Etchings, Chiefly of Views of Scotland*, 1825)

On leaving Dalkeith Grammar School, Clerk studied anatomy at Edinburgh University with fellow student Robert Adam, who shared his passion for drawing castles and ruins on their many sketching trips throughout the city. The eminent architect would become his brother-in-law when Clerk married his sister Susannah Adam in 1753. Following his studies, Clerk launched his career as a merchant in the Luckenbooths on the Royal Mile, before expanding to coal and industrial interests. After Clerk's original plates were discovered at Eldin by his son, this etching featured in *A Series of Etchings, Chiefly of Views of Scotland by John Clerk of Eldin*, published by the Bannatyne Club in 1825. Ever the antiquarian, with skilled use of shading, Eldin draws us into this eighteenth-century view, stretching from the Castle over to the Salisbury Crags. This is not only one of Eldin's most impressive plates, but also a distant memory of one of Edinburgh's lost landmarks.

IN DOMINO CONFIDO – 1400

In God I trust – Inscription, Wrytes' Houses

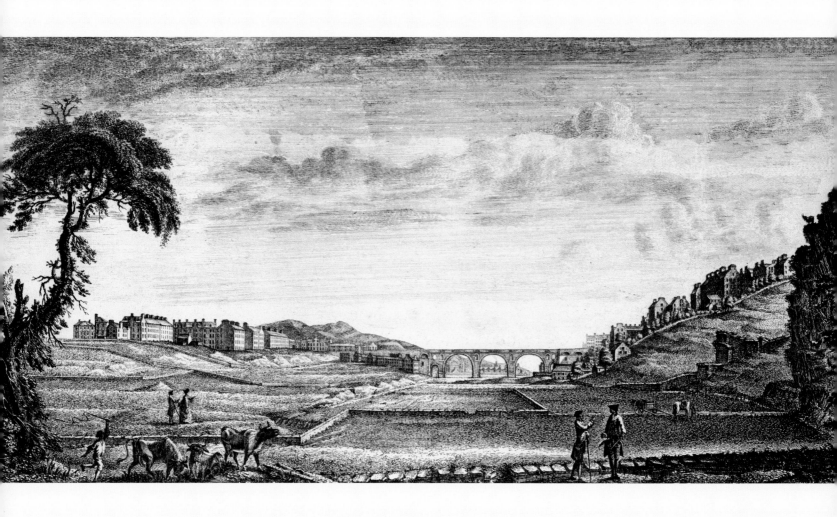

Etching on paper, 22.0 × 31.3cm

1780

Whitson Bequest, 1948

A View of the New Bridge of Edinburgh with the Adjacent Buildings of the Old and New Town from the West (1780)

THOMAS DONALDSON (FL. 1742–1788)

SPANNING THE OLD TO THE NEW, the newly completed New Bridge stands proud as the city's latest landmark. Built before the foundations of the New Town, it was Lord Kames who proposed the idea of a great bridge to encourage development of lands to the north of the city in 1763. As the Council acquired the individual farms, estates and vast acres belonging to Heriot's Hospital, the Nor' Loch was drained and the bridge's foundation stone was laid by Lord Provost George Drummond. Construction eventually began in 1765, supervised by Deacon of the Masons, William Mylne.

In this splendid etching, a member of the Council negotiates the purchase of the old swamplands of the Nor' Loch from the local landlord. Cows are herded across the divided farms as a goat looks out from the Castle Rock. The heap of looming tenements of the Old Town contrasts with the order of the New. Along the Lang Dyke, the building of the grand townhouses advances upon the former lands of Robert Hepburn of Bareford. Under the bridge, the Gothic Trinity Church no longer sits at the head of the Nor' Loch.

Taught by Richard Cooper at the Edinburgh Society of Arts, Thomas Donaldson was a leading printmaker of landscape, botanical and anatomical works. Cooper, an eminent engraver, was a founder of Scotland's very first art establishment, the short-lived St Luke's Academy, which opened its doors in 1729. Its famous students included Andrew Bell, the founder of the *Encyclopaedia Britannica*; interior decorator James Norie; and the young painter, Allan Ramsay.

By the end of the eighteenth century, Edinburgh had bridged the gap. No longer lagging behind, it now bristled with ideas as the centre of the Scottish Enlightenment. Battling the high winds, crossing from old to new, many of the city's great thinkers would be seen crossing the bridge. Within the mass of buildings on the right stands the Royal Exchange, a centre for trade and meeting place of the Town Council. It was from a window here that six times Lord Provost George Drummond once stood with Thomas Somerville and dreamed of a vision, a sight he knew he would never see.

> Look at these fields. You, Mr Somerville, are a young man, and may probably live, though I will not, to see all these fields covered with houses, forming a splendid and magnificent city. To the accomplishment of this, nothing more is necessary than draining the North Loch, and providing a proper access from the old town. I have never lost sight of this object since the year 1725, when I was first elected Provost
> SIR GEORGE DRUMMOND, c.1763

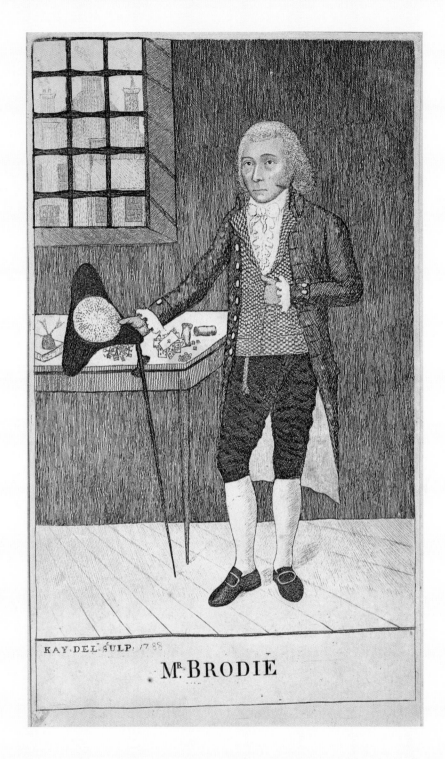

KAY·DEL·SULP·1788

Mʀ BRODIE

Etching on paper, 18.6 × 11cm

1788

Mr Brodie

JOHN KAY (1742–1826)

TOWN COUNCILLOR AND DEACON of the Incorporation of Wrights and Masons, William Brodie was an upstanding and well-respected figure of Edinburgh society. He was the owner of the city's locksmith and cabinet-maker business in the Lawnmarket, and it was a common sight to watch the well-dressed Brodie, cane in hand, parading from his dwellings in Brodie's Close. In 1787, no-one suspected his involvement in a series of midnight robberies targeting the Old Town. Smiling behind closed doors, Brodie held the key.

Fuelling his secret life of drink and gambling, Deacon by day and burglar by night, it was Brodie who returned to rob the properties for which he had recently installed new locks. Meeting in a tavern down the Fleshmarket Close, Brodie planned the raids with his gang of thieves, George Smith, Brown and Ainslie. After a failed attempt to raid the Excise Office in Chessel's Court in the Canongate, the culprits were captured, except for Brodie. Jumping ship at Leith, Brodie 'most wanted' was on the run from Mr Williamson, King's Messenger for Scotland. Escaping to the Netherlands onboard the *Endeavour*, Brodie met Mr Geddes, a tobacconist from Mid-Calder, and gave him letters to give to friends and family back in Edinburgh, detailing his intentions to flee to America from Amsterdam. These proved the means of his discovery, and Brodie was captured in an Amsterdam pub and promptly shipped back to Edinburgh for trial at the High Court, where the former juryman was found guilty. He was hung on the gallows he had himself previously designed at the Old Tolbooth on the Royal Mile and buried in an unmarked grave at Buccleuch Church in Chapel Street.

This brilliant portrait of 'great exactness' was created by the talented John Kay, a miniaturist and printmaker from Dalkeith. Through the windows of his print shop at 14 Parliament Square, Kay studied, sketched and preserved on paper hundreds of Edinburgh characters. With his signature wit and humour, his stylised etchings provide a rare glimpse into society life of the eighteenth century. Kay originally worked as a barber before the patronage of William Nisbet of Dirleton funded his career as a printmaker. Turning the pages of *Kay's Original Portraits* is to look back in time to meet some of the city's most interesting characters, where lawyers, doctors and professors walked the streets with fishwives, beggars and criminals. A retired 'picture dealer', still sketching the characters of the Old Town below his window, Kay died at his home at 227 High Street, aged eighty-four.

Face to face with the unforgettable Deacon Brodie, Kay presents the imprisoned thief with the tools of his trade: copied keys, a disguise, pistol and gambling cards. The most notorious of Kay's portraits, Brodie still walks in the darkest parts of Edinburgh's imagination.

Coloured engraving on paper, 42.5 × 57.3cm
1793
Purchased 1905

View of the High Street of Edinburgh from the East, 1793

DAVID ALLAN (1744–1796)

MASTER OF THE TRUSTEES' ACADEMY, David Allan transports us back to a busy afternoon on the Royal Mile in 1793. With heightened detail, brilliant technique and command of expression, he invites us to experience the drama of the High Street in this lively contemporary view. Below the towering tenements at the Netherbow, aristocrats in their finest fashions dodge the hazardous carriages as women gossip at the Netherbow Well. Chair bearers, chimney sweeps, fishwives and water carriers go about their usual business as the Town Guard announces the proclamation 'God Save the King'. To the left, street signs include the 'London Porter', 'Dempster Druggist' and 'Beugo' the Printmaker. Opposite, in John Knox's House, a gentleman enters 'Knox the Bookseller' as a shoemaker works away in the ground floor. Above, Mrs Grant looks out from the window of her 'Register Office for Servants'.

The son of a shoremaster from Alloa, David Allan was sent to train at the Foulis Academy at Glasgow University, founded in 1753 by publishing brothers Robert and Andrew Foulis. One of its finest students, Allan completed his training in Rome with the Scottish historical painter Gavin Hamilton. After almost a decade in Italy, followed by a couple of years working as a portraitist in London, Allan settled in Edinburgh in 1780. With the death of Alexander Runciman, he secured the influential position of Master of the Trustees' Academy in 1786.

During his lengthy Italian stint, Allan's sketchbook turned from historical studies to contemporary scenes capturing the habits, characters and traditions of the Italian people. Returning to Scotland, Allan transferred the same curiosity to everyday scenes in his native land. The first artist to celebrate Scottish folk at work and play, Allan revived an interest in Scots' song and poetry with his lively rural and cottage scenes. In 1793, he was asked by the Principal Clerk to the Board of Trustees, Scottish folk-song collector George Thomson, to illustrate *A Select Collection of Original Scottish Airs*. Collaborating with the poet Robert Burns, Allan's etchings for *Tam O' Shanter* and *The Cotter's Saturday Night* were praised by the poet: 'He is the only artist who has hit genuine pastoral costume.' As Burns and Allan both died in 1796, the illustrations were never published in their entirety, but they marked Allan's status as a talented and important printmaker.

Ever in search of comical incident and curious characters, Allan found the Royal Mile a hotbed of inspiration. This scene includes many of the characters from Allan's watercolour sketches of Edinburgh trades. Allan knew the folk of the Royal Mile, he was one of them. He married Miss Shirley Welsh at the Tron Church and lived nearby in Dickson's Close, where if you had a guinea to your name you could take part in his private drawing academy. Master of the genre scene, David Allan's study of the customs and characters of the Royal Mile remains one of the most precious views in Scottish art.

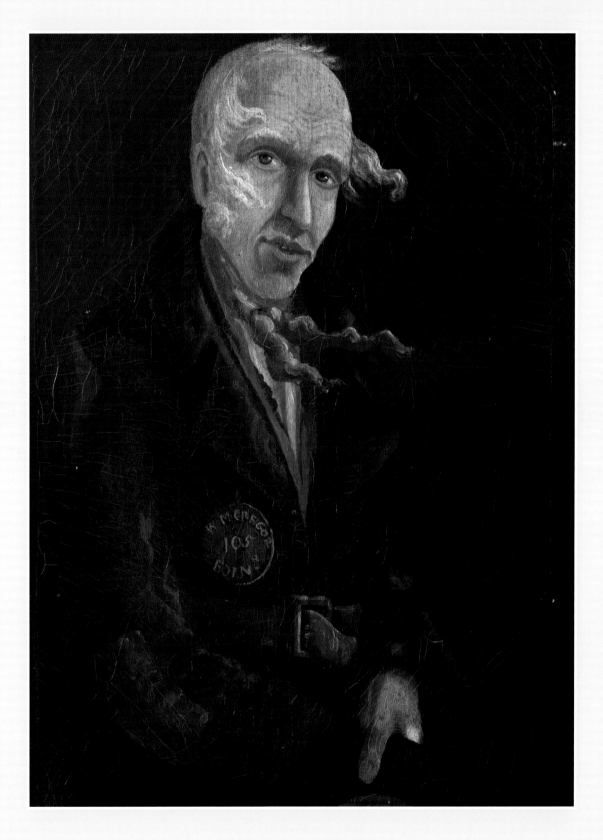

Oil on canvas, 76.2 × 62.2cm

Purchased from Prof. J. D. Macmillan, 1984

William Macgregor, an Edinburgh Porter
ATTRIBUTED JAMES CUMMING (1732–1793)

OF ALL THE CHARACTERS OF THE HIGH STREET, no-one knew the city like old Willie Macgregor. The most trusted of the Edinburgh porters, he was one of the many messengers responsible for transporting goods around the city. Illuminated by his paper lantern, he was often seen scurrying along the dark closes with books, parcels and paintings in hand. Based at the Mercat Cross on the Royal Mile, the 'caddies' with their unrivalled knowledge of the city proved indispensible city guides to newcomers and visitors. Bracing the cold Edinburgh winds, Macgregor's thick patchwork coat is pinned with his porter's badge, engraved with his unique registered number.

This painting is attributed to the heraldic painter James Cumming, Clerk and Keeper of the Lyon Court. Learning the tricks of the trade from the Norie Firm, Cumming was a leading decorative painter and master of many apprentices, including Alexander Nasmyth and the portrait painter George Watson. Cumming was Secretary of the Society of Antiquaries of Scotland founded by David Steuart Erskine, Earl of Buchan, in 1780. In the Cowgate, the Society opened the city's first museum, the Antiquarian Society Hall. Beyond its heavy bolted door, Cumming, the very first curator, would eagerly guide visitors round the dusty library and tiny rooms crammed with Scottish antiquities. In 1787, the eccentric Cumming moved the museum to Chessel's Court in the Canongate, where he died amidst his chaotic collection and beloved hoard of ancient Scottish coins. One of the Enlightenment's great antiquarians, Cumming is affectionately described by his good friend and fellow Cape Club member, the poet Robert Fergusson:

> Just now in fair Edina lives,
> That famous antient town,
> At a known place hight Black Fry'rs Wynd
> A Knight of old renown.
> A Druid's sacred form he bears
> With saucer eyes of fire;
> An antique hat on's head he wears,
> Like Ramsay's the town cryer.
> Down in the Wynd his mansion stands,
> All gloomy dark within;
> Here mangled books like blood and bones
> Strew'd in a giant's den;
> Crude, indigested, half devour'd,
> On groaning shelves they'r thrown;
> Such manuscrips no eye can read,
> No hand write but his own.
> ROBERT FERGUSSON, 'The Antiquarian', c.1772–4

Paste medallion, 9.8 × 6.7cm

1795

View of Edinburgh from the Calton Hill
PATRICK GIBSON (1782–1829)

FROM THE SHADOWS AND ROCKS OF THE CALTON, Patrick Gibson's view sweeps over the smoking chimneys of the Old Calton towards the Castle. Below the North Bridge, a cluster of ancient buildings sit directly in view. Built to improve the lives of Edinburgh's sick and impoverished, these historic landmarks feature in many of Edinburgh's antique views.

Dating back to 1462, the Gothic treasure of the Trinity College Church was built by Mary of Gueldres, the Queen of James II. A victim to the Reformation iconoclasts, it suffered at the hands of the mobs as they desecrated its tombs, hacked its gargoyles and smashed its splendid stained glass. Mary of Gueldres also founded the nearby Trinity Hospital, a refuge for 'decayed burgesses', with its long corridors and tiny cells.

On grounds known as Dingwall Park, the Orphan Hospital was built in 1733 to care for and educate the city's orphans. Founded by the merchant Andrew Gairdner in 1734, it was built to designs of William Adam and funded by the Society in Scotland for Propagating Christian Knowledge. In its slender spire was placed the rescued clock from the sixteenth-century city gate, the Netherbow Port, demolished in 1764.

On-site stands the Chapel of Glenorchy, founded by Willielma Maxwell Campbell, Viscountess Glenorchy in 1772. Painted as a child by Allan Ramsay, she was the daughter of William Maxwell of Preston and sister to Mary Gordon, Countess of Sutherland. The wife of John Campbell, Viscount of Glenorchy, she lived at Barnton House, where she also built a chapel. With private funds the patroness built the Chapel of Glenorchy as an additional place of worship for the poor.

Patrick Gibson, a pupil of the eminent landscapist Alexander Nasmyth, studied at the Trustees' Academy. An accomplished landscapist and writer on the arts, Gibson left the city in 1824 to take up the post of Head of Painting at Dollar Academy. His noted contribution was his publication *Selected Views of Edinburgh* in 1818, a series of detailed etchings recording prominent landmarks and city improvements. As the old Netherbow clock ticked away, Gibson preserved a view that very soon would change forever. This painting is a reminder of the crucial role of the city's artists in recording the changing cityscapes, as outlined in the artist's own words:

> In the present times, many great public improvements have taken place in the City: many buildings have, in consequence, been taken away, and others for a time brought into view and objects of various sorts have presented themselves, of which it is believed that it would be interesting to preserve the remembrance.
> PATRICK GIBSON, *Selected Views of Edinburgh*, 1818

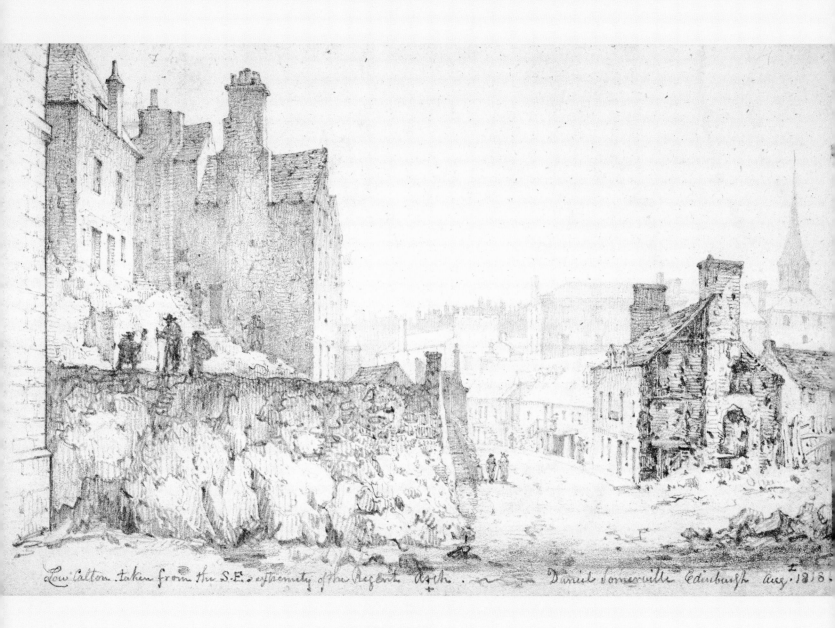

Low Calton, taken from the S.E. extremity of the Regent Arch. — *Daniel Somerville Edinburgh Aug.t 1818*

Pencil on paper, 14 × 23cm

1818

Purchased from the Open Eye Gallery, Edinburgh, 1989

Low Calton Road from the
South East Extremity of the Regent Arch

DANIEL SOMERVILLE (FL.1780S–1830S)

THE LOW CALTON, the long dark street set in the deep valley below Calton Hill, was the historic entry into the city from the east. Once known as St Ninian's Row, it was the main thoroughfare through the old Barony of Calton. By the nineteenth century, the appalling slum conditions of the old Calton village proved an embarrassing and unsightly route into the city. For the extension of the New Town eastwards, the Low Calton and its many inhabitants would have to go.

In 1814, the Lord Provost, Sir John Marjoribanks, proposed to build a bridge over the squalor of the Low Calton, creating an impressive entry into Princes Street. The building of the neo-classical Regent Bridge with its imposing arch was overseen by engineer Robert Stevenson to the design of architect Archibald Elliot. Laid with stone quarried from the Salisbury Crags, Waterloo Place was officially opened by Prince Leopold of Saxe Coburg on 18 August 1819.

This view from under the newly completed arch captures the lingering community of the old Calton. Down the winding street, locals can be seen amongst the dilapidated buildings and old workshops. Villagers walk past Will Ewing's Cooperage towards the Old Calton Well. Workers are ordered to clear the rubble below the towering tenements that within a couple of years would be razed to the ground.

Daniel Somerville's studies of his hometown are revealing windows to the past. Originally from Dalkeith, Somerville lived nearby in St James Square and was a well-regarded teacher, printmaker and topographical artist. In 1817, he published *Sixteen Original Sketches of Edinburgh*, a collection of drawings capturing Old Edinburgh animated with fleeting figures and staring inhabitants.

Cleared for the advance of the New Town, Somerville's drawing remains a sympathetic view of a forgotten street by one of Edinburgh's forgotten artists.

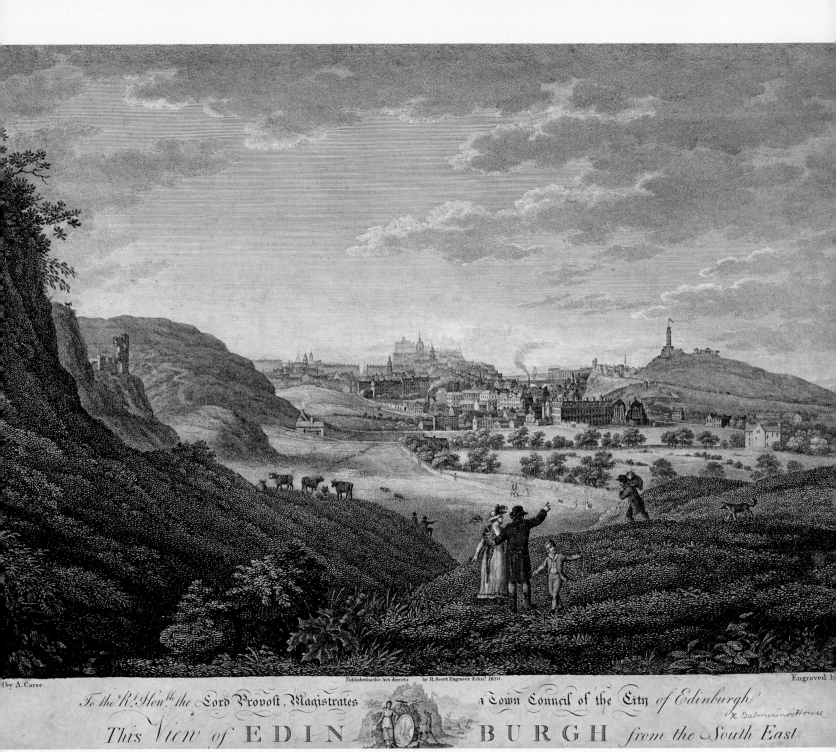

by A. Carse. Published as the Act directs by R. Scott Engraver Edin.r 1820. Engraved

To the Rt Honble the Lord Provost Magistrates & Town Council of the City of Edinburgh
 X. Balmerino's House
This View of EDIN BURGH from the South East

Engraving on paper, 31.9 × 40.6cm
1820
Presented to the City of Edinburgh, 1908

Edinburgh from the South East, 1820

ROBERT SCOTT (1771–1841)
AFTER ALEXANDER CARSE (1771–1843)

A COLLABORATIVE EFFORT BY TWO OF THE CITY'S DISTINGUISHED ARTISTS, this splendid engraving was created by the painter Carse and printer Scott. Looking up towards the town and Holyrood Palace, a couple stroll with their child in the King's Park as a farmer carries one of his sheep over to his cattle. Perched above the Haggis Knowe sit the ruins of St Anthony's Chapel associated with the Knights Hospitallers of St Anthony of Leith. The gentleman points to the new monuments on the Calton Hill. Replacing Thomas Short's Old Observatory, the new City Observatory was completed in 1818 by William Henry Playfair for the Edinburgh Astronomical Institution. The spyglass signal tower of Robert Burn's Nelson Monument was built in 1815 to commemorate the Battle of Trafalgar. Below the Calton, × marks the spot on Lord Balmerino's House. The original laird of the lands of Restalrig and Calton, in 1725 it was Lord Balmerino of Elphinstone who sold the Calton Hill to the Council. Balmerino House was eventually forfeited when Arthur Elphinstone, 6th Lord Balmerino, a Jacobite officer, was executed after being taken prisoner at Culloden.

This engraving was printed in Robert Scott's busy printing office in the top floors of a tenement in Parliament Square. Acclaimed for his landscape engravings and book illustrations, Scott was considered one of Scotland's leading printers, who introduced the art of engraving on steel. Originally from Lanark, Scott grew up in Musselburgh before taking up his apprenticeship with the engraver Andrew Robertson. Of the many plates to be found in his workshop, the most famous included Dr James Anderson's periodical *The Bee* (1792), George Barry's *History of the Orkney Islands* (1805), John Bell's *Poets of Great Britain* and the *Scenery of Allan Ramsay's Gentle Shepherd* (1808). A number of years after the creation of this engraving, Scott's printing house would be lost to one of the worst disasters to hit the city.

Scott taught many pupils, the most accomplished continuing their studies at the Trustees' Academy, as was the case for Alexander Carse. In 1795, Scott engraved *Views of Seats and Scenery Chiefly in the Environs of Edinburgh* from drawings by Carse and Andrew Wilson. Inspired by the art of David Allan, Carse became an important painter of Scottish scenes and character. His early lively depictions of Scots working and dancing would in turn inspire the genre scenes of another great Edinburgh painter, Sir David Wilkie. Settling in London in 1812, Carse created this on his return in 1820.

Robert Scott was not keen for his two sons to pick up the paintbrush, and insisted they learn the art of engraving to ensure their livelihood. David Scott became a noted historical painter and printer of *Monograms of Man* and illustrations to Coleridge's *Ancient Mariner*. In 1838, Scott printed his final work in collaboration with his son William, *The Scenery of Edinburgh and Midlothian*. With David's early death, it was William who would continue the family's artistic reputation.

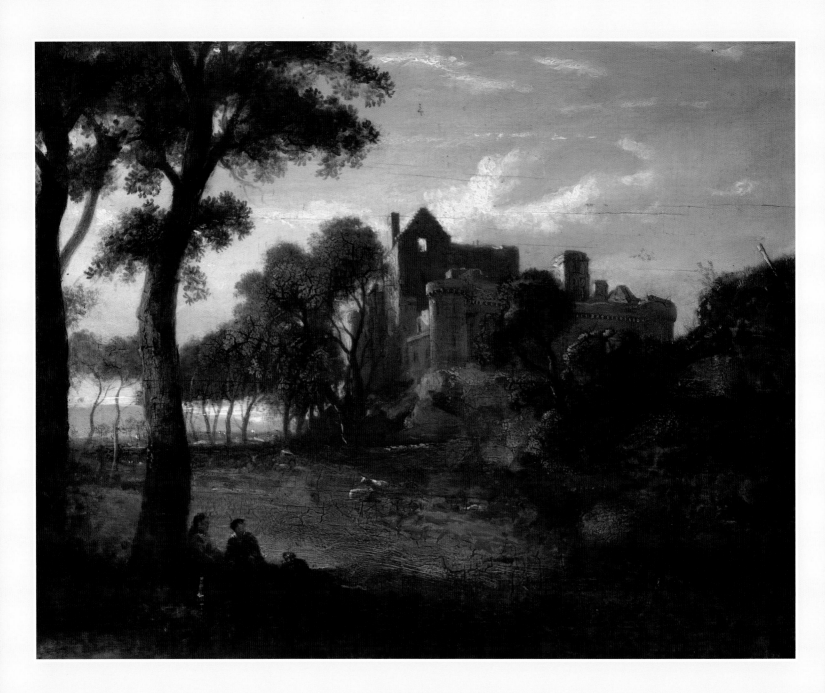

Oil on panel, 35.9 × 48.2cm
1821
Collection of Sir Walter Scott
Purchased at auction, 1963

Craigmillar Castle from the South East

REV. JOHN THOMSON OF DUDDINGSTON (1778–1840)

ON THE OUTSKIRTS OF EDINBURGH, the ruins of Craigmillar Castle overlook the historic village of Duddingston. Seen from the windows of his manse, this castle was a favourite subject of one of Scotland's great romantic landscape painters, the minister of Duddingston Kirk, the Rev. John Thomson.

While studying theology at Edinburgh University, Thomson's artistic talents were encouraged by lessons from Alexander Nasmyth. Despite work commitments and a large family, Thomson the amateur artist flourished as a highly successful landscapist. His atmospheric visions of castles, cliffs and raging seas, created with an energetic use of brush, stirred the emotions. Thomson travelled all over Scotland capturing the wildness and distinctive character of the landscape. He had an unrivalled knowledge of Scottish history and antiquities, and his most poignant works are those associated with particular moments and locations hidden within Scotland's past.

Brother of the Factor of the Duddingston estate and an Elder of Duddingston Kirk, Sir Walter Scott was a regular visitor to the artistic manse. Visiting his dear friend in 1818, Scott proposed a monumental publication celebrating the Scottish landscape, *The Provincial Antiquities and Picturesque Scenery of Scotland (1819–1826)*. Thomson agreed to illustrate, along with other leading landscapists such as Hugh William Williams and Joseph Mallard William Turner. Captivated by its historical associations, Scott included Thomson's painting of Craigmillar in the final publication.

Built in the fifteenth century by the Preston family, the Castle was the country retreat of Mary, Queen of Scots. She fled here in 1566 to recuperate after the birth of her son, James VI, at Edinburgh Castle and the murder of her secretary, David Rizzio at Holyrood. In Scott's words, 'This fine old Ruin, situated on the top of a gentle eminence, forms one of the most striking features in every view on the south of Edinburgh.'

Of all locations in his sketchbook, Duddingston remained Thomson's artistic retreat. With views to the Pentlands, he painted in his studio 'Edinburgh' overlooking the tranquil loch. A constant source of pleasure, its beauty was acknowledged on Turner's departure: 'By God, though, I envy you that piece of water!' After Thomson died in 1840, *The Scotsman*, advertising his sale of paintings, asserted: 'No man had done so much as Mr. Thomson to maintain the character of native art in landscape, and no man has more successfully transferred to the canvas the grand and impressive features of his country's scenery.' Thomson's tomb lies next to his loch, forever to be associated with this beautiful spot.

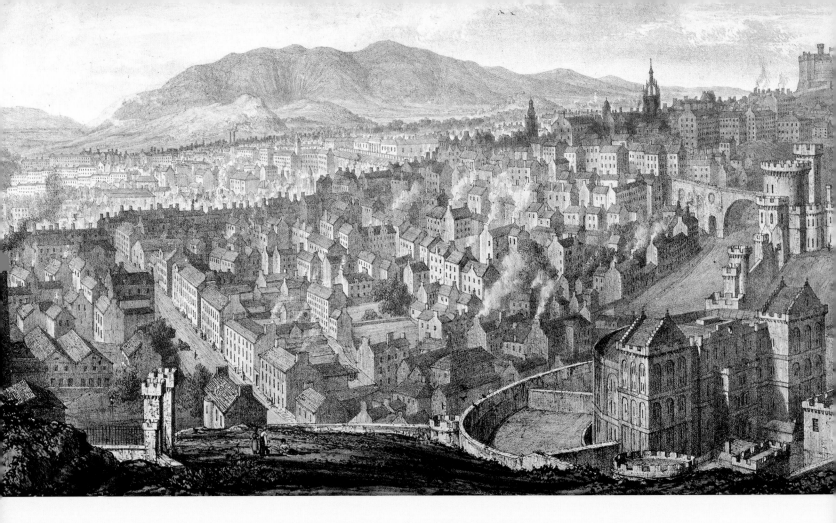

View of the Top of Calton Hill Looking to the West

LADY MARY STEWART (ELTON) (1773–1849)

Sketched by Miss Mary Stewart, 1822./
Drawn on the Stone by W. Westall,
A.R.A. / Printed by C. Hullmandel.

IN 1823, LADY MARY STEWART published her *Four Panoramic Views of the City of Edinburgh*. Inspired by the panoramic efforts of Robert Barker, the young artist drew a highly detailed view from the Calton Hill. Drawn onto stone and printed with the new method of lithography, the prints were published for the benefit of the Deaf and Dumb Institution of Edinburgh.

Looking out towards the west, Lady Mary Stewart sits with her sketchbook admiring the magnificent view. A flock of birds fly across the Pentlands, over the rooftops of the Old Town towards the streets of the New. From Waterloo Place, the view extends along Princes Street towards St George's Church at Charlotte Square to Corstorphine Hill beyond. In the distance pedestrians risk the steep hike up the Earthen Mound. Looking over the three streets of the New Town, Raeburn's Stockbridge is slowly developing. Below the North Bridge, carriages stroll past Register House towards Waterloo Place and the imposing jails of the Bridewell Prison and the new Calton Jail built in 1817.

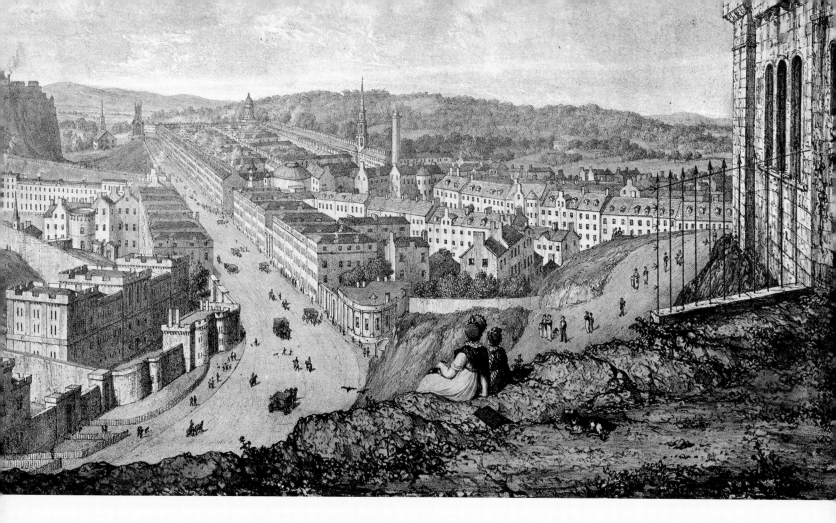

Lithograph on paper, 24 × 61cm
1823
Presented by P. W. Borthwick, 1948

The aristocratic Lady Mary Stewart grew up in Edinburgh, the daughter of William Stewart of Castle Stewart and Euphemia Mackenzie. Painted by Allan Ramsay, her maternal grandmother, Lady Mary Stewart Fortrose, was the eldest daughter of Alexander Stewart, 6th Earl of Galloway, and wife of Kenneth Mackenzie, Lord Fortrose. Owing to their esteemed family heritage, when Lady Mary Stewart's mother died in 1817, she was buried with great honour in the Chapel Royal of Holyrood Abbey. In 1823, Lady Stewart married Sir (Rev.) Abraham Elton, 5th Baronet of Clevedon. Leaving Edinburgh, she spent the rest of her days sketching in the magnificent house, gardens and library of the fourteenth-century manor, Clevedon House, in Somerset.

Through her charitable efforts, Lady Mary Stewart helped the people of Edinburgh and preserved this view of the city in 1822, which, with the visit of King George IV in August, would prove an eventful year.

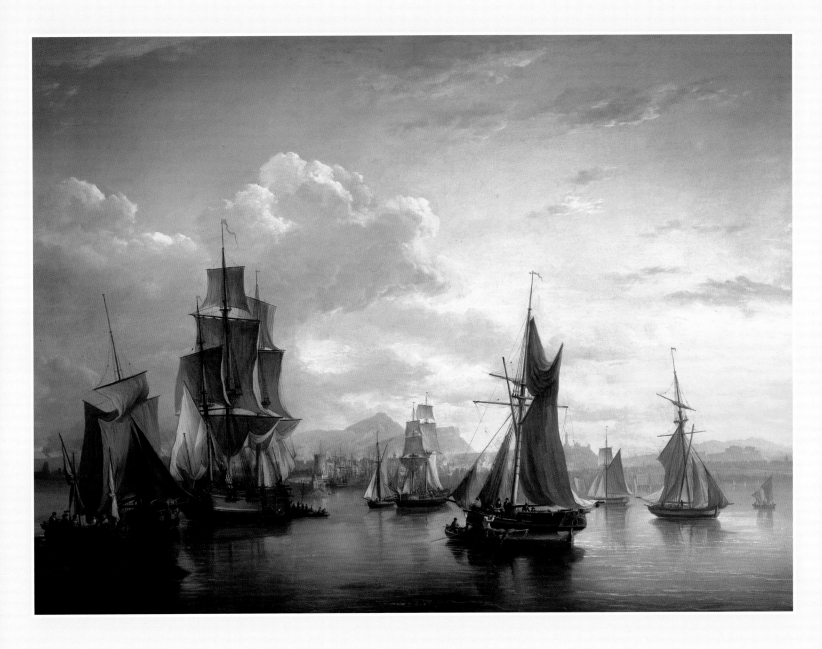

Oil on canvas, 111.8 × 149.8cm
Presented by the Rt Hon. the Earl of Rosebery, 1944

The Port of Leith, 1824

ALEXANDER NASMYTH (1758–1840)

THE SPLENDOUR OF THE PORT OF LEITH shines in this masterpiece by Alexander Nasmyth. Bustling with activity, ships compete for space as sailors unload cargo from boats laden with spices, whale oil and wine. Exporting across the world, Scotland's busiest port was home to a host of thriving industries, including ship building, rope making, flour mills and sail cloth. Bathed in light, Leith harbour is overlooked by the city and Arthur's Seat. One of Nasmyth's grand Edinburgh portraits, this is a local scene from Scotland's most influential nineteenth-century landscapist.

Apprenticed to the house decorator James Cumming, Alexander Nasmyth grew up in Naismyth House in the Grassmarket to a family of Edinburgh master masons. From Alexander Runciman's night classes at the Trustees' Academy, Nasmyth was whisked away by Allan Ramsay to his studio in London. Assisting with many grand royal portraits, Nasmyth inherited his master's talent to draw directly from nature. Nasmyth's plan to return to Edinburgh to establish a portrait studio was scuppered by few commissions and stiff competition from Raeburn. Undaunted and inspired by his travels to Italy, as well as from painting stage scenery, Nasmyth quickly asserted himself as a leading landscapist. Forging the Italian and Dutch traditions into his grand native visions, he was the first artist to truly celebrate the grandeur of the Scottish landscape. Along with sweeping views of the Highlands, Nasmyth continued to study his native city. Painted at the height of his career, this painting belongs to a series of important works recording city development and industrial expansion.

A respected teacher, Nasmyth ran his landscape painting school from his townhouse at 47 York Place. Here he encouraged a generation of younger artists, including his eight children. From the 'Belvidere', a viewing platform on the roof, he loved the magnificent view along the Forth, casting a panorama from Stirling to the Bass Rock. On his many sketching trips around the city, Nasmyth stressed the importance of drawing and sketching out of doors, as remembered by his son, James: 'He was master of the pencil, and in his off-hand sketches communicated his ideas to others in a way that mere words could never have done. It was his Graphic Language.'

A towering figure of the Enlightenment, Nasmyth's enquiring mind and artistic ability stretched to landscape design, engineering and invention. Often venturing to Leith to gaze at the boats, in 1788 he collaborated with retired Edinburgh banker Patrick Miller to design the world's first paddle steamer. When it took to the waters on Dalswinton Loch in Ayrshire, Nasmyth met one of Miller's tenants, Robert Burns, onboard. This was the start of a lasting friendship between poet and painter. On their walks together on Arthur's Seat, looking out towards the Forth, Nasmyth shared his enthusiasm for Edinburgh's stunning scenery, evident in this masterpiece.

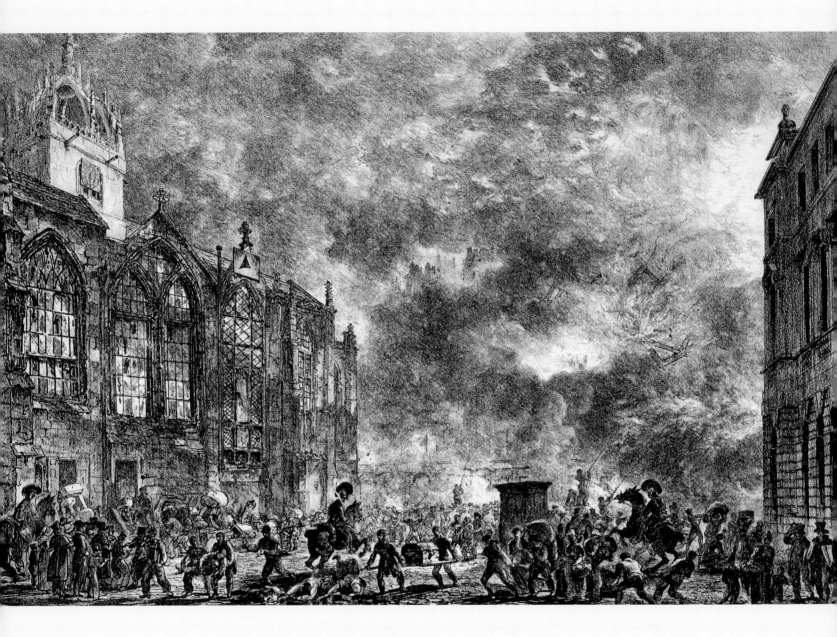

Lithograph on paper, 27.3 × 39.4cm

View of the Great Fire in the Parliament Square, Edinburgh taken on the Night of the 16th of November 1824

WILLIAM TURNER 'DE LOND' (FL.1820–1827)

ON THE NIGHT OF 15 NOVEMBER 1824, clouds of smoke billowed from the tall lands of the Royal Mile. Screams pierced the air and panic filled the streets as the steeple of the Tron fell to the ground; the Old Town was ablaze! Raging for four days, the Great Fire of 1824 ripped through centuries of Edinburgh history and architecture. Sparked in the printing office of engravers James Kirkwood & Son, the fire began in Assembly Close. The inferno was described in a contemporary account:

> A dusky, livid red tinged the clouds and the glare shone on the Castle walls, the rocks of the Calton, the beetling crags, and all the city spires. Scores of lofty chimneys, set on fire by the falling sparks added to the growing horror of the scene; and for a considerable time the Tron Church was completely enveloped in this perilous shower of embers.

The following evening, an eleven-storey house caught fire in the Parliament Square. In a bid to save the historic Parliament House and St Giles' Cathedral, the crowds desperately battled the blaze, as shown in this dramatic view. Soldiers on horseback attempted to keep order as flames engulfed the soaring tenements. Eminent men of law such as Lord Advocate Sir William Rae and Solicitor-General John Hope joined forces with Britain's first fire brigade commanded by James Braidwood. Within the flames, timbers fell from David Scott's print house; here four double tenements were destroyed: 'as the conflagration spread, St Giles' and the Parliament Square resounded with dreadful echoes, and the scene became more and more appalling, from the enormous altitude of the buildings'. Claiming thirteen lives and leaving hundreds homeless, the fire eventually burnt out in Conn's Close. Tearing through the core of the Old Town, the fire consumed the historic lands of Assembly Close, Borthwick's Close and Old Fishmarket Close. However, as a result of the efforts and bravery of the townsfolk, many of the Royal Mile's historic buildings survived.

William Turner de Lond's prints of the disaster were available for purchase three days later, as the scorched ruins still smouldered. A noted recorder of contemporary scenes in Dublin, these lively views of one of the worst fires to strike Edinburgh established his credentials as a recorder of current events.

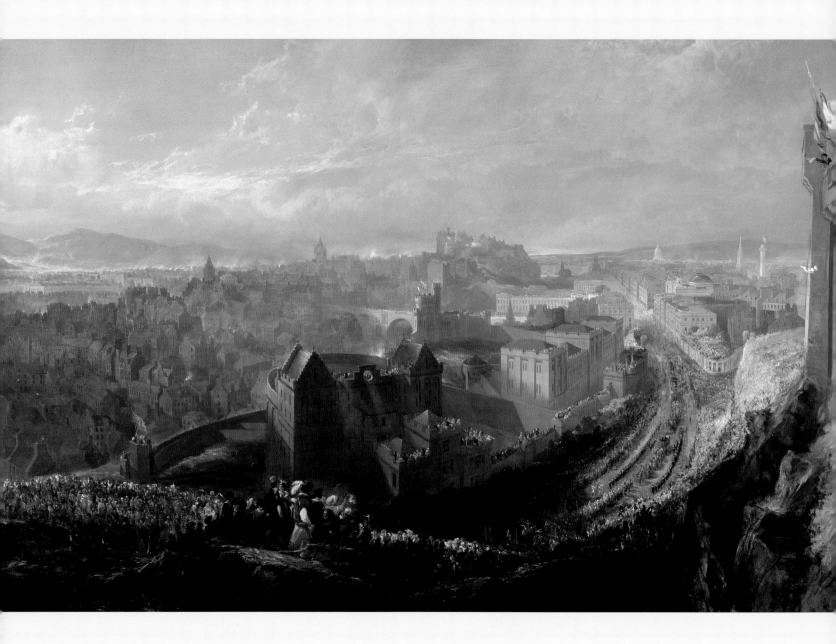

Oil on canvas, 150.5 × 240.0cm

1827

The Signing of the National Covenant in Greyfriars Kirkyard

SIR WILLIAM ALLAN (1782–1850)

CAPTURING A PIVOTAL MOMENT IN SCOTTISH HISTORY, *The Signing of the National Covenant in Greyfriars Kirkyard* was painted by the President of the Royal Scottish Academy and Master of the Trustees' Academy, Sir William Allan.

With great intensity, the Scottish nobles and clergy sign the National Covenant in defiance of the Stuart monarch, King Charles I, in 1638. Spurred by the King's introduction of the Book of Common Prayer and Bishops into Government, the Scottish Kirk vehemently opposed the King's interference in their religious affairs. Recognising only God as the head of the Kirk, they signed this petition in defence of their rights and national identity. Proposing a free Scottish Parliament and a free General Assembly, this contract was signed by thousands of Scots across the country. The ensuing violence, bloodshed and political upheaval eventually led to civil war. Created to commemorate the bi-centenary of this seismic event, this grand painting with its display of costume and historical detail shows the Covenanters jostling to sign the parchment lying upon one of the ancient gravestones of Greyfriars Kirkyard.

Sir William Allan grew up in Edinburgh the son of an officer of the Court of Session, the macer William Allan senior. After his apprenticeship painting heraldry for Crichton and Field the coachmakers, he studied at the Trustees' Academy with David Wilkie and at the Royal Academy schools in London. Leaving British shores in 1805, he spent over ten years travelling throughout Russia and the Ukraine, capturing many studies of Cossacks, Circassians and Tartars. It was through the help of fellow Scot Sir Alexander Crichton, physician to Tsar Alexander, that Allan acquired the patronage of the Russian court. However, after witnessing horrific scenes of Napoleon's invasion of Russia, Allan grew homesick and returned to Scotland in 1814.

Inspired by the writings of Scott, Allan turned his eye to his native history. He painted poignant events from Scottish history, genre scenes and historical portraits. As the preferred historical painter of Sir Walter Scott, he painted many portraits of Scott and his family at Abbotsford and was one of the first illustrators of the Waverley Novels. Allan retained his royal links to Russia, and when the Grand Duke Nicolas visited Allan's Edinburgh studio in 1816 he bought a pair of paintings now in the State Hermitage Museum, *Frontier Guards* and *Bashkirs Conducting Convicts to Siberia* (1814). Always the adventurer, from his home on Great King Street in the New Town Allan ventured on further travels to Italy, Spain, Morocco and Constantinople, Germany and France. He returned to St Petersburg in 1841, when he was commissioned by the Tsar to paint *Peter the Great Teaching his Subjects the Art of Shipbuilding*. In 1843, his painting *Battle of Waterloo from the English Side* was bought by the Duke of Wellington.

While working on his last painting, *The Battle of Bannockburn*, Scotland's great historical painter died in 1850. Dandy, his faithful and grief stricken Skye Terrier, died on the morning of his funeral.

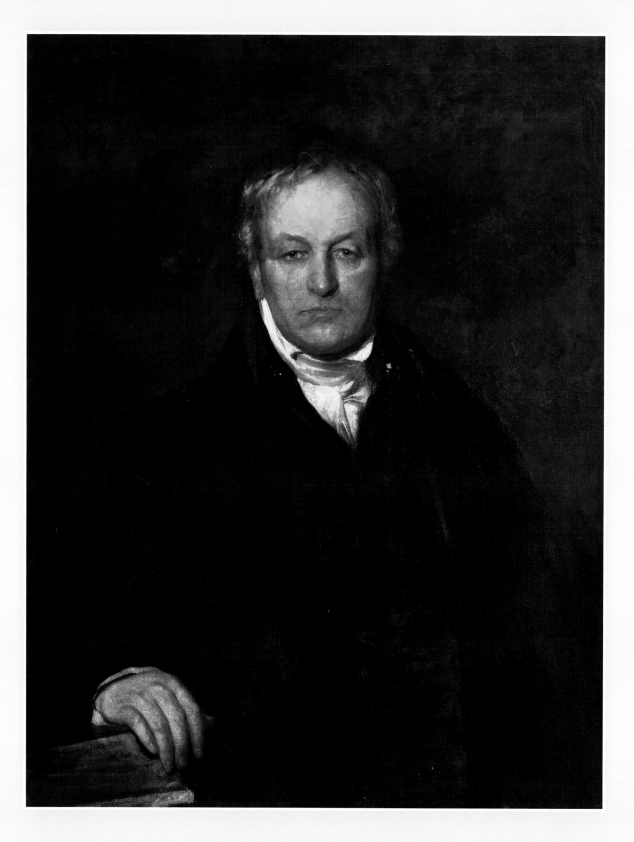

Oil on canvas, 72.7 × 92.7cm

c.1830

John Lauder of Silvermills
ROBERT SCOTT LAUDER (1803–1869)

THE OLD VILLAGE OF SILVERMILLS AT STOCKBRIDGE took its name from the ancient mills refining silver upon the Water of Leith. By the nineteenth century this pocket of industry was dominated by a tannery owned by John Lauder of Silvermills House. A successful industrialist, Lauder expected his sons James and Robert to carry on the family business. To his great frustration, the stench of hides and lure of manufacture did not interest them; they wanted to be artists.

Encouraged by neighbour and scene painter David Roberts, Robert Scott Lauder was determined to become a painter. For inspiration and advice he turned to another Edinburgh painter, the Rev. John Thomson. The young artist often ventured to Duddingston Kirk for lessons from his kind tutor. During the many visits, he fell in love with Thomson's daughter, Isabella, and they married at the manse in 1833. Thomson's lessons paid off; his son-in-law became one of Scotland's most influential Victorian artists.

Following a period of study in Italy, Lauder settled in London, specialising in religious and historical scenes. Returning to Edinburgh, in 1852 Lauder assumed the role of Master of the Trustees' Academy housed in the Royal Institution on the Mound. Here he encouraged a future generation of star pupils including George Paul Chalmers, William Quiller Orchardson, John MacWhirter, Peter Graham, Hugh Cameron, John Pettie and the brilliant sea-painter William McTaggart. Lamenting the loss of the Life School to the Royal Scottish Academy, Lauder was Master when the Academy was affiliated to the Science and Art Department in London, becoming the Government School of Art in 1858. Scott Lauder's famous painting *Christ Teaching Humility* (1848), an unsuccessful public competition entry to the Houses of Parliament, was purchased by the Royal Association for the Promotion of the Fine Arts in Scotland as the first 'Great Picture' for the collection of the Scottish National Gallery.

Along with this stern portrait of his father, Lauder painted his fellow artists David Octavius Hill, Sir John Steell, the Rev. John Thomson and David Scott, and the famed portrait of his friend David Roberts clad in Arab dress, fresh from his travels in 1840.

For the northern expansion of the New Town, the stench of the tanpits disappeared when John Lauder sold his lands of Silvermills to the Council and moved to Fettes Row. On the same site Playfair built his imposing St Stephen's Church in 1828, whose colossal arch would later ignite the artistic imagination of a future family descendant, James Pryde.

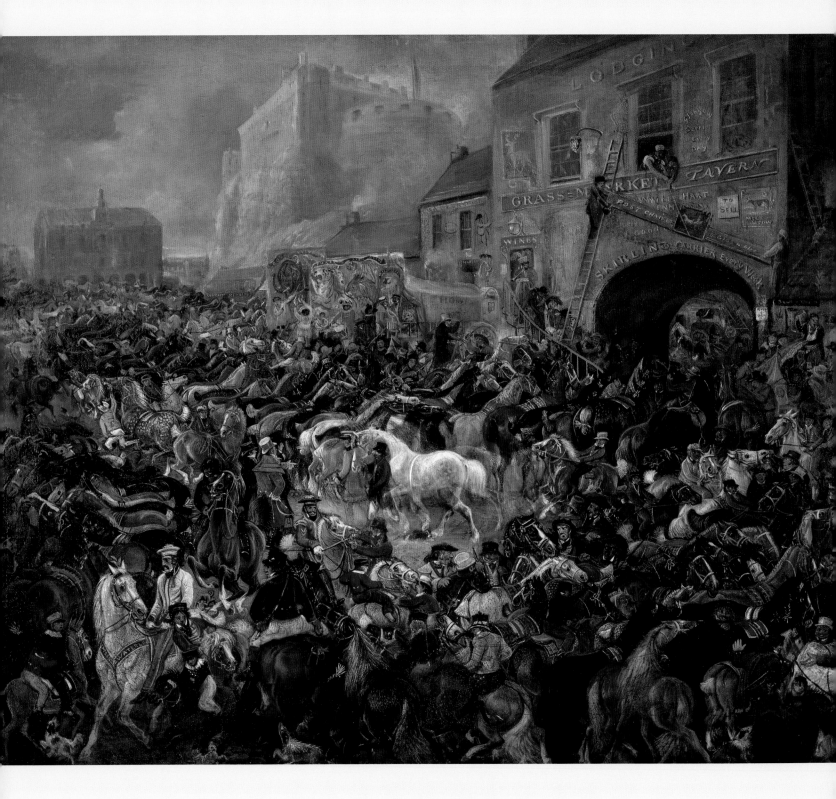

Oil on canvas, 91.5 × 114.3cm

Purchased at auction (with government grant-in-aid), 1980

Horse Fair in the Grassmarket

JAMES HOWE (1780–1836)

THE EXCITEMENT AND CHAOS of the annual All Hallows' horse fair in the Grassmarket is brought to life by Scotland's first great animal painter, James Howe. In an explosion of colour, energy and incident, Howe catches the fervour of the moment in this intriguing scene of trading and entertainment. In homage to Sir David Wilkie's *Pitlessie Fair* of 1804, the congestion of drovers, farmers, fiddlers and street sellers is animated by Howe's signature bright colour, expression and lively brush. With his usual humour, Howe includes a sign for his Border birthplace of Skirling, and a portrait of himself painting the canvas of the travelling menagerie. Howe was regularly found sketching the stramash of nags and thoroughbreds of the Grassmarket. With its many drover pubs and taverns, it had long been the site of the city's horse and cattle fairs, and Howe's favourite of all the local markets.

When he arrived in Edinburgh from Peeblesshire, Howe was apprenticed to the house painter Walter Smiton. Bored of whitewashing the Old Tolbooth, he moved on when his fast brush was snapped up by Mr Marshall, the owner of a panorama. There he painted numerous scenes of battles, journeys and exotic locations, becoming the city's leading panoramic painter, and soon acquired the patronage of the Earl of Buchan, David Steuart Erskine. Specialising in animal portraits and hunting scenes for the gentry, Howe was recognised as the paramount animal painter in Scotland.

The sign of a prancing piebald pony advertised the premises of the great horse painter on Greenside Street. On hearing of the death of George Stubbs, horse painter to George III, Howe hoped to escape his humble abode for the lights of London. With a letter of introduction from his patron, Howe was sent to paint the horses of the Royal Stud for the King. Despite an impressive grand portrait of 'Adonis', the King's charger, Howe failed to win royal favour and returned to Edinburgh to pick up his panoramic brush again. In 1815, he set off from Leith to Waterloo to record accurate sketches of soldiers and horses for Mr Marshall's GRAND PANORAMIC PANORAMA OF WATERLOO. Exhibited at York Place, Howe's battlefield, seething with horses, men and artillery, wowed the crowds. It travelled to Glasgow, but there Howe blew his profits on drink and returned to Edinburgh a struggling artist, never to paint a panorama again.

To relieve his fragile health, Howe retreated to Newhaven by the sea. Although outcast from the art establishment, Howe never lost his humour or passion for drawing equine studies, evident in his hundreds of minimal ink sketches. In 1824, he collaborated with the Edinburgh engraver William Home Lizars on a series of stunning studies for *Drawings of the Horse*. Plagued by health and financial worries, Howe left Newhaven to spend his final years back in the city within the care of a former pupil, Mr Robertson. This painting, one of his favourite works of art, was one of the few to remain in his possession at the time of his death.

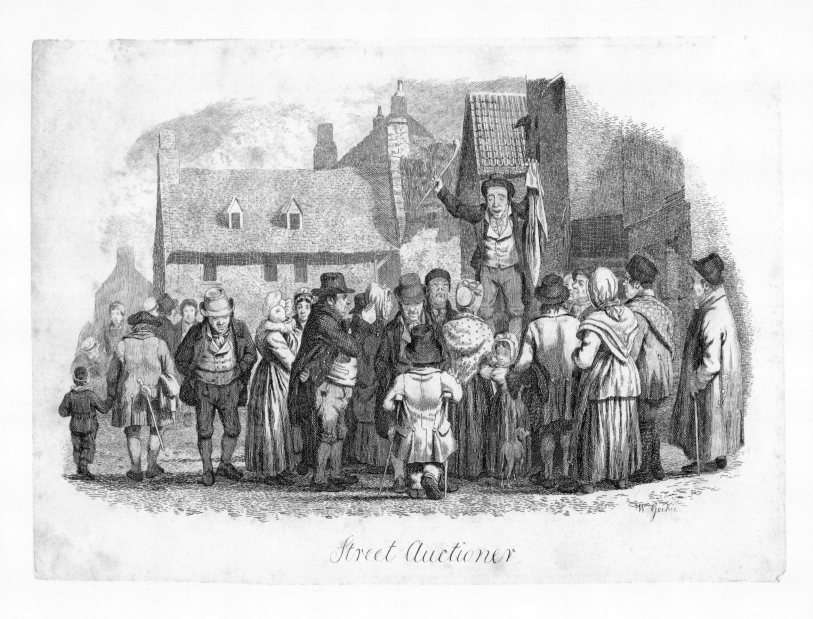

Street Auctioner

Etching on paper, 11.8 × 16.9cm

D. Grassmarket

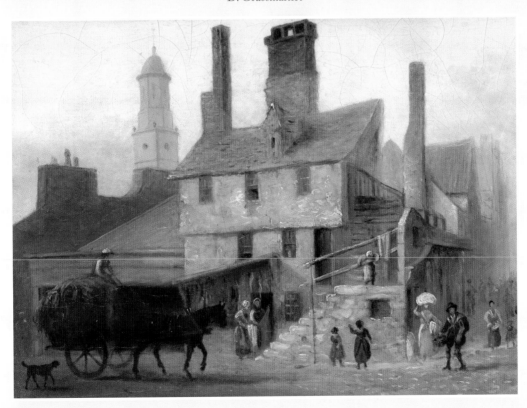

E. Cowgate Port

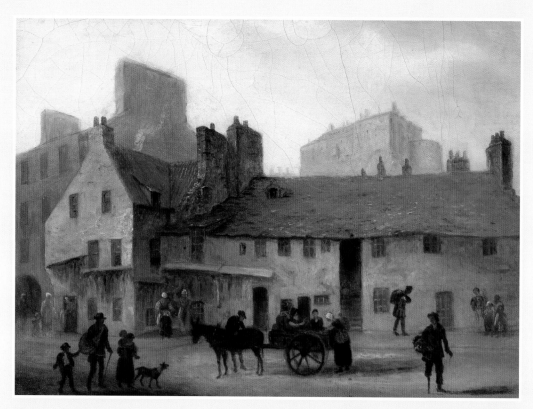

F. Foot of West Port

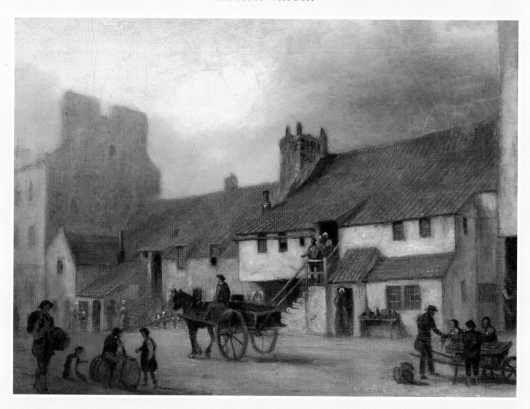

G. The Pleasance

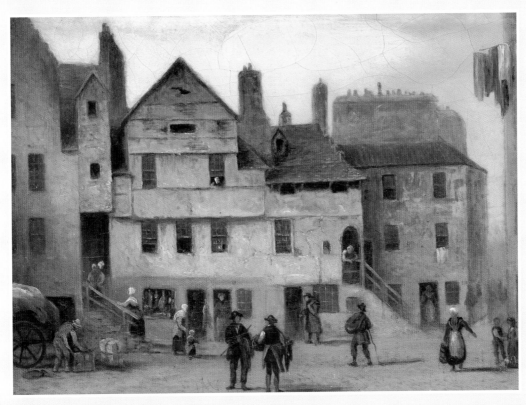

H. Foot of Candlemaker Row

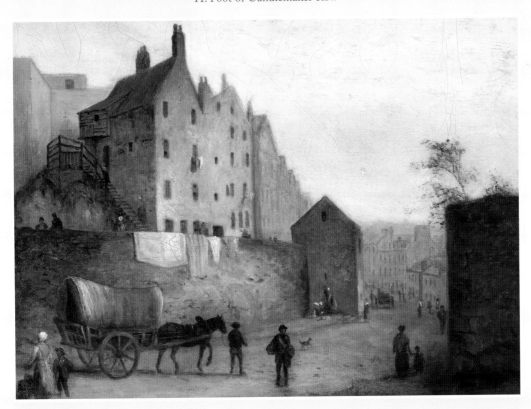

I. Calton

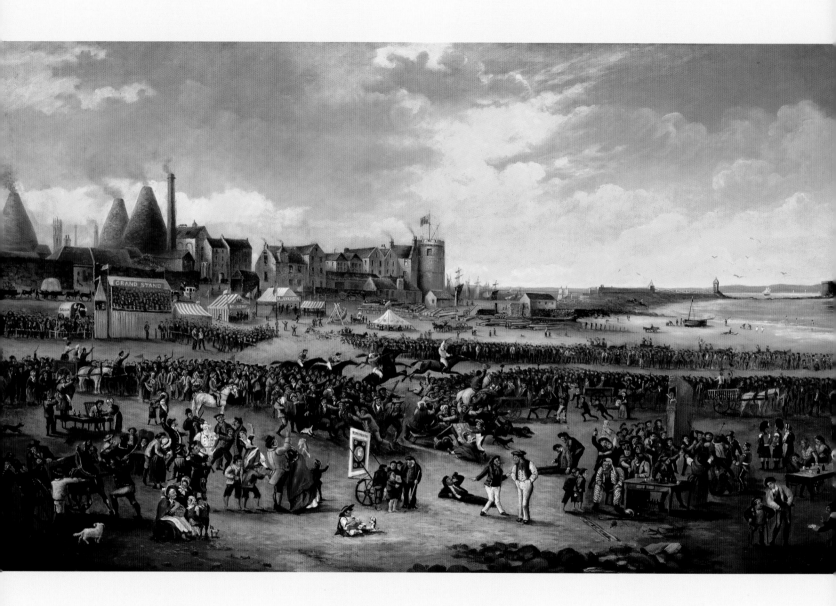

Oil on canvas, 90.0 × 154.0cm
Purchased (Jean F. Watson Bequest Fund
and government grant-in-aid), 1983

Leith Races

WILLIAM THOMAS REED (C.1842–1884)

To town-guard Drum, of clangour clear,
Baith men and steeds are raingit;
Some liveries red or yellow wear,
And some are tartan spraingit!
ROBERT FERGUSSON, *Leith Races*

THE MAYHEM AND EXCITEMENT of the nation's major sporting event is captured in this image of the Leith Races. Participants travelled from all over Scotland to take part in the famous race held on the Sands of Leith every July. Celebrated with piping competitions, balls at the Assembly Rooms and productions at the Theatre Royal, by the mid eighteenth century the annual event had developed into a week-long festival with a daily race.

To the excitement of the townsfolk, the crowds gathered each morning to watch the Procession of the Purse. Accompanied by pipe and drum, the City Guard marched from the City Chambers clutching the coveted prize money. On reaching the Sands, the list of horses and racers was announced. The race was open to all, and the competitors ranged from labourers to lords, nags to thoroughbreds, all chomping at the bit to win the coins and gold cup.

An amateur painter, Reed worked as a philosophical and photographic instrument maker. First hung in the Three Tuns Hostelry in Castle Street, then moved to Mr Hare's pub in Duke Street in Leith, this painting is a lively portrait of the races after their revival in the 1830s. The most famous of Edinburgh's sporting pictures, William Reed's vibrant portrayal is one of the few depictions of the raucous event. From the grandstand, the city dignitaries place their bets for the Grand Finale. As the jockeys hurtle down the track, spectators run for their lives as a horse plunges into the bustling crowd. The locals clamber over carts for a closer look. All the fun of the fair is depicted in the drink stalls, wheels of fortune and puppet shows. The show folk and children mingle with fishwives, fruit sellers, pickpockets, drunks, recruiting sergeants and the odd piper. Preserving the characters and drama of the event, this scene is mirrored in Grant's *Old and New Edinburgh*: 'the whole varied by shows, roley-poleys, hobby horses, wheels-of-fortune, and many of those strange characters which were once familiar in the streets of Edinburgh, and of whom, "Jamie, the Showman", was perhaps the last'. In the background, ships wait in the harbour, the flag flies from the signal tower and smoke rises from the distinctive cone towers of the Edinburgh and Leith Glassworks.

To the regret of many, the long tradition of the Leith Races came to an end in 1816 when they were transferred to the turf at Musselburgh. Although the Sands were still used for Subscription Races, which had their origins in the 1650s, the Leith Races thundered down the Sands for the last time on 22 September 1859.

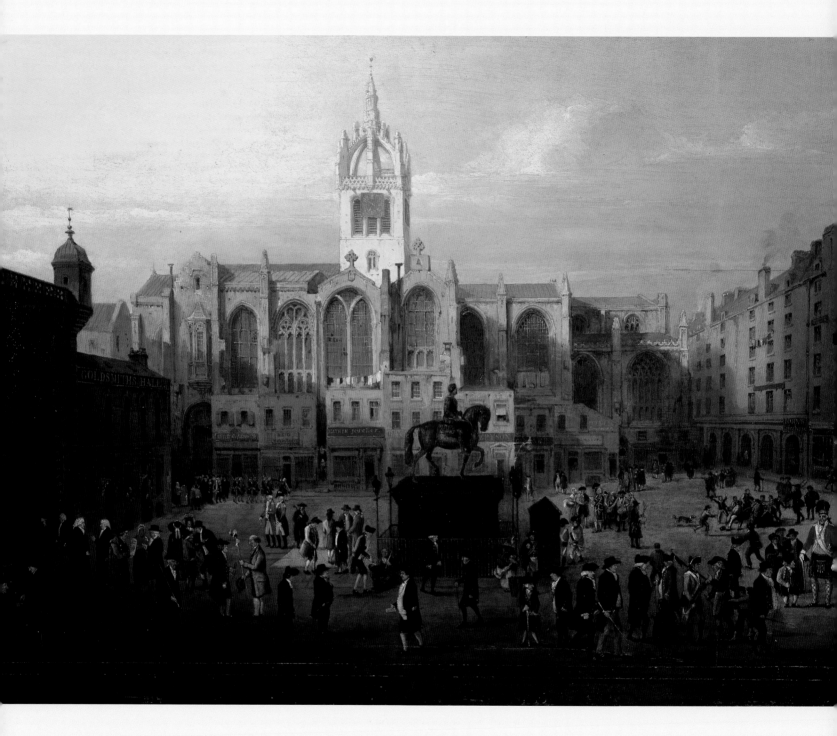

Oil on panel, 59.0 × 91.1cm
Nineteenth century
Whitson Bequest, 1948

The Parliament Close and Public Characters of Edinburgh, 50 Years Since

THE JOINT PRODUCTION OF SIR DAVID WILKIE, ALEXANDER NASMYTH, DAVID ROBERTS, CLARKSON STANFIELD AND OTHERS

A BUSY AFTERNOON ON THE PARLIAMENT CLOSE: the meeting place of the Enlightenment. Bustling with lawyers, politicians, merchants and traders, this historic spot was long the social and business centre of the town. It was the location of John Kay's print shop, from where he sketched the locals as they passed by his window. A tribute to his talent, his characters congregate outside the courts, walking over the ancient graves. As judges and men of law meet outside the courts, the Lord Provost and his entourage exit St Giles'. The advocate Hugo Arnot selects the dubious wares of Gingerbread Jock as John Dhu, the City Guard, parades the square. Noticeable from afar, Big Sam Macdonald gossips with the singing beggar, Georgie Cranston. Past the Newhaven fishwife and the Town Crier, Lord Adam Gordon and the Count D'Artois make their way from their 12 o'clock dram at St John's Coffee House.

Built upon the graveyard of St Giles' Cathedral, Parliament Square was constructed in 1632 as a forecourt to Parliament House, the seat of the Scottish Parliament and Court of Session. Set into the cobbles, a yellow plaque still indicates the last grave to be interred in 1572, that of the Protestant reformer John Knox. Owned by the Parliament-Close Council, below the line of washing on St Giles' we can see the many shops fixed to the side of the cathedral. Restricted to jewellers, watchmakers and booksellers, these include the premises of Petrie the Engraver, Green the Watchmaker and Mathie the Jeweller. Of all the traders, the goldsmiths were considered the most prestigious. Until 1809 the ancient workshop of eminent goldsmith George Heriot stood here. On the site of the Signet Library, the Incorporation of Goldsmith's Hall rests above two jewellers.

This painting preserves the scene before the square was destroyed by the flames of 1824. In the centre stands the triumphant lead statue of Charles II. Attributed to the Dutch sculptor Grinling Gibbons, it was erected in the year of the King's death in 1685. Having spent a decade in decay in the yard of Calton Jail, the statue was restored and returned in 1835. The oldest of Edinburgh's statues, he could tell many stories about Parliament Square.

> Where Charles's statue stands in lasting brass
> Amidst a lofty square, which strikes the sight
> With spacious fabrics of stupendous height,
> Whose roofs into the clouds advance so high,
> They seem the watch towers of a further sky.
> ALLAN RAMSAY, 'The Morning Interview', 1719

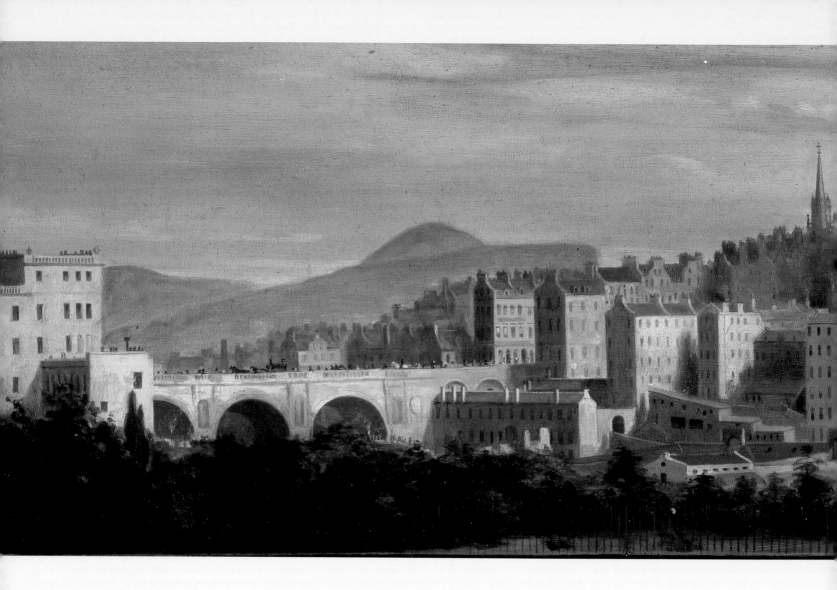

A View of the Old Town from the North

UNKNOWN ARTIST

THE SUN SHINES UPON THE DISTINCTIVE SKYLINE of the Old Town in this splendid portrait of the city, viewed from Princes Street, with the crown of St Giles and the steeple of the Tron Kirk rising from the smoking chimneys of the Royal Mile. Arthur's Seat looms behind the densely packed buildings and lofty rooftops. The display of tiny windows accentuates the incredible heights of the tenements. The City Chambers dominates the cluster of buildings. Built to the neo-classical designs of Robert and James Adam in 1753 as the Royal Exchange, the building opened its doors as the City Chambers in 1811.

Carriages and pedestrians brace the winds of the old North Bridge; it was soon to be demolished, and would be replaced in 1866. Within its arches stand the purpose-built fish, fruit and meat markets. These replaced the old hazardous street markets located in the Fishmarket and Fleshmarket closes, where the stench and grime proved intolerable, as described by Lord Cockburn: 'The fish was generally thrown

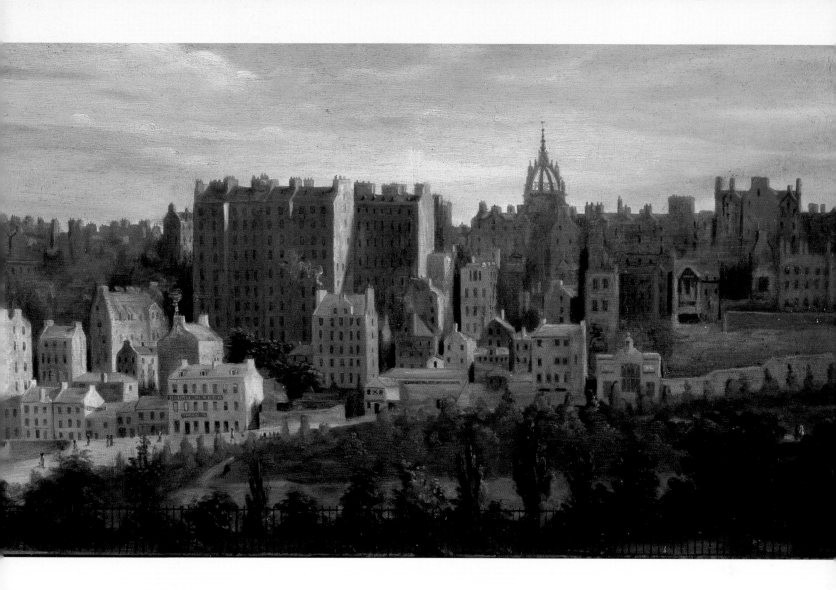

Oil on panel, 34.9 × 121.3cm
Nineteenth century
Presented by W. Watt, 1949

out on the street at the head of the close, whence they were dragged down by dirty boys or dirtier women; and then sold unwashed – for there was not a drop of water in the place – from old, rickety, scaly, wooden tables, exposed to all the rain, dust, and filth; an abomination the recollection of which greatly impaired the pleasantness of the fish at a later hour of the day.'

This scene shows Market Street, where the warehouses of the *Scotsman* newspaper would later house the City Art Centre. With the arrival of steam, this view from the New Town would soon change forever when Cockburn Street was created to improve access from the Royal Mile to Waverley Station. A city of antiquity, resisting the threat of further improvements, the outline of the Old Town is still one of Edinburgh's most impressive views.

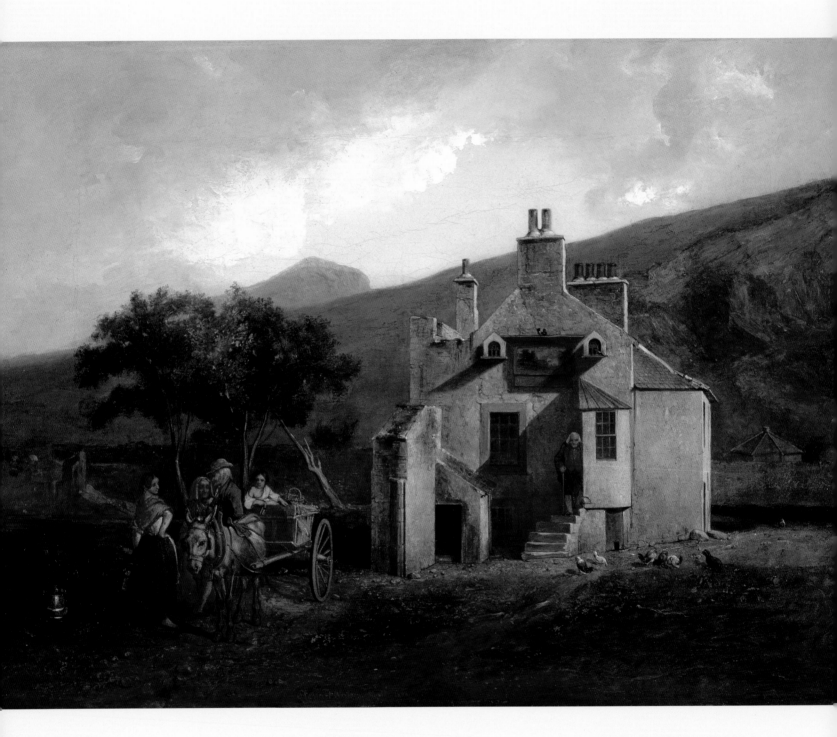

Oil on canvas, 40.6 × 55.9cm

Purchased from unknown source, 1903

Holyrood Dairy, Edinburgh, c.1840

WILLIAM STEWART WATSON (1800–1870)

A FORGOTTEN SCENE: within the shadow of Arthur's Seat, the old dairy of Holyrood Park once stood to the south of the palace. Enclosed within the gardens, it was the prominent landmark of an old village known as St Anne's Yards. The village was the property of the Dukes of Hamilton, the Hereditary Keepers of Holyroodhouse, and from the sixteenth century onwards it was the city's Sanctuary for Debt. A place of protection from creditors, it provided haven for those crippled by financial ruin. The inhabitants of the sanctuary were known as the 'Abbey Lairds' and this dairy was one of a number of buildings serving the village, along with a brewery and stables. The unsightly village of St Anne's Yards was cleared away with the extension of the royal gardens in the nineteenth century. Held by the Corporation of Perth for charitable purposes, Holyrood Dairy was demolished in 1858.

Under the painted sign of two horses fleeing across a glen, the old dairy master waits in the shadows as a maid fills up a cart. In the background can be seen temporary government buildings and the decrepit ruins of St Anne's Yards. This is a rare work by a painter of historical and genre scenes, William Stewart Watson. Originally from Jedburgh, Roxburghshire, Watson was related to the famed portrait painter and President of the Royal Scottish Academy, Sir John Watson Gordon. Struggling to pay bills, Stewart Watson also worked as an insurance broker; with cruel irony, he was seized by debt in later life and, with the Abbey sanctuary long gone, was declared bankrupt before his death in 1870.

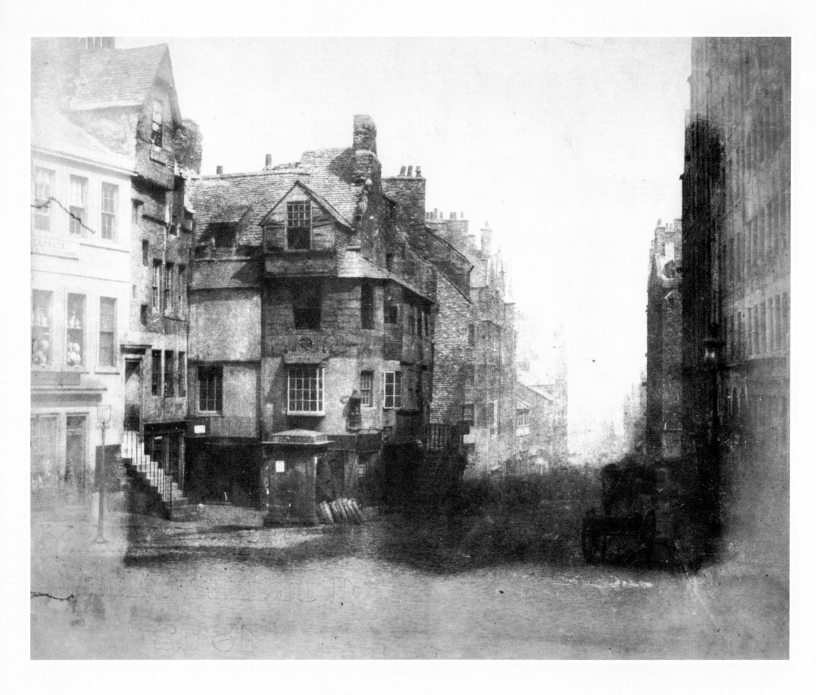

Calotype, 30.5 × 38.5cm
Purchased (Jean F. Watson Bequest Fund and government grant-in-aid), 1977

The High Street, Edinburgh, Looking East

DAVID OCTAVIUS HILL (1802–1870)
AND ROBERT ADAMSON (1821–1848)

ONE OF EDINBURGH'S MOST FAMOUS VIEWS, John Knox's House has stood at the Netherbow since the fifteenth century. The survivor of city improvements and fire, it is one of the oldest mansions of the Royal Mile. John Knox stayed in the house for a couple of months before his death in 1572, but carved above its entrance are the coat of arms and initials of the original owner, John Mossman. Royal jeweller and goldsmith, Mossman lost his house and life for his loyal support of Mary, Queen of Scots. Supplying coinage during Mary's exile, Mossman was charged with counterfeiting and was hung, drawn and quartered down the road at the Old Mercat Cross.

Caught in the haze of the moment during the 1840s, this is a prized calotype by Hill and Adamson, Edinburgh's photographic pioneers. It was the creation of a painting that led to one of the most important collaborations in the history of photography. Landscapist David Octavius Hill joined forces with pioneering photographer Robert Adamson to capture hundreds of portraits for a painting commemorating the establishment of the Free Church of Scotland during the momentous Disruption of 1843. They successfully used the new invention of photography as an aid for Hill's painting *The Signing of the Deed of Demission.* Tired of staring at austere portraits of ministers, Hill and Adamson began experimenting with the new medium with astounding results.

On the Calton Hill, from their studio at Rock House, Hill and Adamson watched a series of innovative portraits emerge from the salt prints of their darkroom. Using the calotype process, invented by William Henry Fox Talbot, Hill and Adamson's studies of Edinburgh people and architecture were praised for their artistic sophistication. From studies of the Newhaven fishwives to the soldiers of Edinburgh Castle, they created some of the most powerful portraits in Scottish art, characterised by their sense of drama and delicate play of shadow and light. It was Hill and Adamson who captured fellow artists Sir John Steell, George Meikle Kemp, James Drummond, David Roberts and Sir William Allan. Between 1843 and 1847, Hill and Adamson created over 3,000 calotypes, but the creative partnership was cut short by Adamson's early death in 1848.

Captured as they hauled their bulky camera around the city, this is one of a number of topographical views of Edinburgh intended for their publication, *The Architecture of Edinburgh and Glasgow.* They also recorded the building of the Scott Monument from the roof of the Royal Institution, and took the first photographic panorama of the city from the ramparts of Edinburgh Castle. This view of John Knox's House is a reminder that the invention of artistic photography developed in the streets of Edinburgh.

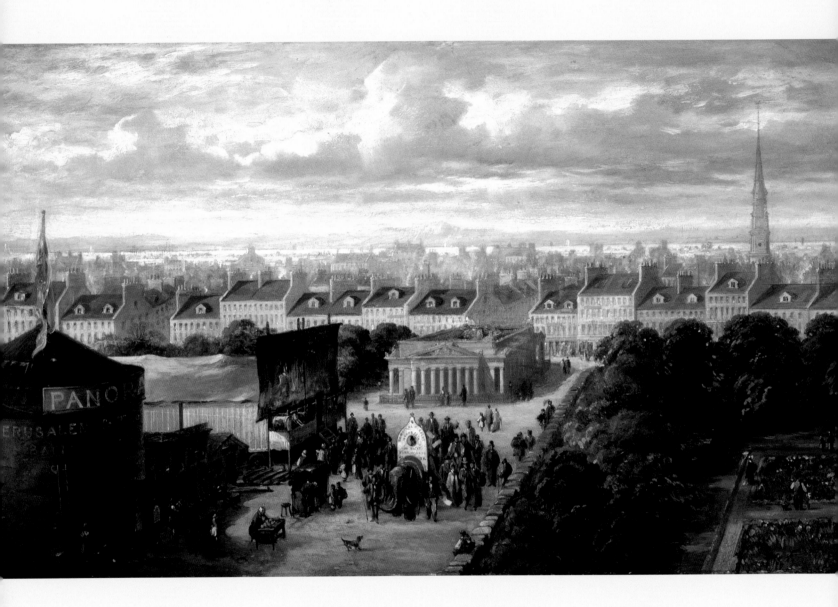

Oil on panel, 28.0 × 47.3cm
Purchased from the Scottish Gallery, Edinburgh
(with government grant-in-aid), 1982

View of Princes Street from the Mound, Edinburgh, 1843

CHARLES HALKERSTON (C.1829–1899)

COMMANDING A VIEW TO THE FORTH across the rooftops of Princes Street, this forgotten view reveals that long ago the Mound was the site of the city funfair, bustling with colourful tents, stalls and show folk. Crowds wander past the wooden buildings of the peep shows, fortune tellers and travelling menagerie. Next to the pleasure gardens, an elephant advertises a fireworks display: 'A grand fête tonight fireworks'. Of all the attractions, the most exciting was the latest showing of Mr Marshall's Moving Panorama.

The principal proprietors of moving panoramas in Britain were Messrs William and Peter Marshall of Edinburgh. In 1809, Peter Marshall, artist and owner of the panorama on York Place, exhibited a moving panorama of the Clyde on Princes Street. With permission from the Council, the great showman built a new panoramic building on the Mound in 1818, the Rotunda. Through its velvet doors, crowds rushed to embark on exotic journeys and historical processions by watching a moving canvas spooled horizontally across a screen. To augment the stationary panorama, the experience was heightened with a lecturer and live music. Messrs Marshall's Peristrephic Panoramas exhibited a host of exciting shows, including *The Shipwreck of Medusa, The Polar Regions, The Battle of Bannockburn* and the most famous, *The Grand Peristrephic Panorama of the Coronation of His Majesty George IV* in 1823. For the fifth anniversary of the Battle of Waterloo in 1820, the animal painter James Howe lost out to Henry Barker's *Historical Peristrephic Panorama of the Three Battles, Ligny, Quatre Bras and Waterloo.* A sell-out event, the show consisted of ten episodes accompanied with music, lighting and a full military band.

In this view of 1843, tickets have sold out for a show of *Jerusalem & Thebes*. The owner of this successful and highly lucrative venture, William Marshall enjoyed the view from his splendid townhouse at 100 Princes Street. As the moving canvas was replaced by spools of film, he watched the advent of cinema on the Earthen Mound.

With its many colours and characters, the funfair was a favourite haunt of the city's artists. There were also exhibitions in the newly built Royal Institution. William Henry Playfair's Doric temple dedicated to the arts was opened in 1828 for the Royal Institution of the Fine Arts in Scotland, founded in 1819. Here were held the classes of the Trustees' Academy of Art and the annual exhibitions of the Scottish Academy.

Painter and picture restorer Charles Halkerston often headed down to the Mound from his home in Newington. This intriguing view is a reminder that the people of Edinburgh had been staring at paintings long before the completion of the National Gallery of Scotland, built on the original site of the Moving Panorama.

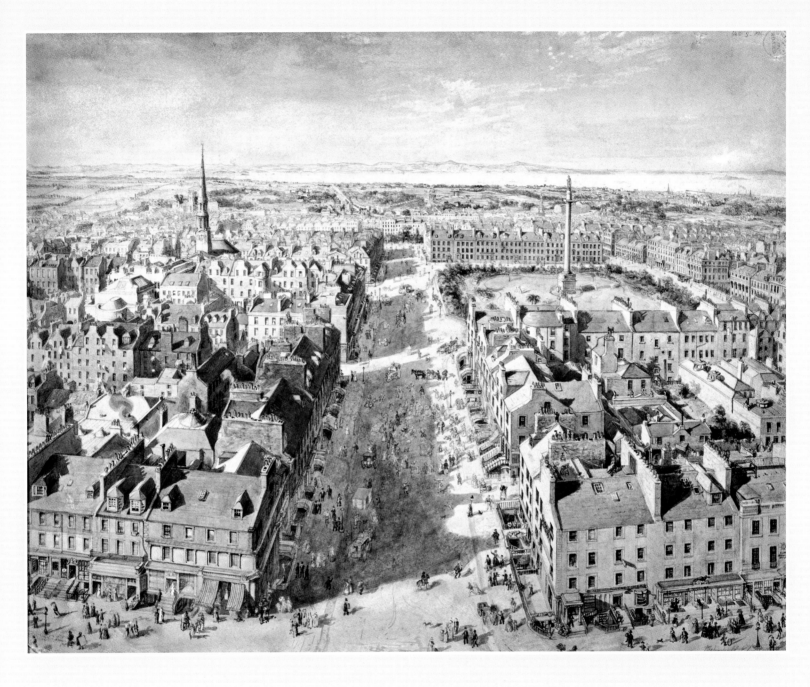

Ink and watercolour on paper, 34.0 × 44.4cm
1845
Presented by .J. Collins Francis, 1910

North View from Scott Monument, 2.45pm, 15 September, 1845

JOSEPH WOODFALL EBSWORTH (1824–1908)

FROM THE HEIGHTS OF THE SCOTT MONUMENT, this stunning view stretches across the blue rooftops of the New Town over the Forth to Fife. As shoppers peruse the elegant shops of Princes Street, carriages wander up South St David Street towards the Melville Monument on St Andrew Square. Here a group of street performers attract a crowd. Meanwhile, a couple pose for their portrait on the rooftop studio of 'Howie' the photographer. Preserved in time, this is one of four detailed views painted on the spot on 15 September 1845 by Joseph Woodfall Ebsworth.

Ebsworth grew up in his father's bookshop on Leith Walk, the 'English and Foreign Dramatic Library and Caricature Repository', a world of music and literature. Dramatist and composer Joseph Ebsworth senior was librarian of the Edinburgh Harmonists' Society, and for over thirty years he organised the annual concerts at the Hopetoun Rooms on Queen Street. He sent his fourteen-year-old son to the 'Ornamental and Architectural Department' at the Trustees' Academy, where Ebsworth excelled as a lithographer of topographical works. European travels followed teaching posts at the Institute of Lithography in Manchester and the Glasgow Government School of Design.

Exhibited at the Royal Scottish Academy in 1849, Ebsworth's four views were painted as a tribute to his father and that 'great old man' he often met in his father's shop, Sir Walter Scott. In 1842, Ebsworth illustrated the Abbotsford edition of the Waverley Novels; these eventually took pride of place in the great library in the vicarage of Molash, Ashford, Kent, where he lived. In 1871, Ebsworth left the life of an artist for the Church. After graduating from Cambridge University, he spent the rest of his days as an acclaimed literary critic, dedicating his time to the study of English ballad history. He is buried under yew trees at Ashford Cemetery, although it was his wish to be interred with his father at Edinburgh's Dean Cemetery near his beloved teacher, David Scott, from the Trustees' Academy.

This view hung in the office of Ebsworth's friend John Collins Francis of the *Athenaeum Magazine*, who in 1910 presented the watercolours to Edinburgh City Council.

In Ebsworth's own words:

> They were executed wholly from the one uppermost gallery of stone, topmost of four, day by day 200 feet above the level of Princes Street. In that narrow and windy nook, whatever weather prevailed, unflinchingly against cold, but sometimes baffled by rain, these were wrought out in 1845, totally unaided by spyglass or photograph. In fact, the public photographing of portraits at that very epoch, in a singularly primitive manner, is shown at Hourie's [Howie's] studio on the housetop without any shelter or glasshouse, in the north view. Nobody ever helped me with them; they were drawn to give pleasure to my dear father. I never touched them apart from the gallery of the Scott Monument.

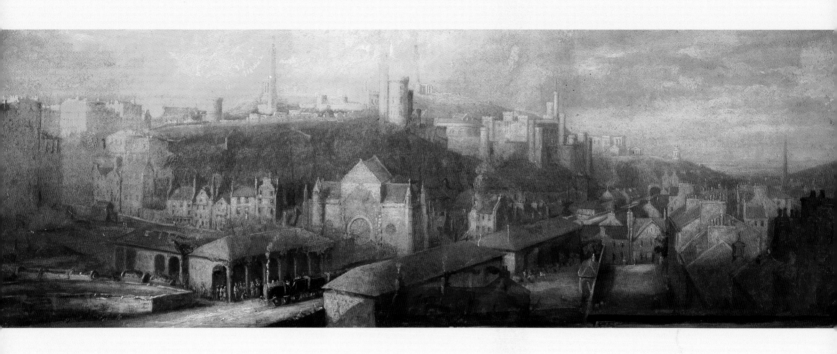

Oil on board, 17.0 × 49.5cm
1848
Purchased (with the assistance of the Jean F. Watson Bequest Fund
and the National Fund for Acquisitions), 2007

Waverley Station, Edinburgh

JOHN H. ROSS

OVERLOOKED BY THE MONUMENTS OF THE CALTON HILL, the age of steam has arrived in this lovely painting of Waverley Station. The hazy view reveals that Waverley, still under construction, originally consisted of three separate stations. Passengers wait at the platforms of North British Railway's North Bridge, Edinburgh and Glasgow Railway's General Station, and Leith and Newhaven Railway's Canal Street Station. Resisting the changing scene, the Trinity College Church still stands, along with the old printing works of James Ballantyne, where in 1814 Sir Walter Scott's novel *Waverley* was first printed for publishers Archibald Constable. The strange scene met on stepping into the station was described by a contemporary passenger: 'That the traveller, just as he emerges from the temporary looking sheds and fresh timber and plaster-work of the railway offices, finds himself hurried along a dusky and mouldering collection of buttresses, pinnacles, niches, and Gothic windows, as striking a contrast to the scene of fresh bustle and new life.'

For the advance of the rails, the historic buildings that once nestled below the bridge were razed to the ground. The Orphanage Hospital, Glenorchy's Church and Trinity Church all disappeared, along with the grounds of the Old Physic Garden, the city's original botanic garden, founded in 1676 by Sir Andrew Balfour and Sir Robert Sibbald for the supply of medical herbs.

The new Orphan Hospital was built at the Dean, where the clock of the Netherbow Port still ticks away on the Scottish National Gallery of Modern Art. The transept of the Trinity College Kirk was rebuilt in Chalmers Close off the Royal Mile and served for many years as the Brass Rubbing Centre. The recovered bones of Mary of Gueldres were reputedly taken to the Royal Stuart tomb at Holyrood Abbey.

In 1868, North British Railway rebuilt the Victorian station with its grand addition, the North British Hotel. The legacy of Sibbald and Balfour continues at the Royal Botanical Gardens today; only a plaque at Platform 11 recalls the original site of the Old Physic Garden, where Lord Henry Cockburn once recalled:

> There is a garden about one hundred feet square; but it is only turf surrounded by a gravel walk. An old thorn, and an old elm, destined never to be in leaf again, tell of old springs and old care.
> LORD HENRY COCKBURN, *Memorials of his Time*, 1821–1830, pub. 1856

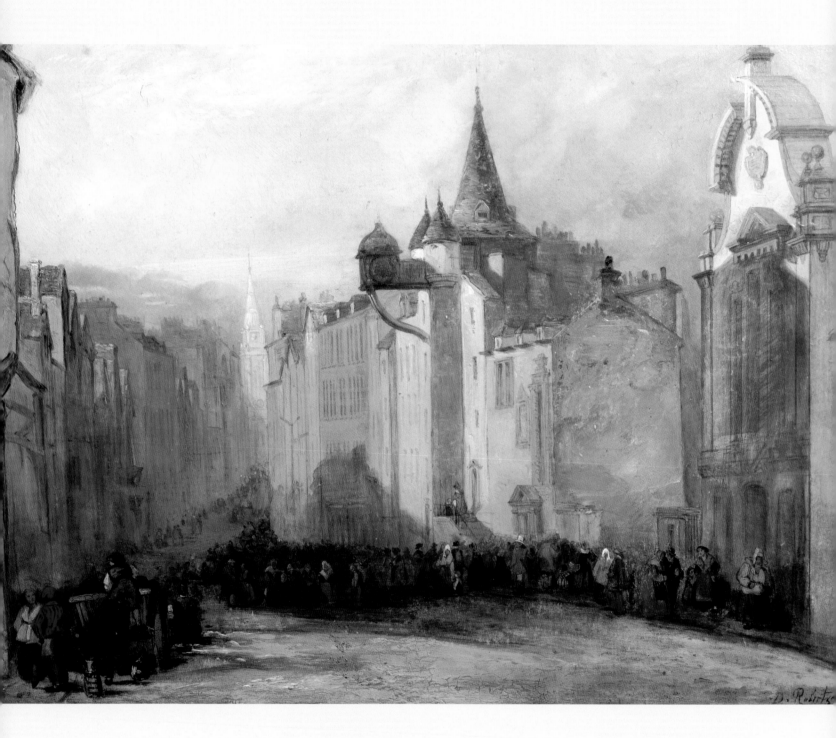

Oil on panel, 25.5 × 35.5 cm
Purchased at auction (Jean F. Watson Bequest Fund
and government grant-in-aid), 1987

The Toll House

DAVID ROBERTS (1796–1864)

WANDER DOWN THE ROYAL MILE TOWARDS HOLYROOD and you will find the Canongate Tolbooth. This historic landmark once served as a council house, courtroom, prison and toll house for the independent Canongate burgh. This delicate painting is by the celebrated Victorian landscapist David Roberts, famed for his romantic visions of exotic and foreign lands.

Inspired by Arnot's *History of Edinburgh* and trips to Rosslyn Chapel, Roberts, the son of a shoemaker from Stockbridge, dreamed of adventure, antiquity and distant lands as a child. Too poor to train at the Trustees' Academy, he served an apprenticeship with house painter Gavin Beugo. Determined to be an artist, Roberts set up his own life academy in Mary King's Close with fellow apprentices William Kidd and William Mitchell. It was a gruesome gallery for their exhibitions, as Roberts recalled: 'It was generally believed that any one daring enough to peep through some of the keyholes might have seen numberless uncoffined and unburied skeletons.' Picking up his brush for Mr Bannister's Circus in North College Street, Roberts began his successful career as a scene painter for the theatre.

Moving to London in 1822, Roberts became the leading painter for stage and panoramas; his monumental scenes of epic history filled the seats of Covent Garden and the British Diorama. The success of paintings such as *The Israelites Leaving Egypt,* exhibited at the Royal Scottish Academy in 1830, encouraged him to give up stage design to pursue his career as a painter. His subsequent travels across France and Spain were preserved in his sweeping views of ruins, temples and cathedrals. In 1838, Roberts, by then the President of the Society of British Artists, fulfilled his ambition to reach the Holy Lands and published an ambitious series of lithographs, *Views of the Holy Land, Syria, Idumea, Arabia, Egypt and Nubia* between 1842 and 1849.

In celebration of his artistic achievement, on return from his travels in 1842, Edinburgh hosted a Dinner of Honour. To Lord Cockburn's toast, Roberts replied: 'Yet, with all our admiration of what we behold in other countries, we naturally look back to the land of our birth – we think of its barren hills and sequestered glens hallowed by the tender recollections of childhood. The songs and melodies of our native land cheer us in foreign climes and distant countries.' Visiting annually from London, Roberts continued to be inspired by Edinburgh's history and architecture; he campaigned to save many historic buildings, including John Knox's House. In recognition of his success and promotion of his hometown, Roberts was granted the Freedom of the City in 1858.

Always the antiquarian, Roberts would be pleased that the Canongate Tolbooth now houses the People's Story Museum and that his birthplace, Duncan's Land, still stands in Stockbridge.

Ink and watercolour on paper, 23.2 × 17.5cm
Purchased (with government grant-in-aid), 1977

The Winning Shot – Duddingston Loch
CHARLES ALTAMONT DOYLE (1832–1893)

HAVING LAID DOWN THE FIRST RULES OF CURLING IN 1804, the lords and lawyers of the Duddingston Curling Club take to the ice. In the background, the Edinburgh Skating Club compete for the prized 'Duddingston Medal'. Spontaneous and full of humour, this lively watercolour of a Victorian curling match on Duddingston Loch was painted by the most curious of Edinburgh artists, Charles Altamont Doyle.

The son of the famed political cartoonist John Doyle, Charles was sent from London to Edinburgh at the age of seventeen to shine as an independent artist. His skills as a draughtsman secured him his first job as an assistant clerk in the Scottish Office of Works at Holyrood Palace. The young artist soon married the daughter of his landlady, fellow Irish Catholic Mary Foley, with whom he had seven children.

Struggling to provide for his large family and with artistic dreams fading, Doyle succumbed to the demon drink. After his move from 11 Picardy Place to 3 Sciennes Hill Place, Doyle lost his job and, in exchange for alcohol, he gave up a hoard of his precious watercolours. Consumed by alcoholism and depression, in 1881 Doyle left his family to recover at a Home for Gentlemen in Kincardineshire. Suffering from memory loss, hallucinations and epilepsy, he spent the rest of his days institutionalised in Scotland. He died in the Crichton Royal Institution in Dumfries in 1893, where his private care was paid for by his estranged eldest son. Doyle's artistic talents almost fell into obscurity until the discovery of the Doyle Diary in 1977. Surfacing at a house sale in the New Forest, this treasure trove of imagination and artistic delights was discovered to be Doyle's sketchbook from his incarceration at Montrose Royal Lunatic Asylum in 1889. Combining morbid visions of guardian angels and architectural memories of Edinburgh, the diary revealed Doyle to be an artist of great originality, an accomplished draughtsman and one of Scotland's great fantasy painters.

The only exhibition of Doyle's work was proudly organised by his son, Arthur Conan Doyle, in London in 1924. Arthur Conan Doyle left the medical profession to become an author, and found inspiration in his father's visionary watercolours for his novels. In 1888, Charles contributed a number of drawings for his son's first detective novel, *A Study in Scarlett,* including a portrait of himself as Sherlock Holmes.

His brush was concerned not only with fairies and delicate themes of the kind, but with wild and fearsome subjects, so that his work had a very peculiar style of its own, mitigated by great natural humour.
SIR ARTHUR CONAN DOYLE

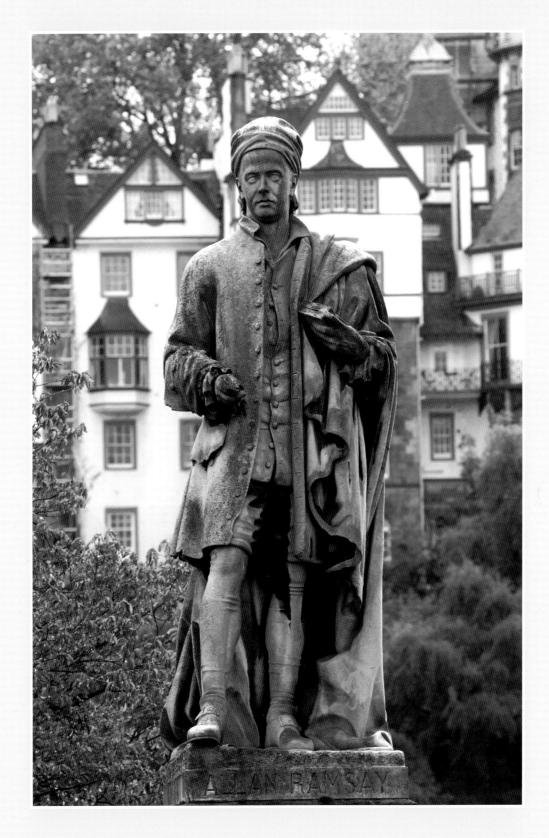

Carrara marble, 325 cm high
1865

Allan Ramsay

SIR JOHN STEELL (1804–1891)

THIS STATUE OF THE POET ALLAN RAMSAY stands below Ramsay Garden, his house on Castle Hill. A leading cultural figure of the eighteenth century, Ramsay was one of the brightest sparks of the Scottish Enlightenment.

The son of Robert Ramsay of Edinburgh, Factor for the gold and lead mines of the Hopes of Hopetoun in Lanarkshire, Allan Ramsay was born at Crawford in the Leadhills in 1686. A gifted writer, Ramsay left a wig-making business to open a bookshop on the Royal Mile. Here he began writing the poems that would seal his reputation as one of the most famous Scots poets. The original owner of Creech's bookshop in the Luckenbooths, here Ramsay sold copies of his *Collection of Poems* (1722), a collection of early Scots poetry derived from the Bannatyne Manuscript entitled *The Ever Green* (1724) and his acclaimed pastoral, *The Gentle Shepherd* (1725). Ramsay also established Britain's first circulating library, founded a new theatre in Carrubbers Close and supported the establishment in 1729 of Scotland's first art academy, St Luke's. Ramsay's eldest son became one of its finest students, and the academy provided an intellectual haven for him to flourish. With an unrivalled knowledge of arts and literature, Allan Ramsay (junior) was destined to be great. Inheriting his father's love for words, Allan Ramsay was not only a famous portraitist, but also an accomplished writer on the arts, classical scholar and political essayist. In 1734, father and son designed a magnificent villa on Castle Hill known as the 'Gus Pye'. Dedicated to the Sister Arts of Painting and Poetry, this landmark of the city was home to Scotland's leading poet and painter.

A descendant of Allan Ramsay, Lord Murray, commissioned this statue from Sculptor for Scotland Sir John Steell in 1865. Carved in Carrara marble, the Scots makar, presented in contemporary dress, was unveiled to assembled crowds in Princes Street. The leading sculptor of his generation, Sir John Steell created many of the city's finest neo-classical sculptures. His commission for *Alexander Taming Bucephalus* outside the City Chambers was followed by *Queen Victoria* on the roof of the Royal Scottish Academy, the *Duke of Wellington* outside Register House and *Sir Walter Scott* resting in the Scott Monument. Establishing the Grove Foundry on Grove Street, Steell was the first sculptor to introduce fine art bronze casting to Scotland and, from his international studio, Steell sent works of art as far as India and New Zealand. His statues of Sir Walter Scott and Robert Burns still stand in Central Park in New York. Following the inauguration of Steell's Prince Albert Memorial in Charlotte Square Gardens, he was knighted by Queen Victoria in 1876.

The works of Steell and Ramsay, both champions of the arts in Edinburgh, influenced generations of Scottish artists. Always proud of the city's artistic talents, looking out from the windows of his house, Ramsay hoped Edinburgh would preserve its fame as a city of art *and* literature.

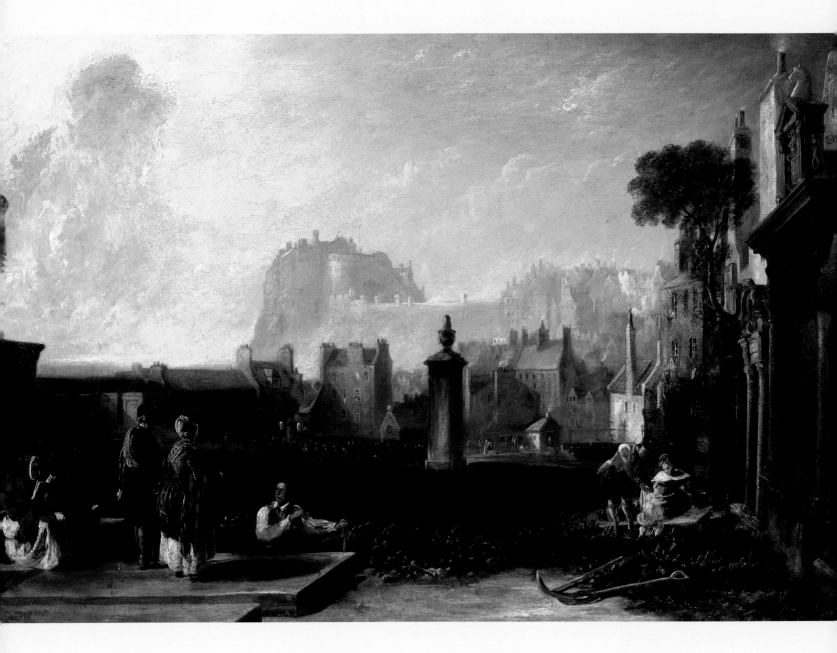

Oil on canvas, 86.4 × 119.3cm
Presented by Sir Edward Moss of Middleton, 1909

Old Edinburgh, Showing the Castle from Greyfriars Churchyard

DAVID OCTAVIUS HILL (1802–1870)

IN VICTORIAN EDINBURGH, no tour of the city was complete without visiting Greyfriars Churchyard. A burial ground since 1562, the oldest of the city's cemeteries lies upon the ancient lands of Greyfriars monastery, which once stood in the Grassmarket. Historic Greyfriars was the final resting place of the city's great and good, from provosts, professors and lord presidents, to the artists John Kay, Walter Geikie, George Jamesone, the architect James Craig and the poet Allan Ramsay.

In this painting, in the shadow of the Castle, a funeral takes place in the background as a couple listen intently to the dark tales of the gravedigger. The graveyard guide, he recounts the history hidden deep within the morbid setting and deciphers the ancient carvings on the centuries-old tombs, encrusted with *memento mori* and a host of forgotten heraldry. His tour includes the Martyr's Monument, the Nasmyth Tomb and the mausoleum of architect William Adam.

After Robert Adamson's death brought an end to their pioneering photographic partnership, David Octavius Hill returned to painting, reviving his talents as one of Scotland's great landscapists. Originally from Perth, the eighth child of Thomas Hill the bookseller, Hill studied at the Trustees' Academy under landscapist Andrew Wilson. It was the engravings for his illustrations to the popular *The Land of Burns* (1840) that quickly established Hill's reputation. A founding member of the Society of Artists, Secretary to the Royal Scottish Academy and founder of the Art Union of Edinburgh, Hill was an influential figure in the development of the arts in Edinburgh.

Hill's collection of calotypes shows that his photography influenced his later work. Hill and Adamson often ventured into Greyfriars Kirk, intrigued by its associations. Some of their finest portraits were taken of friends posing against the monuments, including the geologist Hugh Miller and the artist David Roberts. The ruins of Greyfriars Kirk, the first church to be built after the Reformation in 1620, were also captured by Hill and Adamson's lens after the church was destroyed by fire in 1845.

In memory of his dear friend and partner, Hill painted this at Rock House on the Calton Hill, where he remained after the death of Adamson. In 1862, he married the sculptor Amelia Robertson Paton, who encouraged him to finish the monumental painting that had originally inspired their calotypes. Completed after twenty-three years, the first painting to use photography as an aid in portraiture, *The Signing of the Deed of Demission* still hangs in the Free College offices overlooking the Mound.

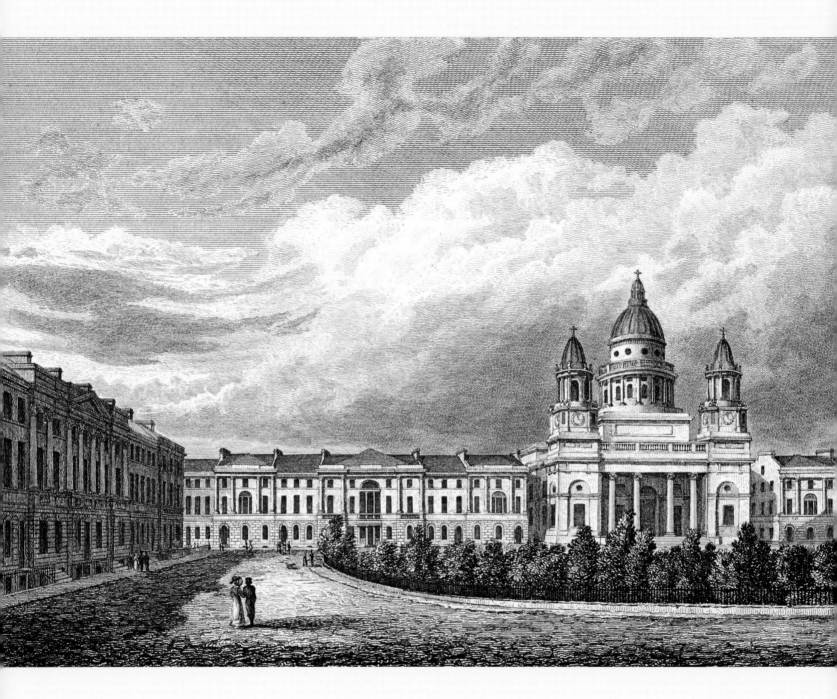

Engraving on paper, 19.7 × 23.2cm

View of the Mound, Edinburgh
WILLIAM GAWIN HERDMAN (1805–1882)

I have not yet seen my friend Playfair's College, but it must be
more important than I can imagine, if it can keep its ground beside
the gigantic piles by which it is overtopped and surrounded.
DAVID ROBERTS, 1849

THE SPARKLING NEW FREE CHURCH COLLEGE dominates the Earthen Mound. William Playfair's
Gothic spectacular was built as the Theological College for the Free Church of Scotland following the
Disruption of 1843. The latest addition to the skyline of the Old Town, this imposing city landmark was
built upon the demolished ruins of the sixteenth-century palace of Mary of Guise on Castle Hill. Respon-
sible for many of its neo-classical landmarks, Edinburgh's esteemed architect William Henry Playfair
continued the city's reputation for architectural splendour. His designs can be seen at the Old College
of the University of Edinburgh, the City Observatory, the Advocates Library, Surgeons' Hall and
Donaldson's College. He created many splendid views, but it was Playfair's transformation of the Mound
that would significantly impact the development of the arts in Edinburgh.

With the completion of the college, the unsightly buildings of the funfair and the old panorama
were cleared from the Mound. This painting shows the ground being prepared for the foundations of
Playfair's third building on the Mound, the National Gallery of Scotland. Returning to his neo-classical
design, the Gallery opened its doors in 1859, two years after the architect's death. This transitional view
of the Mound was painted by a tourist from Liverpool, William Herdman. He was best known for
hundreds of watercolours documenting change in his hometown, published in the *Pictorial Relics of
Ancient Liverpool* in 1843. In the shadow of the College, beside temporary wooden buildings, the street
sellers and fishwives still hold their daily market. Herdman was intrigued by this fascinating view, with
the Castle and Ramsay Lodge in the background and the Mound revealed as a heap of stone and rubble.
Created from the excavations of the foundations of the New Town and rubbish from the Old, reaching
towering heights, the Mound was a hazardous bridge from the old to new. It was eventually levelled with
a roadway, and the extracted earth used for the landscaping of Princes Street Gardens.

For many years the Mound was an architectural headache for the City Council, but Playfair's stamp
transformed it into one of the most striking features in the city.

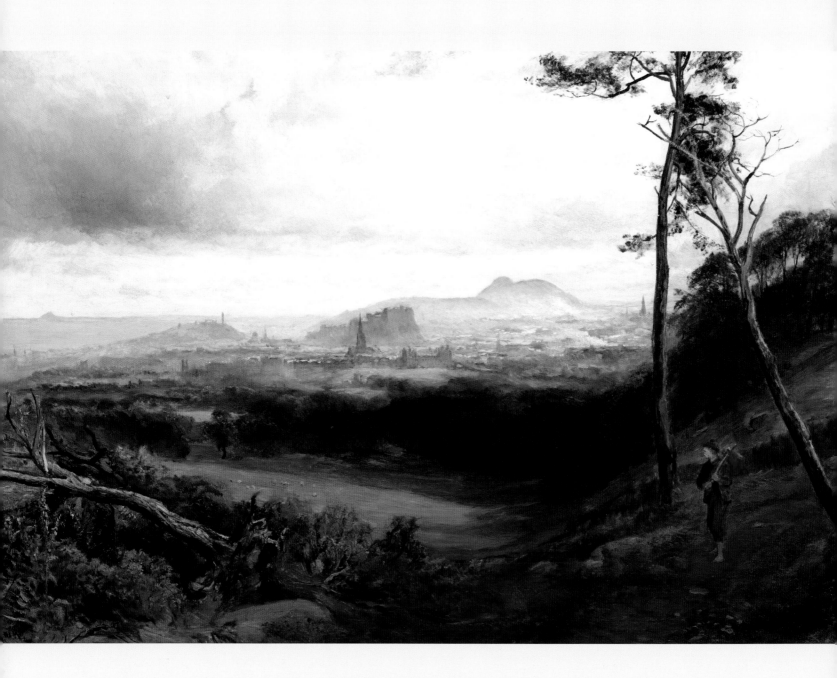

Oil on canvas, 50.2 × 74.9cm
Presented by the Scottish Modern Arts Association, 1964

Edinburgh from Corstorphine

JOHN MacWHIRTER (1839–1911)

OF ALL THE VIEWS IN THE CITY, the *Rest and be Thankful* on Corstorphine Hill is undoubtedly one of the finest. Below the rocky outcrop, the city sits enveloped in haar in this beautiful painting by the celebrated Victorian landscapist John MacWhirter.

Often walking the hill, MacWhirter painted this while he was living in Corstorphine during the 1860s. The artist shared a passion for sketching with his father, George MacWhirter, an amateur geologist, botanist and paper mill owner in Colinton. After his father's early death, MacWhirter was apprenticed to the booksellers Oliver & Boyd. After a short stint working in the Canongate, he soon found himself on the Mound studying at the Trustees' Academy. Along with William McTaggart, William Quiller Orchardson and John Pettie, he was one of the talented students taught by Robert Scott Lauder.

The nephew of African explorer Major Alexander Gordon, MacWhirter was inspired by his uncle's expeditions and, with sketchbook in hand, he set off for many years travelling across Europe, to Italy, Switzerland, Germany and Norway. After exhibiting *Old Edinburgh: Night* at the Royal Academy in 1868, MacWhirter finally settled in London as a successful and prolific landscapist. Indebted to the paintings of Millais and Turner, MacWhirter's detailed Pre-Raphaelite vision always influenced his romantic Scottish views. With an eye for detail and a commitment to sketching out of doors, he specialised in wild mountain and forest scenes. In 1887, he held an exhibition, *The Land of Burns and Scott*, at the Fine Art Society in London. Popularising the Victorian enthusiasm for Highland scenes, MacWhirter travelled widely sketching lochs, glens and mountains, and his autumn months were always spent in Scotland. His last visit was to the Kyle of Lochalsh, where his wife Katherine remembered, 'It was there, near the rugged mountains which had drawn him to their misty grandeur as a boy, that he might be found every evening on the pier, notebook in hand, waiting for the sunset.'

The lands of the *Crostorfyn*, a village to the west of the city, were long associated with the Forrester family. Sir Adam Forrester, wealthy burgess and Lord Provost, acquired the site in 1376. All that remains of his castle is the sixteenth-century Doocot. Dating to 1440, the effigy tomb of his son, Sir John Forrester, lies intact in the Old Parish Church of Corstorphine. In 1713, the estate was transferred to another Lord Provost, Sir James Dick of Prestonfield.

MacWhirter knew this picturesque spot was associated with Sir Walter Scott; Corstorphine Hill was one of Scott's favourite haunts. His father owned the nearby lands of Clermiston, and as a boy Scott often sat daydreaming by the Bannatyne Fountain at Ravelston House, the property of his cousins. Overlooking the hill, Corstorphine Hill Tower was built in Scott's honour in 1871 by William Macfie of Clermiston to commemorate the centenary of his birth. In 1932, on the centenary of his death, the tower was presented to the people of Edinburgh.

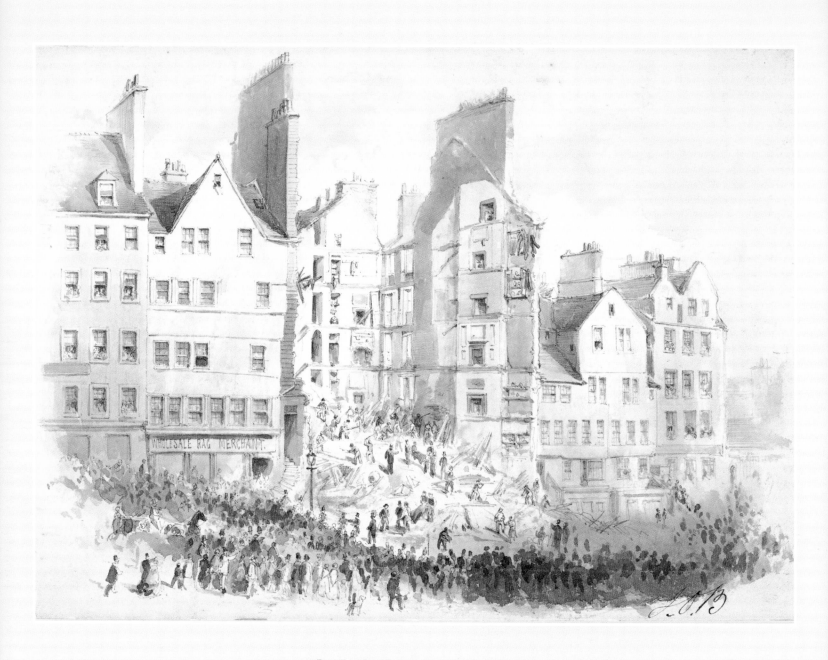

Pencil and wash on paper, 18.5 × 25.5 cm

Collapse of a Tenement, High Street, 24th November 1861

J.O. BROWN

*Sketch of the House that fell in the High Street of Edin on Sunday
Last 24th Nov 1861, J. O. Brown, 18 St James' Square, Edinburgh*

ON THE MORNING OF 24 NOVEMBER 1861, a five-storey tenement in Bailie Fyfe's Close collapsed in the High Street, killing thirty-five people. This remarkable pencil study details the extent of destruction. As crowds gather outside the 'Wholesale Rag Merchant', faces peer from the surviving tenements as workers desperately try to clear rubble and recover victims. Preserved on paper, this tragic scene would prove the spur to change and improve the living conditions of the Edinburgh people.

With an explosion in industrialisation and a working-class population, by the nineteenth century the living conditions of the Old Town had become intolerable. Plagued by cholera, deprivation and disease, the overcrowded tenements proved a dangerous place to live. It was this disaster in 1861 that prompted the Council to take decisive measures and appoint Police Surgeon Henry Duncan Littlejohn as the first Medical Officer for Health. One of the city's great medical figures, he significantly alleviated the conditions for Edinburgh's working class by improving sanitation and battling disease. He was instrumental in passing the General Vaccination Act for Scotland in 1863 and supported the Edinburgh City Improvement Act of 1867 to clear densely populated areas of the Old Town. Professor of Medical Jurisprudence at Edinburgh University and Chief Medical Advisor to the courts, Littlejohn's brilliant forensic deductions would prove inspirational for a certain young medical student, Arthur Conan Doyle.

As the debris was cleared from the Royal Mile, the cries of a young boy were faintly heard from within the collapsed building, 'Heave awa men, I'm no deid yet.' When a replacement building was erected on Paisley Close, a portrait of Joseph McIver, the boy who was pulled from the rubble, was sculpted above the entrance.

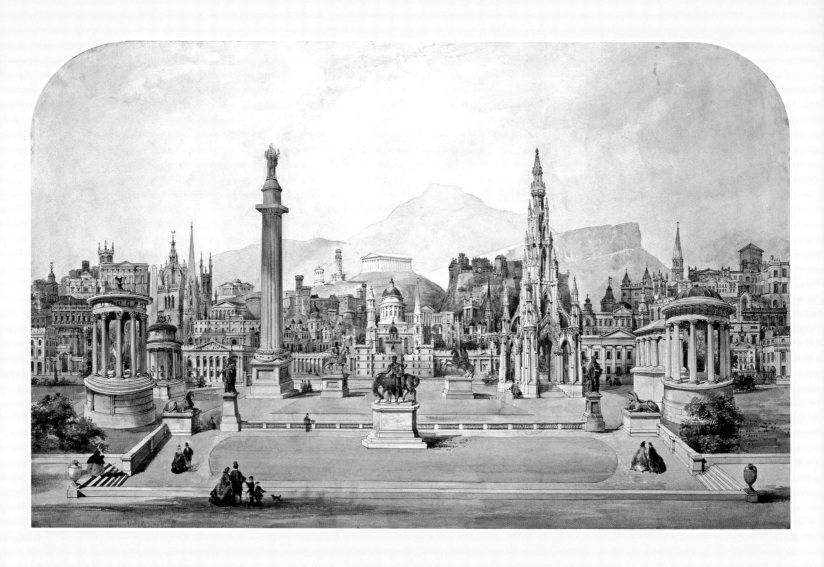

Ink and watercolour on paper, 61.2 × 101.6cm

c.1862

Presented by W.W. Peploe, 1920

Capriccio: The Monuments of Edinburgh, Circa 1862

DAVID RHIND (1808–1883)

THIS IMAGINARY VISION OF EDINBURGH's architectural splendour was created by leading Victorian architect David Rhind. Fusing the old and new, Edinburgh's finest monuments and landmarks are juxtaposed around a classical palazzo within a mass of spires, temples, columns and domes. The medieval and Gothic buildings are overwhelmed by the many neo-classical facades. In the centre the statue of John Hope is flanked by the monuments of Dugald Stewart, Robert Burns, St Bernard's Well and Playfair's monument to his uncle, John Playfair. The Melville and Scott Monuments tower above the statues of George IV, the Duke of Wellington and Charles II. Clinging to the past, the buildings of Holyrood, St Giles' Cathedral, Heriot's Hospital and the Castle merge with buildings of the New Town such as the Assembly Rooms, Dundas House and St George's Church. Hovering above the 'Athens of the North', the monuments of the Calton include the Nelson Monument, the City Observatory and a completed National Monument of Scotland. With the mighty stamp of Robert Adam and William Henry Playfair, in a contrast of styles, this is a view of Edinburgh's architectural history set in stone.

A master of the neo-classical revival, Edinburgh architect David Rhind designed many commercial buildings throughout Scotland. As architect to the Commercial Bank of Scotland, his elaborate palazzo style graced many of the branches throughout the country. Along with William Henry Playfair, Thomas Hamilton and William Burn, Rhind was a founding member of the Institute of Architects in Scotland in 1840. In 1855, he was the first architect to be elected President of the Scottish Society of Arts. A keen photographer of architecture, he was also a progressive member of the Photographic Society of Scotland.

Rhind's architectural tribute features his own designs. On the site of James Craig's Physicians' Hall on George Street he designed the Head Office for the Commercial Bank of Scotland in 1843, The Dome. Losing out to Augustus Pugin for the rebuilding of the Houses of Parliament, he reused his Jacobethan design for Daniel Stewart's Hospital in 1848. In 1860, he was appointed architect to the General Assembly of the Church of Scotland and extended the Assembly's meeting hall. In 1853, he was commissioned by Maria Short to reconstruct an old townhouse on Castle Hill for *Short's Observatory and Museum of Science and Art*. There, Maria Short installed her father's 'Great Telescope' from the Old Observatory on the Calton Hill to capture a panoramic view of the city. The Camera Obscura is still a popular tourist attraction today.

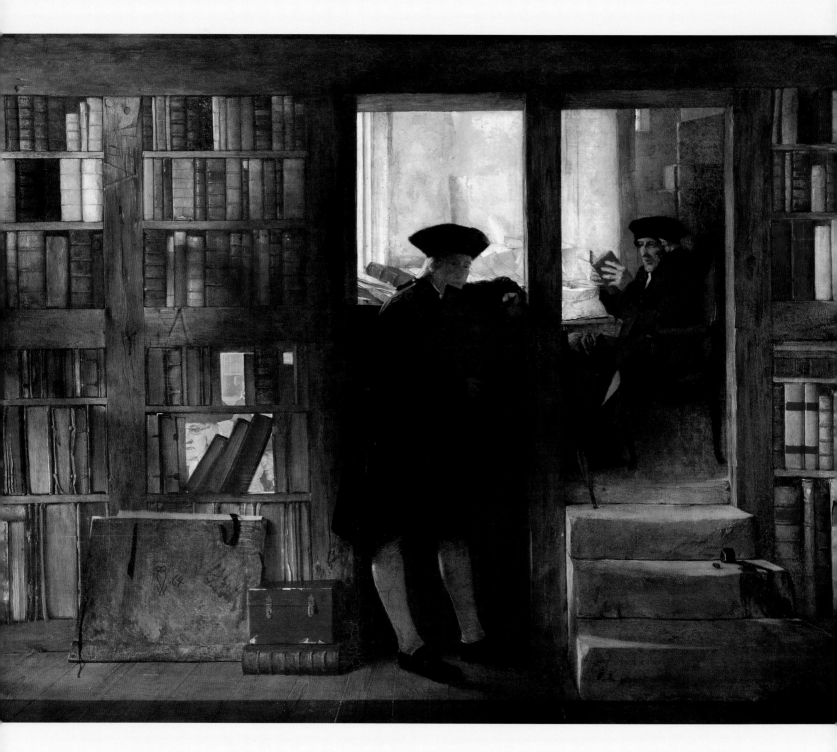

Oil on canvas, 66.3 × 86.7cm
1864
Purchased from James Thin Ltd, Edinburgh (Jean F. Watson Bequest Fund
and government grant-in-aid), 1982

The Bibliophilist's Haunt (Creech's Bookshop)

SIR WILLIAM FETTES DOUGLAS (1822–1891)

ENGROSSED IN ONE OF HIS PRECIOUS BOOKS, William Creech edits his latest work in his famous bookshop on the Royal Mile. Creech was Edinburgh's leading publisher, and here among the shelves sit many of the great literary works of the Enlightenment. A noted scholar, praised for his quick wit and brilliant conversation, Creech was also a shrewd and successful businessman. A founder of the Society of Antiquaries of Scotland and the Society of Booksellers of Edinburgh and Leith, he was one of Edinburgh's most influential figures. The bookshop was a magnet for the literary glitterati of the day, with professors and philosophers peering through the windows hoping to catch a glance of some famous author. A frequent visitor to the shop, Lord Cockburn remarked, 'The position of his shop in the very tideway of all our business made it the natural resort of lawyers, authors, and all sorts of literary idlers, who were always buzzing about the convenient hive. All who wished to see a poet or a stranger, or to hear the public news, the last joke by Erskine, or yesterday's occurrence in the Parliament House, or to get the publication of the day or newspapers all congregated there.'

The bookshop specialised in 'several branches of ancient and modern literature'; sifting through the shelves at one of Creech's many booksales, one would discover copies of Professor Dugald Stewart's *Outline of Moral Philosophy* (1793), Dr Gregory's *Philosophical and Literary Essays* (1792) or Hugo Arnot's *History of Edinburgh* (1788). In 1787, the crowds lined up to grab the bestseller, the Edinburgh edition of *Poems, Chiefly in the Scottish Dialect* by the young Ayrshire poet Robert Burns. It was this publication, with Alexander Nasmyth's famous portrait of the poet on the frontispiece, that propelled Burns to national stardom.

Inheriting his business from Lord Provost and Majesty's Printer for Scotland Alexander Kincaid, Creech also took a prominent role in civic affairs. Ever critical of Edinburgh's progress and politics, in 1781 he published an account of Edinburgh manners and customs in *Edinburgh Fugitive Pieces*. As City Councillor and juror in the courts, Creech's *Account of the Trial of William Brodie* hit the bookshelf a couple of days after his fellow councillor's execution. In the days when publishers ruled the city, Creech finally donned his Lord Provost robes in 1811.

On the floor of the bookshop lies one of Creech's folios stamped with the distinctive monogram of the great antiquarian painter Sir William Fettes Douglas. A nephew of Lord Provost Sir William Fettes, the artist left a career at the Commercial Bank to become a painter. Growing up in George Square, he taught himself to paint by imagining scenes from the past, often with an antiquarian nature. Painted after tours to France and Italy, his paintings are littered with his own collectables and antiques preserved in exquisite still lifes. This painting is an intriguing tribute from one antiquarian to another: in minute detail and vivid colour, William Fettes Douglas has captured Creech in all his glory.

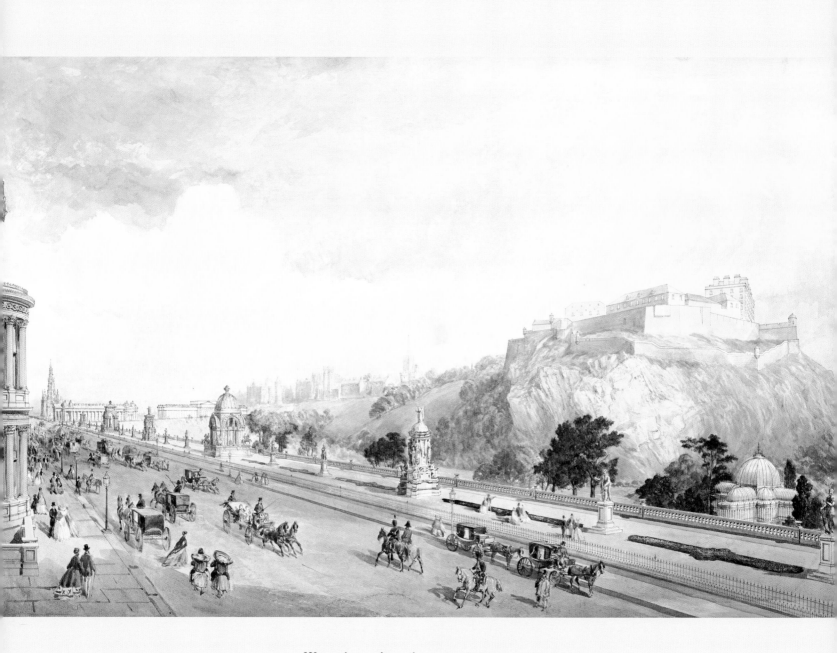

Watercolour and pencil on paper, 64.8 × 102.2cm

A Suggestion for the Improvement of Edinburgh: Winter Garden at West End of Princes Street Gardens, Edinburgh

JOHN DICK PEDDIE (1824–1891)

OVERLOOKED BY THE CASTLE, carriages stroll along the street in John Dick Peddie's imaginative proposal for winter gardens on Princes Street. In addition to glasshouses set within the gardens, Peddie has included a number of elaborate monuments along the famous and grand thoroughfare. As the Georgian townhouses gave way to department stores and decorated tearooms, Princes Street would reign as Edinburgh's finest street and premier shopping destination.

Peddie was one of the city's leading architects' and his artistic flair features in a number of proposals for the improvement of Edinburgh. He exhibited another version of this scheme at the Royal Scottish Academy in 1870, the same year he was made a Royal Academician and Treasurer. In 1866, he contributed designs for the North British Station and the Waverley Market competition. The grandson of Lord Provost Donald Smith, John Dick Peddie studied law at Edinburgh University before being articled to architect David Rhind. After setting up his own practice at 1 George Street, he worked on one of his early commissions designing the original Caledonian Station before venturing on an extensive continental tour, exploring Constantinople, Prague and Munich. As architect to the Royal Bank of Scotland, Peddie designed many of their Scottish branches. In 1857, he built the magnificent telling room of the Royal Bank of Scotland Headquarters on St Andrew Square.

Peddie later joined forces with Charles Hood Kinnear to create one of Scotland's most famous and highly successful architectural businesses, which they ran from their office at 4 South Charlotte Street. Along with overseeing the construction of Cockburn Street, Peddie & Kinnear designed many of the new facades of Princes Street. As well as inventing the first bellows camera, Kinnear founded the Photographic Society for Scotland with David MacGibbon, Sir David Brewster and David Bryce. With many business interests, Peddie also became an MP for Kilmarnock in 1880 and represented the Society for the Protection of Ancient Buildings. The firm became Peddie, Kinnear & Peddie when Peddie's son, John More Dick Peddie, joined the firm. Also a prominent architect, he would go on to design the Caledonian Hotel at Edinburgh's West End and Edinburgh College of Art.

For Mr Traill with compliments,
Mr Gourlay Steell, Studio, 90 George Street

Etching on paper, 10 × 13cm
1867

Greyfriars Bobby

GOURLAY STEELL (1819–1894)

IN 1867, THE SCRUFFY SKYE TERRIER GREYFRIARS BOBBY sat for this portrait in the George Street studio of Animal Painter to the Queen Gourlay Steell. Crowds rushed through the doors of the Royal Scottish Academy to see his painting of Edinburgh's best-loved pet and faithful friend. After his master, John Gray, died in 1857 faithful Bobby famously mourned him by resting upon his grave in Greyfriars Chruchyard.

As the One O' Clock gun blasted from the Castle, it was a daily spectacle to watch Greyfriars Bobby make his way from his master's grave to Traill's Refreshment Rooms and Temperance Coffee House on Greyfriars Row for his lunch. When the Council decreed all stray dogs with no licence were to be destroyed, Lord Provost Sir William Chambers intervened and bought the dog a collar engraved with the words 'Greyfriars Bobby from the Lord Provost, 1867 Licensed'. When Greyfriars Bobby died in 1872, he was buried at the entrance to the churchyard and commemorated in the famous statue by William Brodie commissioned by Baroness Burdett-Coutts.

The brother of sculptor Sir John Steell, Gourlay Steell was the leading animal painter of his day. A student of Sir William Allan and Robert Scott Lauder, he was highly regarded for his animal portraits and sporting scenes. Steell's *Highland Raid*, showing the MacGregors defending their cattle, was copied for Queen Victoria in 1859. Also a gifted sculptor, Steell inherited his skills from his father, John Steell, an Edinburgh woodcarver and print-seller who taught ornamental modelling at the Watt Institute in Adam Square. Steell originally specialised in models of animals; his first exhibit at the Royal Scottish Academy was a life-sized model of a greyhound. He also painted a number of subjects from Scott's Waverley Novels, his most famous being *Dandie Dinmont and his Terriers* from *Guy Mannering*. Following the death of Sir Edwin Landseer, Steell was appointed Animal Painter to her Majesty for Scotland, Queen Victoria, in 1872. This was followed by his appointment as curator of the National Gallery of Scotland in 1882.

Steell gifted this etching to John Traill, the owner of the Coffee House, who always opened his door at one o'clock to welcome his famous guest. This study of the real Greyfriars Bobby is an endearing memory of one of our best-loved stories.

Watercolour on paper, 34.0 × 24.7cm
1869

Head of West Bow, Lawnmarket

JANE STEWART SMITH (1839–1925)

THE STREET LIGHTS AND WINDOWS OF THE BOWHEAD HOUSE glimmer in this evening study of the Lawnmarket on the Royal Mile. Over the crown of St Giles', moonlight floods the scene as an old cart passes by the Liberton Dairy and a piper and his dog play outside Barron's Woollen Rag Store. Once covered in the many stalls and booths of the 'lawn merchants', this quiet scene was the site of the city's linen market.

This is one of many watercolours to appear in *Historic Stones and Stories of Bygone Edinburgh*, illustrated and written by Edinburgh artist Jane Stewart Smith in 1924. Dedicated to Edinburgh's history and architecture, Smith set out to preserve many disappearing scenes of the Old Town. A busy wife and mother, she spent her spare time sketching and painting in the early hours and late at night. Edinburgh's closes, courts and historic houses were all captured in hundreds of drawings and paintings. Over sixty watercolours are now held in the City Collection.

Situated at 340 High Street, the Bowhead House was an historic city landmark that stood at the head of the West Bow. Once the eighteenth-century premises of Thomas Nelson the bookseller, the building was described by Stewart Smith as 'a fine example of an old burgher dwelling, with carved timber front and overhanging upper storeys, built without any reference to the law of gravitation'. With its air of antiquity, the West Bow, the crooked street that connected the Grassmarket to the Royal Mile, was the historic entry to the city from the west, home to merchants, tradesmen and aristocrats. Here among the ancient tenements and decaying mansions were found the Old Assembly Rooms, the mansions of Lord Ruthven, Lord Provost Archibald Stewart, the bookseller Alexander Donaldson, and the town mansion of the Napiers of Wrightishousis.

Through Jane Stewart's Smith's dedication we can still cast our eye upon the lights of the Bowhead House, which was soon to be demolished. Saving the scene for future generations, she describes her intention:

> My desire is to simply catch the reverberating echoes of the
> past as they linger round the old historic buildings which I
> have sketched from time to time as they were passing away.
> Some of them, infact, were actually in the process of demoli-
> tion as I plied my pencil and rapidly laid in the colour.
> JANE STEWART SMITH, *Historic Stones and Stories of
> Bygone Edinburgh*, 1924

Oil on canvas, 139.8 × 193.1cm

1879

Edinburgh from Craigleith Quarry

ATTRIBUTED JOHN ZEPHANIAH BELL (1794–1883)

HEWN FROM THE LANDSCAPE, for hundreds of years one of the extraordinary geological landmarks of the city, Craigleith Quarry was the largest and oldest of Edinburgh's sandstone quarries. With Pre-Raphaelite detail, this monumental painting depicts Craigleith's Victorian heyday. Dwarfed by the scale and height of the cliff face, workers use cranes to heave massive blocks of stone onto carts heading into town. An impressive study in geology, the painting shows the different layers of the Carboniferous Craigleith sandstone left exposed. In the distance, below the Castle the New Town stands proud, built from sandstone quarried from Craigleith. In 1791, workers delivered the massive blocks for the pillars of Robert Adam's Old College and in 1823 the stone was ordered for the massive architrave for the National Monument on Calton Hill.

This magnificent painting is attributed to the artist, 'JZ' Bell. Originally from Dundee, forfeiting his uncle's country seat and tanning business, he escaped to Edinburgh to work as a portrait miniaturist. Armed with a letter of introduction from the artist Sir David Wilkie, Bell studied at the Royal Academy in London, but later abandoned his course to train in Paris at the studio of the great history painter and pupil of Jacques-Louis David, Baron Gros. In Rome in 1825, Bell learnt the technique of fresco painting directly from the brotherhood of German history painters known as the Nazarenes. With his new-found skills, returning to Edinburgh, Bell worked as a portraitist and decorative artist. As well as murals for Lord Airlie at Cortachy Castle in Angus, he also painted the ceiling of Muirhouse Mansion in Edinburgh for Captain William Davidson in 1832. In 1831, he married Jane Graham Hay Campbell of Argyll and lived at Haddington House near the Palace of Holyrood. In 1837, David Wilkie secured Bell the prestigious appointment of the first Master of the new Manchester School of Design. However, Bell resigned in 1843, clashing over education policies with the Head of the Government School of Design, the Scottish artist William Dyce. Eventually settling in London, Bell independently set up his own art academy. As his father was a member of the Glasite Church of Dundee, when the artist died an elegy was sung in the Glasite Chapel on Barony Street in Edinburgh. Bell was remembered as one of the first artists of the British fresco revival of the nineteenth century. His nephew, Arthur Bell, would go on to found Bell's Whisky.

The last major project for Craigleith was supplying stone for the building of Leith Docks in 1895. The quarry finally closed for commercial business in 1942. The last stone to be removed was for building the Chinese Garden Pathways at the Royal Botanic Gardens in 1995. Nearby at the entrance to the Palm House lies the largest of Scotland's fossils, the Craigleith Tree. This was one of several fossils of giant trees (*Pitus withamii*) discovered by Victorian workers hidden among the sandstone at Craigleith. Now a busy shopping centre, Craigleith's forgotten industrial past is revealed in this painting.

Ink, watercolour and gouache on paper, 114.2 × 149.5 cm

Castle Terrace

SAMUEL BOUGH (1822–1878)

DESIGNED BY THE ECCENTRIC ARCHITECT JAMES GOWANS IN 1870, Castle Terrace sweeps below the Castle at the city's West End. The clouds gather in this delicate watercolour by Scotland's great Victorian landscapist Sam Bough. Elaborating on the original architectural design, this is a rare collaboration between two of Edinburgh's most eccentric and rebellious characters.

Originally from Carlisle, Bough settled in Edinburgh after working as a scene painter in Glasgow. With plans to make it as a real artist, he moved to Edinburgh in 1855 and never left. Famed for his atmospheric and romantic views, Bough became a highly prolific and successful landscapist. From Edinburgh, he ventured on sketching trips along the Forth, capturing the storms and fishing folk of the East Neuk of Fife and East Lothian. With his command of weather and light, Bough's paintings in oil and watercolour always reflect his extraordinary memory for atmospheric effects. As a landscapist, Bough of course tried his hand at the ever popular panorama. In 1869, he created his *National Panorama,* a journey throughout Scotland in twenty-four scenes. Exhibited in Edinburgh and across Scotland, it proved a financial disaster and Bough was forced to sell his paintings.

This painting once hung in one of Edinburgh's strangest mansions, Rockville House in Merchiston. Architect and quarry owner James Gowans built this Chinese Gothic pile for his second wife, Mary Brodie, the daughter of sculptor William Brodie. Built with rocks and stones collected from across Scotland, the 'Pagoda House' was a marvel of architecture. With its five-storey viewing tower, 'Nightmare Abbey' overlooked its magnificent gardens decorated with statues by his father-in law. Through his efforts in organising the 1886 exhibition and heavy investment in the ill-fated New Edinburgh Theatre on Castle Terrace, Gowans was financially crippled. Despite a trust fund set up for him at Dowells Auctioneers in 1887, he was declared bankrupt and forced to sell Rockville. Demolished in 1966, the only surviving memory of Rockville is one of Brodie's rescued statues placed in Princes Street Gardens, *The Genius of Architecture Crowned by the Theory and Practice of Art.*

Bough lived nearby in an equally eccentric house, Jordan Bank Villa. An impressive building combining three properties, it was stuffed with Bough's collection of antiques, furniture, paintings and books. On his death, Bough was buried in the Dean Cemetery with a monument carved by William Brodie, and the contents of his house were sold at a five-day sale at Dowells Auctioneers on George Street.

> It was a sight to see him attack a sketch, peering boldly through his spectacles and, without somewhat tremulous fingers, flooding the page with colour; for a moment it was an indescribable hurly-burly, and then chaos would see a speaking transcript.
> ROBERT LOUIS STEVENSON, *Academy,* 30 November 1878

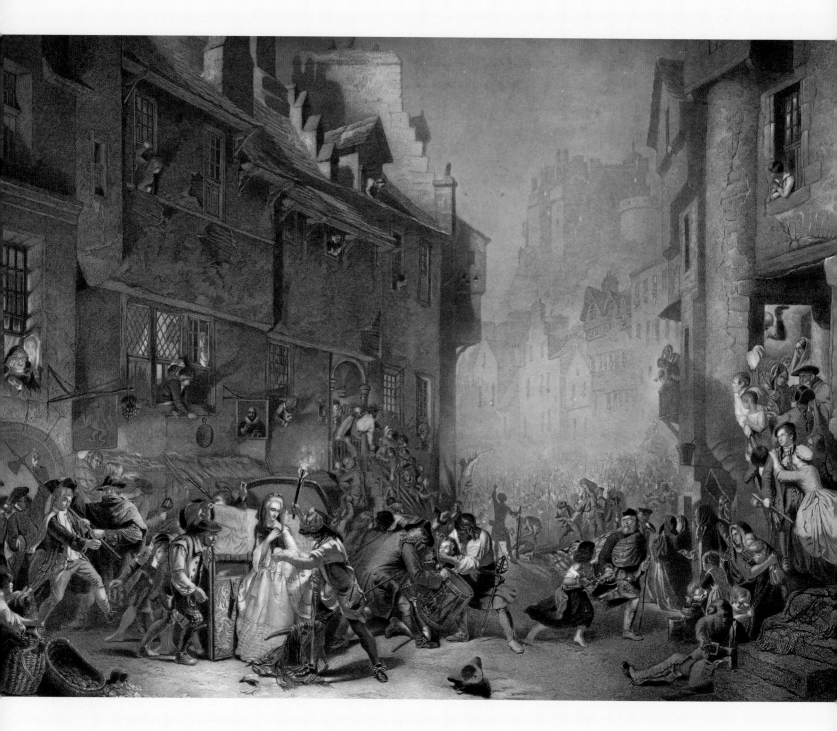

Engraving on paper, 60.9 × 78.8cm
1855
Presented by James McNair, 1927

The Porteous Mob, 1736

ENGRAVING (EDWARD BURTON)
AFTER JAMES DRUMMOND (1816–1877)

JAMES DRUMMOND'S FAMOUS PAINTING of the Porteous Riots of 1736 dramatises one of the goriest moments in Edinburgh's history.

On 14 April 1736, people gathered at the site of execution, the Grassmarket, to watch the hanging of local merchant and thief Andrew Wilson. A riot ensued, and the mob was silenced when the despised Captain John Porteous of the City Guard signalled to his men to fire into the crowd. Instantly killing a man, they also wounded many innocent bystanders. At the High Court of Justiciary, Porteous was found guilty of murder and sentenced to death. Hearing of his subsequent reprieve from the Secretary of State's Office, the townsfolk decided to take matters into their own hands. Storming the Guard House on the Royal Mile, they armed themselves with bayonets and Lochaber axes before seizing the city ports. They then marched to the Old Tolbooth, the ominous prison known as the Heart of Midlothian that stood on the Royal Mile. Porteous was dragged from his chimney hiding place to the Grassmarket and brutally lynched from a dyer's pole.

Capturing the drama of the gruesome scene, Drummond's portrayal accurately describes the historical episode as retold in Sir Walter Scott's famous novel *The Heart of Midlothian*. Illuminated by torches, faces peer from every window on Candlemaker Row as rioters stop a lady in her sedan and drag a drummer to the cobbles. In this most famous of Drummond's Edinburgh scenes, the hapless Porteous is carried by the bloodthirsty mob towards the dyer's pole. Drummond's work was known for its historical accuracy and attention to detail. A great antiquarian, his paintings convey his expert knowledge of Edinburgh's Old Town history.

Born in John Knox's House on the High Street, James Drummond, the son of a merchant, was educated at George Watson's Hospital before working as a draughtsman for the ornithologist Captain Thomas Brown. Studying at the Trustees' Academy, he inherited Sir William Allan's passion and flair for depicting Scottish history. An avid collector of antiques and literature, in 1868 he was appointed Principal Curator and Keeper of the National Gallery of Scotland. He often illustrated *Proceedings for the Society of Antiquaries of Scotland*, and his own papers included 'Medieval Triumphs and Processions' (1874) and 'Ancient Scottish Weapons' (1881). In a bid to preserve the nation's Celtic artistry, he published the important *Archaelogia Scotia: Sculptured Monuments in Iona and the West Highlands* in 1881. He was an outspoken campaigner for the conservation of Edinburgh's Old Town, and the City Collection holds several of Drummond's original drawings of historic closes and buildings, which he preserved in the lithographic volume *Old Edinburgh* (1879).

When the Old Tolbooth was pulled down in 1817, the front door was gifted to Sir Walter Scott by the Dean of Guild. At his mansion, Abbotsford, in the Scottish Borders, Scott incorporated it into Lady Scott's conservatory. Gazing at the door to nowhere inspired him to complete *The Heart of Midlothian* in 1818.

Bronze
Princes Street Gardens, Edinburgh
1877

Sir James Young Simpson
WILLIAM BRODIE (1815–1881)

GAZING TOWARDS THE WEST END, the larger-than-life figure of Sir James Young Simpson, Queen's Physician for Scotland, sits proudly on Princes Street, forever cast in bronze by William Brodie.

Depicting Simpson dressed in his academic robes and reading one of his precious books, this memorial reflects Simpson's monumental status as Edinburgh's great medical pioneer. Professor of Midwifery at Edinburgh University for over thirty years, Simpson was honoured for his contribution to obstetrics and admired for his intellect, kindness and dedication. Surviving the chemical experiments performed in his dining room at 52 Queen Street, Simpson discovered the anaesthetic properties of chloroform in 1847. Battling his critics, he introduced the use of chloroform in childbirth and surgery and was granted royal approval when it was used successfully by Queen Victoria for the birth of Prince Leopold in 1853. In 1849, as President of the Royal College of Physicians, Simpson was the first person to be knighted for his contribution to medicine. This was a towering achievement for the son of a baker from Bathgate, West Lothian. When Simpson died in 1870, his family declined burial at Westminster Abbey and he was laid to rest at Edinburgh's Warriston Cemetery.

Paid for by public subscription, the statue was unveiled on behalf of the Simpson Memorial Committee by Lady Galloway on 26 May 1877. It was the most ambitious of the Edinburgh works by William Brodie, a leading sculptor of portrait busts. His best known works range from Robert the Bruce and Mary, Queen of Scots to Baroness Burdett-Coutts, Lord Cockburn, the geologist Hugh Miller and Queen Victoria. One of his early sculptures, *Little Nell and her Grandfather* from Charles Dickens' *The Old Curiosity Shop,* was exhibited at the Great Exhibition of 1851 and his Italian-inspired *Corinna, the Lyric Muse* stunned the crowds at the Royal Scottish Academy in 1855. From his busy studio on North Andrew Street, the prolific Brodie also cast a varied selection of architectural and funerary works, including figures for the Scott Monument and of course his famous statue of Greyfriars Bobby. The son of a ship master from Banff, Brodie first worked as a plumber in Aberdeen before his talent for modelling medallions was encouraged by his drawing master, the photographer George Washington Wilson. After study at the Trustees' Academy and working under the Scots sculptor Lawrence Macdonald in Rome, Brodie returned to Edinburgh to take his plinth as one of Scotland's great sculptors.

Hidden within the archives of the Royal College of Surgeons is a letter from the artist to his subject. As Honorary Professor of Antiquities for the Royal Scottish Academy, it was Brodie who wrote to congratulate Simpson on his knighthood on behalf of Scotland's artists. His words of praise, 'on your elevation to a rank which you will in every way adorn', are reflected in this tribute, Brodie's Edinburgh masterpiece.

Oil on canvas, 62.0 × 47.0cm

1878

Plainstane's Close, 1878

ROBERT NOBLE (1857–1917)

DOWN THE CANONGATE, an elderly woman turns the key of her door in Plainstane's Close. Once known as Bloody Mary's Close, the street sign was changed when the old cobbles were replaced with heavy flagstones. A prestigious address surrounded by luxurious apartments and mansions, a stone's throw from the Palace of Holyrood, this was the domain of the aristocracy. With the loss of the Royal Court following the Union of 1707, the status of the Canongate diminished as merchants filled its floors. This close stood next to Chessel's Court, the mansion apartments built by Archibald Chessel in the 1750s. By 1878 Plainstane's Close, now standing among dilapidated surroundings, was reduced to the humble abode of labourers.

Growing up at Abbeyhill, Holyrood, Robert Noble, the son of a railway journeyman, knew this scene well. An Edinburgh boy, he loved to linger here and sketch the locals during his days as an apprentice lithographic printer. Noble went on to train at the Trustees' Academy and the Royal Scottish Academy Life Class under his cousin, the landscapist James Campbell Noble. This is one of Noble's early figurative studies set in the Old Town before his departure to Paris to the studio of the great Carolus-Duran, the avant-garde society portraitist and tutor of John Singer Sargent. After he returned to Scotland, Noble's vision turned from portraiture to landscape, inspired by his move to the artistic hotspot of East Linton in East Lothian. Following the Glasgow Boys, who had settled in the nearby village of Cockburnspath to paint scenes of country folk with their French realist brush, Noble became one of the leading artists of the East Lothian School of painters. Featuring open fields, crystal clear rivers and red-roofed mills, Noble's East Lothian views were celebrated for their atmospheric and lustrous quality. Noble became the first President of the Society of Scottish Artists, founded in 1891. This would prove to be an influential platform for promoting younger artists and staging 'progressive' exhibitions. Noble was elected an Academician of the Royal Scottish Academy in 1903.

By 1904, Planstaine's Close and its inhabitants had disappeared. As the wrecking ball demolished the ancient timbers, its memory was preserved only by this lovely painting: a view of a forgotten close and its old way of life. The artist Bruce James Home recalled: 'it retained to the last an air of homely comfort; and its demolition has effaced one more landmark of the old burgher life'.

Oil on canvas, 119.3 × 82.5 cm
1878
Purchased from Steigal Fine Art (Jean F. Watson Bequest Fund
and government grant-in-aid), 1980

The Village of the Water of Leith from a Window in Rothesay Terrace

SIR WILLIAM FETTES DOUGLAS (1822–1891)

THIS IS THE VIEW FROM THE DINING ROOM of Melvin House at 3 Rothesay Terrace, the magnificent townhouse belonging to the proprietor of the *Scotsman* newspaper, Sir John Ritchie Findlay. Once a thriving mill district on the Water of Leith, now the site of a brewery, tannery and distillery, the old Dean Village festered as an industrial slum. The smoke rises from the chimneys of the red-roofed tenements looking down upon the squalor, as inhabitants linger among the decrepit conditions. Distressed by the daily scene of poverty, Findlay pledged to help his less fortunate neighbours. To preserve the view, in 1878 he commissioned his neighbour and fellow antiquarian, the curator of the National Gallery of Scotland, William Fettes Douglas, to paint the scene.

One of Edinburgh's grandest properties, Melvin House was remodelled in the Arts and Crafts style by city architect Sydney Mitchell in 1883. With its magnificent library, marble fireplaces and stairwell displaying the finest selection of Scottish art, it had an opulence in marked contrast to the hardship below. In an ambitious act of social reform, Findlay bought the land of the Dean Village, cleared the tenements and asked Sydney Mitchell to design model housing for the local workers. The impressive Well Court, with its distinctive red sandstone and Arts and Crafts style, was completed in 1886. This modern development boasted a communal courtyard, shops and a social hall. Transforming the slum, the building of Well Court was followed by the completion of the Dean Hawthorn Buildings and Dean Path Buildings.

Along with improving the lives of Edinburgh's poor, Findlay was greatly involved in the promotion of the arts. With Sir Robert Rowand Anderson as architect, in 1889 Findlay presented to the nation the Scottish National Portrait Gallery. In grateful recognition of his philanthropy, Findlay was granted the Freedom of the City in 1896, 'in token of respect for him, in recognition of his public spirit as a citizen of Edinburgh, and in testimony of their appreciation of his munificence in providing a noble edifice for the Scottish National Portrait Gallery'.

William Fettes Douglas turned to landscape later in his career; this is one of his best-known works. Its creation was followed in 1882 with a knighthood and presidency of the Royal Scottish Academy. Some years later, the 'former historical painter' would move to Lynedoch Place, a short walk from the Dean. Looking out from the window of No. 3 Rothesay Terrace, here Findlay stood proudly overlooking his new Dean Village. In changing the view, Findlay not only improved the living conditions of the workers, but also created one of Edinburgh's most picturesque locations.

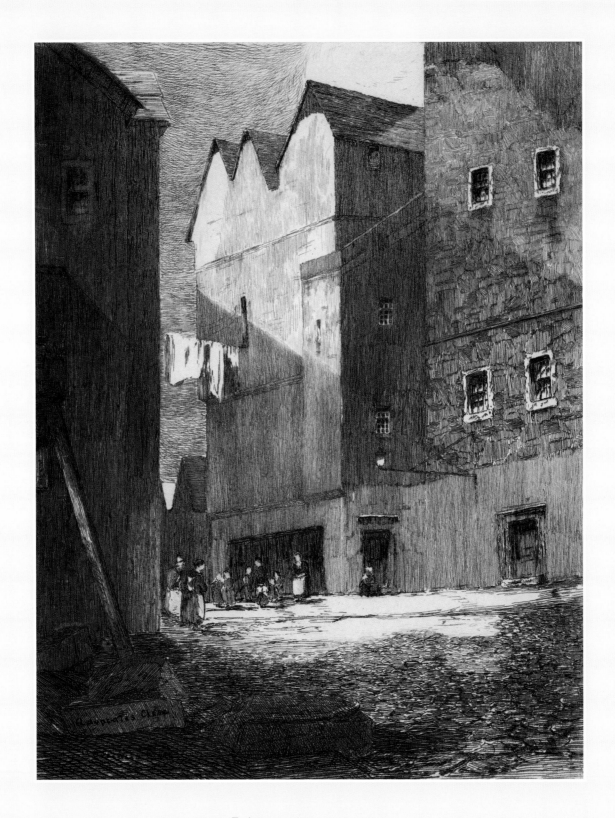

Etching on paper, 24.3 × 19.0cm
1884
Presented by Councillor Dr Nasmyth, 1922

Advocate's Close

JOHN MUNRO BELL

> Tall tenements of stone lined both sides of a very steep declivity. These
> afforded support to a series of timber outworks which projected storey
> above storey over the narrow roadway, until, near the top, the inmates
> shake hands with their neighbours opposite.
> ROBERT CHAMBERS, *Traditions of Edinburgh,* 1868

OBLIVIOUS TO THE HISTORIC AND ANCIENT SURROUNDINGS, children play in this most dramatic of Edinburgh's hidden closes. With its proximity to the courts of the Royal Mile, this was once the haunt of lawyers, politicians and Lord Provosts. In the foreground, the name carved into the stone relates to the close's most famous inhabitant, Sir James Stewart of Goodtrees, Lord Advocate in 1692. Above the steep, narrow and claustrophobic close tower the tenements with their timber projections and tiny windows. One of the many views included in John Bell's *Old Edinburgh Closes,* this etching is just one of many stops in this artistic tour of the Old Town.

Once situated at the foot of the close, Sir James Stewart of Goodtrees' house was inherited from his father, Sir James Steuart of Coltness, Lord Provost in 1648. His provost portrait was painted by David Scougall (c.1610–1680), a relative of the eminent portraitist John Scougall (c.1645–1744), who lived in the house opposite. Here in the upper storey, Scougall built Edinburgh's first art gallery, displaying his historic and contemporary portraits, including his copy of Van Somer's *George Heriot* and versions of his portraits of William III and Queen Mary. Today, memories of the old mansions and merchants of Advocate's Close are still evident. In 1590, merchant Clement Cor rebuilt his townhouse and his initials are still carved above his doorway with the inscription *Spes Altera Vitae* ('Another Hope of Life'). The historic Adam Bothwell's House, home to Sir William Dick of Braid, Lord Provost in 1638, is now the property of the Faculty of Advocates.

In the late nineteenth century the lower part of the close, by then the domain of the poorer classes, was completely demolished for the sinking of the foundations of a printing office and the creation of Cockburn Street. The bizarre sight was described by Bruce James Home: 'the west side towering to a gigantic height above the abyss, was gaunt and rugged as some great sea-cliff'. As a result, Advocate's Close now provides a splendid open view of the city.

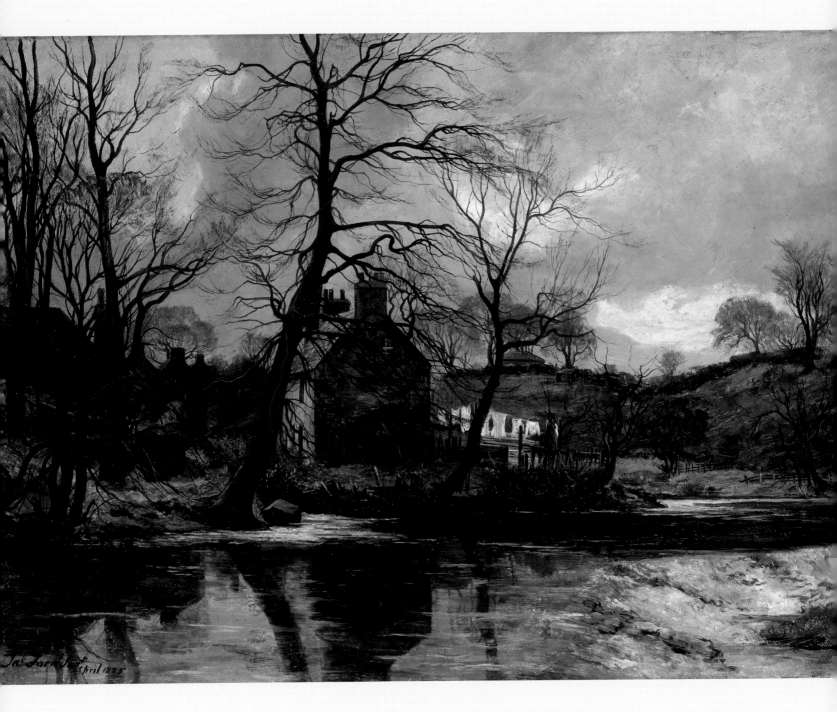

Oil on canvas, 27.0 × 36.5 cm
1885
Purchased (Jean F. Watson Bequest Fund and
the National Fund for Acquisitions), 1996

At Cramond, Early Spring

JAMES FAED, JUNIOR (1856–1920)

Of the mill products themselves, we have a few nails
and one small iron bar trademarked with a stag's
head, the crest of the Cadell family, and the word
'Cramond', rare survivals of a once prolific factory.
PATRICK CADELL, *The Iron Mills of Cramond*

WHERE THE RIVER ALMOND MEETS THE FIRTH OF FORTH, once the site of the Roman fort of *Caer Amon*, the water rushes past one of the old mills of Cramond. In the eighteenth century, this industrial village thrived with its collection of iron mills operated by the Cadell family. Once the property of the Carron Iron Works Company of Falkirk, the old mills were sold to one of the Carron founders, William Cadell of Cockenzie, in 1770. For the next 100 years, the Cadells of Cramond owned this important pre-industrial centre of iron manufacture in Scotland. The first iron works to produce steel commercially, the Cadells milled rod iron, hoops, nails and spades for export to Spain, Portugal and the West Indies. By 1885, production was in decline, and when the mills stopped turning, this polluted industrial site transformed into an idyllic picturesque village. With its red-roofed workers' cottages, stretch of beach and cobbled streets, this was a local painting haunt of young artist James Faed.

Born at Overshiel House, Mid Calder, James Faed junior grew up nearby at Craigleith, the son of the celebrated artist James Faed. He was an acclaimed Victorian landscapist and also a leading mezzotint engraver who created over 140 plates for prominent Scottish artists such as Sir John Watson Gordon, Sir J. Noel Paton and Sir Francis Grant. With a nostalgic affection for picturesque mills, James Faed senior was born in the Barley Mill at Gatehouse of Fleet in Kirkcudbrightshire. A member of a family dynasty of Victorian artists, he moved with his siblings, all accomplished artists, to Edinburgh to further their careers. James remained in Edinburgh as his brothers, John and Thomas, left for London, where they flourished, painting Scottish historical and sentimental genre scenes. Diverse and highly talented, the Faeds are responsible for creating some of the finest Victorian Scottish masterpieces.

Like his father, James Faed junior specialised in romantic views of heather-lined glens and mountains. From Edinburgh he ventured all across Scotland, to the Trossachs, the Cadzow Forest at Hamilton, Inverness-shire and Kirkcudbrightshire. His favourite location was his family's artistic retreat of New Galloway and Gatehouse of Fleet. James finally left the family home in Edinburgh after marrying Eleanor Annie Herdman in 1897. Off to London, they settled in the artists' colony of St John's Wood at 38 Abbey Road, with his uncle, Thomas Faed, as a neighbour. In 1912 he returned to Scotland and his beloved New Galloway. Heartbroken at the death of his eldest son Ronnie during the First World War, he gave up painting. He died in 1920, The Last of the Clan.

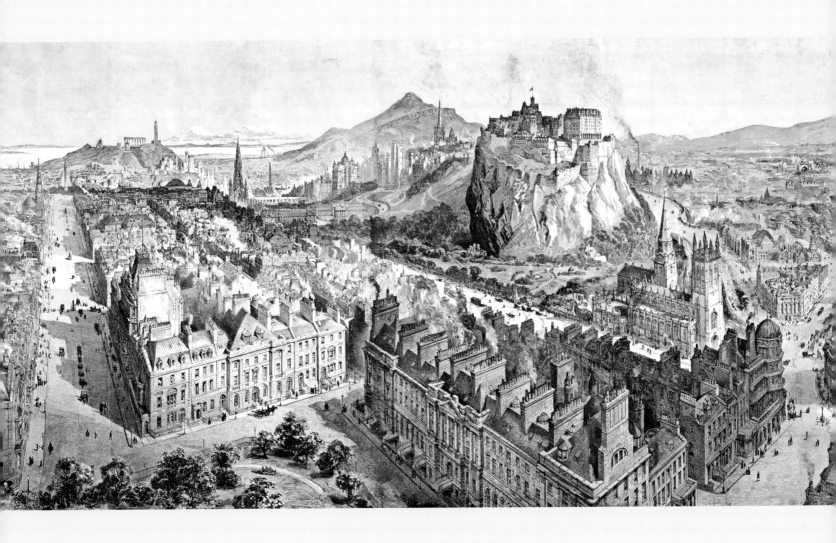

Engraving on paper, 62.0 × 111.4cm

1886

Whitson Bequest, 1948

Edinburgh in 1886

H.W. BREWER AND T. GRIFFITHS

IN 1886, EDINBURGH HOSTED THE INTERNATIONAL EXHIBITION OF SCIENCE, Art and Industry, a spectacular event of the Victorian age. Attention turned to Edinburgh as over 40,000 visitors flocked to the capital. The exhibition was a showcase for the city, as reflected in this commemorative print by H.W. Brewer, a London-based architectural illustrator known for his aerial panoramas of British cities. This bird's-eye view hovers above the grandeur of Charlotte Square. Accentuating the city's architectural wonders, the view extends from George Street, over the rooftops of Princes Street, towards Edinburgh Castle. The streets swarm with carriages, as smoke rises from almost every chimney. In the distance, the Victorian splendour of the Great Hall awaits at the Meadows.

At the official launch of the exhibition on 6 May, the doors of the main pavilion were opened by Prince Albert Victor, Lord Provost Thomas Clark and the event organiser and Lord Dean of Guild, James Gowans. Entering the main hall, the crowds delighted in the vast array of stalls and exhibits displaying curiosities, inventions and artistic treasures from across the globe. In promotion of Scottish innovation, talent and design, it was the Scottish stalls that drew in the crowds. Visitors could peruse a fine selection of prints and paintings at the National Gallery of Scotland stand, take a quick nip at the National Exhibition of Scotch Malt Whiskies, before heading to Robert Hamilton Bruce's collection of French and Dutch masters. Then, after jostling past the Glasgow Boys, they could delight in the beautiful paintings by Millet, Corot, Monticelli and Israels.

From gazing at paintings, the crowds moved on to the most popular exhibit, the recreation of 'Old Edinburgh'. Designed by the architect Sydney Mitchell, this life-sized set comprised of lost historic buildings set around an old Edinburgh Street. In realistic detail, visitors could walk under the ancient Netherbow Port, visit the Old Mint, stop by Cardinal Beaton's House in the Cowgate, visit the Oratory of Mary of Guise or dance at the Old Assembly Rooms. Clutching the street guide, *The Book of Old Edinburgh and Hand-book to the Old Edinburgh Street*, illustrated by William Hole, visitors enjoyed this intriguing stroll back in time.

Outside in the landscaped grounds, visitors would hop on Gowans' electric railway to travel across the Meadows or visit his recreation of a model dwelling house. As night fell, they would witness the spectacle of the Great Hall illuminated with hundreds of electric lamps. In recognition of his efforts in organising this ambitious event, James Gowans was knighted by Queen Victoria, who visited the Exhibition on 18 August. Gowans had hoped the Great Hall would be a permanent feature for the city, but forgot about the Improvement Act of 1827, prohibiting permanent building on the Meadows. The hall was demolished; only a few souvenirs linger in its place such as the Prince Albert Victor Sundial and the Memorial Masons' Pillars. Most noteworthy is the Jawbone Arch, presented to the City by the Zetland and Fair Isle Knitting stand; this maritime curiosity is still to be found on Jawbone Walk.

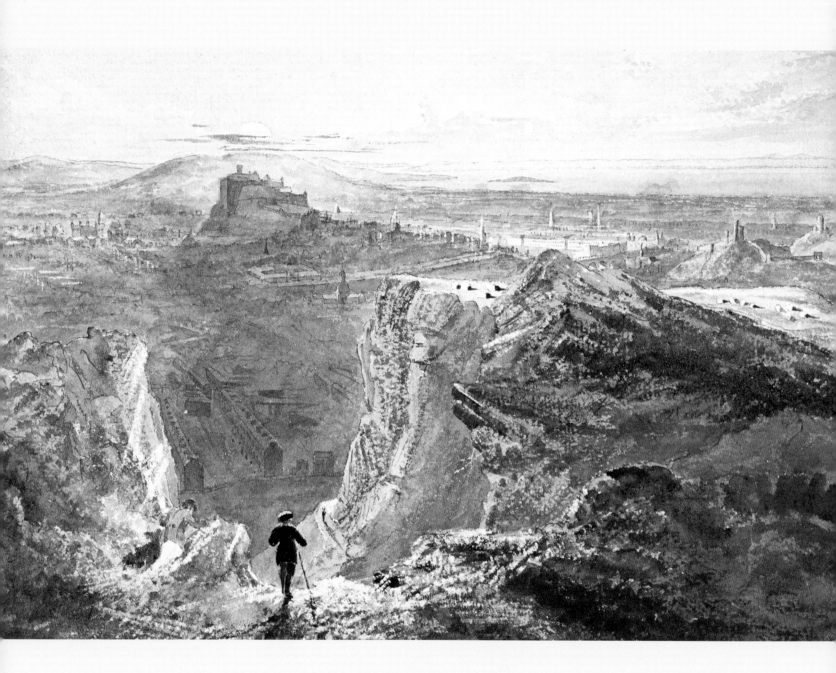

Watercolour on paper 18.1 × 27.3cm
Purchased from The Scottish Gallery (Jean F. Watson Bequest Fund
and government grant-in-aid), 1979

Edinburgh from Salisbury Crags

WILLIAM BELL SCOTT (1811–1890)

FROM THE TOWERING CLIFFS OF SALISBURY CRAGS, a young artist and his father contemplate the view in this Romantic memory of Edinburgh. This exquisite watercolour was painted by the Scottish Pre-Raphaelite William Bell Scott.

With a view of the crags from the windows of his home on St Leonard's Street, William Bell Scott grew up in a house full of engravings, poetry and books. The son of eminent printer Robert Scott, and one of the young artists to be encouraged by the Rev. John Thomson, William Bell Scott often ventured around Arthur's Seat for lessons at Duddingston Kirk. His first exhibit at the Royal Scottish Academy was Coleridge's *The Ancient Mariner* and his first poem was 'In Memory of P. B. Shelley' for *Tait's Edinburgh Magazine* in 1831. In 1837, Edinburgh's talented poet-painter left for London.

Through his reputation for painting historical, literary and contemporary subjects, Scott soon secured a prestigious position as Master of the Newcastle School of Design. In 1846, his poems 'Rosabell' and 'The Dream of Love' grabbed the attention of the Pre-Raphaelite artist Dante Gabriel Rossetti: 'So beautiful, so original did they appear to me, that I assure you I could think of little else for several days, and I became possessed by quite a troublesome anxiety to know what else you had written and where it was to be found.' Scott was invited to contribute to *The Germ* in 1849, and his friendship with Rossetti assured his close membership of the Pre-Raphaelite circle. Scott was commissioned to paint a mural cycle depicting Northumbrian history for Sir Walter and Lady Trevelyan at Wallington Hall in Northumberland. While painting one of the murals, Scott fell in love with his model, Scottish art student Alice Boyd. Continuing the relationship throughout his own unhappy marriage, Scott often visited her ancestral home of Penkill Castle in South Ayrshire. In romantic gesture, in 1868 he painted the Castle's spiral staircase with the mural of James I's *The Kingis Quair*.

After almost twenty years, Scott left his post at Newcastle to divide his time between London and Penkill. Working as an examiner in London art schools, he edited the literary texts of Keats, Byron, Coleridge and Shakespeare. In 1870, he was commissioned to design the stained-glass windows depicting the lives of the Renaissance painters and architects for the South Kensington Museum (now the Victoria and Albert Museum). He was a confessed expert on German art from Durer to the Nazarenes, and this painting alludes to the work of the German Romantic artist Caspar David Friedrich.

At Penkill, Scott spent his last days in the care of Alice Boyd. His final collection of poetry, *A Poet's Harvest Home*, was published in 1882.

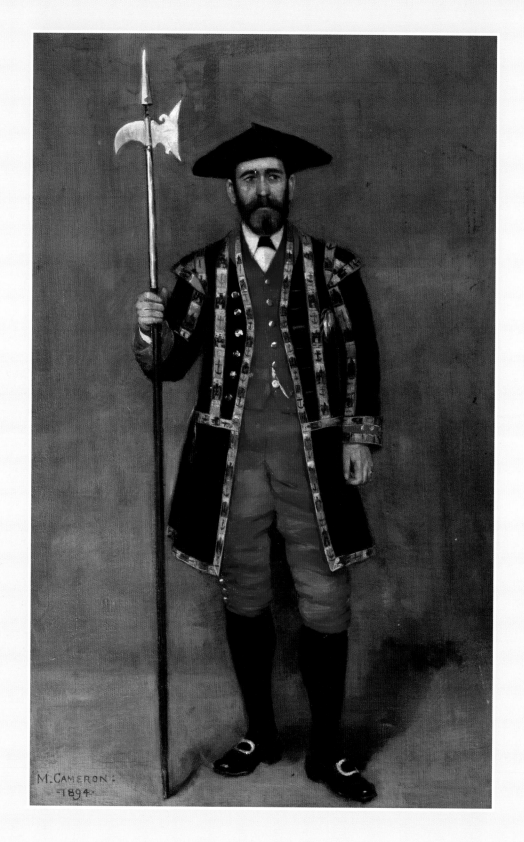

Oil on canvas, 61.6 × 39.2cm

1894

An Edinburgh Halberdier

MARY CAMERON (C.1865–1921)

They come as a boon and blessing to men, the
Pickwick, the Owl and the Waverley Pen
COMPANY MOTTO – MacNiven and Cameron

THIS STRIKING CIVIC PORTRAIT OF AN EDINBURGH HALBERDIER was painted by local artist Mary Cameron. It is a study of one of the old City Officers, resplendent in scarlet breeches and overcoat emblazoned with anchors and castles. With realistic detail, the seal upon his chest flickers along with the glint of the halberd. His costume harks back to the uniform of the old Town Guard.

Formed as early as 1648, the Town Council appointed a small army to preserve order in the city. Recruited mainly from retired Highland soldiers, the City Guard was based at the Old Guardhouse on the Royal Mile. Presiding over riots, state occasions, invasions and fire, armed with their Lochaber axes, they were commanded by the Captain of the City Guard, who paraded throughout the streets clutching his halberd. With the formation of a local police force, the Guard was disbanded and their headquarters, the Old Tolbooth, was demolished in 1817. Their very last duty was marching out to the Hallow Fair beating the drums to 'The Last Time I Cam' O'er the Muir'. The last Captain of the Guard was James Burnet, a grocer in the Fleshmarket Close, who died in 1814. The last two survivors of the City Guard were present at the laying of the foundation stone of the Scott Monument in 1840.

A gifted artist, linguist and writer, Mary Cameron grew up in Waverley House on Colinton Road. She was the daughter of Duncan Cameron, a partner in the printers and stationery wholesaler MacNiven and Cameron on Blair Street. Duncan Cameron was the inventor of the revolutionary 'Waverley nib' fountain pen, 'sold by all stationers throughout the world'. Supported by her family's fortune, Mary Cameron enrolled at the Edinburgh School of Art on the Mound. A member of the Edinburgh Ladies Art Club, as a young artist she soon became frustrated with the conservatism and male exclusiveness of the Royal Scottish Academy's Life School and fled to the studios of Gustave Courtois and Jean-André Rixens in Paris. Moving on to Madrid and Seville, Cameron was acclaimed for her accomplished portraits and Spanish subjects. In 1911, she held a solo exhibition at the Galleries des Artistes Modernes in Paris. Cameron was heavily criticised for her gory depictions of Spanish bull fights, considered unsuitable subjects for a female artist. Returning to Edinburgh, she married the horse dealer Alexis Miller and worked for the rest of her days from her studio at Turnhouse. Along with her fellow female artists, Mary Cameron never received the recognition she deserved from her hometown. The City Collection is now proud to hold some of Cameron's finest Edinburgh work.

Oil on canvas, 63.5 × 91.8cm
Presented by the Scottish Modern Arts Association, 1964
Purchased 1913

The Taking of Excalibur

JOHN DUNCAN (1866–1945)

> Merlin, calling to those who had come to see this wonder, said
> that on the morrow the red dragon would rise from the loch
> below (now Duddingston) in the form of a sword, and to him
> who had the hardihood to grasp it, the sword would be yielded.
> ARTHUR THOMSON, in *Interpretation of the Paintings in the*
> *Lounge of Ramsay Lodge*

THIS PAINTING RECALLS THE LEGEND OF ARTHUR'S SEAT. It was believed that two great dragons lived deep within the volcanic rock. The last in Scotland, they battled underground every night as the King tried in vain to build a great fortress in the land. When the King caused the hill to be opened, there commenced an almighty battle between the serpent giants. Spiralling into the air, they struck each other and fell back into the depths of the seat. This scene shows the red dragon re-emerging as Excalibur from the nearby Duddingston Loch. Merlin rows, as Arthur is presented with the sword by Morgan Le Fay. In the background, Arthur's queens linger with Nimue, Lady of the Lake. Ever drawing on his Celtic heritage, Scotland's Symbolist painter John Duncan painted this legendary vision.

This is the study for one of six murals painted in 1897 to decorate the Student Common Room of Ramsay Gardens on Castle Hill. As part of his regeneration of the Old Town, the sociologist and town planner Patrick Geddes redeveloped Allan Ramsay's Ramsay Lodge with the help of architect Sydney Mitchell in 1893. Committed to a Celtic Revival in the arts, Geddes and Duncan designed an ambitious mural scheme that would celebrate Scotland's historical achievements in arts, literature and science. The Ramsay Lodge scheme was completed in 1928 with the addition of a further six murals featuring prominent figures such as John Napier of Merchiston, James Watt, Sir Walter Scott and Lord Lister.

Originally an illustrator from Dundee, Duncan collaborated with Geddes to kick-start the Celtic Revival in Edinburgh. This painting shows Duncan's unique flat and decorative style indebted to the Pre-Raphaelites, Early Renaissance frescoes and the Symbolist movement. His visions are all enriched by Celtic symbolism. Multi-talented, Duncan worked in murals, paintings, stained glass and book illustration.

With the glimmer of the Celtic Revival fading, Duncan left Scotland to teach at the Chicago Institute in 1900. He returned to Edinburgh three years later, and his studio at Torphicen Street flourished as a creative hub in the city, encouraging a younger generation of artists such as Stanley Cursiter, Eric Robertson and Cecile Walton. Duncan's other notable Edinburgh schemes include the stained-glass panels *Stations of the Cross* in 1907 for St Peter's Church in Morningside. These were commissioned by Father John 'Dorian' Gray, poet and one-time love of Oscar Wilde. Duncan's stained glass still sparkles in Morningside Church and his angels fly upon the chancel arch at St Cuthbert's on Lothian Road. The leading artist of the Celtic Revival movement, John Duncan always looked to the old to bolster the new. One of the most important Arts and Crafts schemes in the city, the Ramsay Lodge murals remain one of Scotland's artistic treasures and precious proof of the fluttering of a Scottish artistic Renaissance.

Ink and wash on paper, 32.5 × 24.2cm
1898
Purchased 1913

Old House in Courtyard near Foot of West Bow

BRUCE JAMES HOME (1830–1912)

HIDDEN AT THE BOWFOOT OF THE GRASSMARKET, this empty silent courtyard with its old lamp, cobbles, iron railings and bolted doors is a surviving remnant of the medieval tenements that once stood at the West Bow. This beautiful drawing is one of the many fine studies of the Old Town by one of its leading authorities, the artist Bruce James Home.

As the first curator of the Edinburgh Museum in the historic Huntly House at the Canongate, Home's knowledge of the Old Town was exceptional. The son of engraver Robert Home, he was apprenticed to his father's printing office before training at the city's Trustees' Academy. Working as an engraver on Broughton Street in the New Town, he devoted his spare time to preserving Old Edinburgh in a series of detailed pencil drawings. From closes to historic houses, inscriptions, architectural curiosities and scenes of destruction, he campaigned for the preservation of the Old Town. This is one of the many drawings used to illustrate his own publication, *The Old Houses of Edinburgh*, published between 1905 and 1907.

The West Bow, the steep zig-zagged street that linked the Grassmarket to the Lawnmarket on the Royal Mile, was noted for its lofty heights and projected gables. As Home describes, 'Its quaint, irregular and diversified tenements towered one above another in a most unexpected, almost incredible fashion, in apparent defiance of the law of gravitation.' At the foot of the West Bow stood the Templar Lands. Here the old tenements were reputedly built upon ground that once belonged to the Knights Templars, indicated by the rusting iron crosses pinned above the doors. The ancient thoroughfare of the West Bow was demolished in the 1830s to improve access to the High Street. Lamenting its destruction, Home wrote of 'improved modes of access to which were sacrificed the most rare and inestimable of our antiquarian treasures'.

Home's drawings were displayed in the Edinburgh Room in the Outlook Tower on Castlehill, where he was also curator. Dedicated to the city's history and development, this room contained pictures, murals and models of Edinburgh. This museum belonged to Patrick Geddes, sociologist and town planner, who transformed Short's Observatory into the Outlook Tower. This was the office, college and cultural centre for Geddes' plans and ideas associated with the city.

Through his curation, expertise and artwork, Bruce James Home saved many parts of Edinburgh's Old Town, which now help give the city its distinctive character. Even today, his words still seem pertinent:

> Unless our citizens can be awakened to a jealous care in
> preserving the few relics which still remain, the Old Town
> of Edinburgh will speedily become nothing more than a
> memory and a name.
> BRUCE JAMES HOWE, *The Old Houses of Edinburgh*, 1906.

XVII

Etching on paper, 20.2 × 12.5 cm
1904–5
Purchased from Garton and Cooke (Jean F. Watson Bequest Fund
and with grant aid from the National Fund for Acquisitions), 1997

The Cowgate, Edinburgh, 1904

JAMES McBEY (1883–1959)

BELOW THE ARCH OF GEORGE IV BRIDGE, figures linger amongst the shadows of the gloomy under-world of the Cowgate. Washing hangs from the overcrowded tenements as darkness descends upon the Irish slum. The most impressive of his Edinburgh plates, this evening study reveals the early talents of a young bank clerk who dreamed of becoming an artist.

Working for the North of Scotland Bank in Aberdeen, James McBey spent his evenings studying Maxine Lalanne's *A Treatise on Etching* in Aberdeen Library. Teaching himself to etch, the poor clerk created his first studies of Aberdeen harbour on a homemade printing press. In 1904 McBey was sent to Edinburgh to cover the branch on George Street. Finding digs in a room in the attic of an old church on Queen Street, he recalled: 'It had a small window which looked right over part of Edinburgh, Leith, and right across the hills of Fife. In my spare time I began etching Edinburgh subjects. I had not to search far in that most fascinating city.' Inspired by the impressive architecture, McBey spent his evenings exploring. With visits to the Calton Hill, Holyrood, New Town and Dean Bridge, he captured the city in a series of twenty-five views, drawing directly onto copper plates.

Settling in London in 1911, McBey dominated as one of the prominent Scottish stars of the Etching Revival. Inspired by Whistler and Rembrandt, his landscapes documenting his travels to Spain, Venice, the Netherlands and Morocco made him one of the most commercially successful artists of the last century. In 1917 he was appointed Official War Artist with the British Expeditionary Force in France and Egypt. Battling the sands of the Sinai Desert, McBey created more than 300 drawings and water-colours of the Middle East, including his portrait of Lawrence of Arabia. When his most famous etching, *Dawn: The Camel Patrol Setting Out,* sold for £445, it was the highest price ever paid for a print by a living artist.

With the collapse of the print market in the 1930s, McBey relied on watercolours and portrait commissions for a living. On his second visit to America in 1930, he met the much younger and very beautiful Margaret Loeb in Philadelphia, a fellow artist and talented bookbinder. They married four months later. While he was based in New York during the Second World War, McBey's achievements were celebrated at the Smithsonian Museum in Washington, which held a retrospective of his work in 1943. After the war, the McBeys returned to their beloved Tangiers in Morocco and spent the last years working on renovating their hillside house, El Foolk.

When James McBey returned to Aberdeen Library in 1926, he replaced Lalanne's well-worn *Traité de la Gravure a l'Eau-Forte* with a new edition. It was this precious book that inspired the creation of this view of the Cowgate and sparked the career of one of Britain's most famous printmakers.

Oil on canvas, 77.0 × 128.0cm
1905
Presented by the Scottish Modern Arts Association, 1964

Edinburgh's Playground

JAMES PATERSON (1854–1932)

GIRLS DANCE IN THE SUN below the shadows of the moving clouds hovering above the Forth. This romantic view of Arthur's Seat from the Braid Hills was painted in the George Street studio of acclaimed landscapist James Paterson.

Originally a Glasgow Boy, Paterson was born at Blantyre near Glasgow, the son of wealthy industrialist Andrew Paterson. After starting his career working for the family muslin business, Paterson studied at Glasgow School of Art before heading to the ateliers of Paris with the rest of the Glasgow Boys. Returning, inspired by the modern realism and 'plein-air' painting he encountered in France, Paterson settled in the village of Moniaive in Dumfries and Galloway and spent the next twenty years capturing the changing seasons of the local landscape. His fluid watercolours of Moniaive, painted in his outdoor studio on the Craigdarroch Water, are considered some of the prized landscapes of the Glasgow School. He also painted local views of Helensburgh, where his father lived at the beautiful Torwood House at Rhu. To further his artistic career and distance himself from the rest of the Glasgow Boys, Paterson moved to Edinburgh around 1905 to live and work at 115 George Street.

Exhibited at the Royal Scottish Academy in 1907 and the Scottish National Exhibition in 1908, this is one of Paterson's sweeping romantic views of his adopted city. He also painted the Nor' Loch, Craigleith Quarry and Arthur's Seat. Although his painting style had changed, his landscapes were still concerned with capturing the atmospheric colours, effects of lights and nuances of the landscape. He still used incidental figures as a way to lead the eye into the painting. Primarily a landscapist, Paterson's portrait studies included Principal Marcus Dods of New College, Edinburgh (1908), and fellow artist John Duncan (1909). Following the early death of his wife, Eliza, Paterson was left to raise five children. Despite his parental responsibilities, he took a prominent role in the arts in Edinburgh. He exhibited with the Society of Eight and became President of the Royal Scottish Society of Painters in Watercolours in 1922. An active member of the Royal Scottish Academy, he served as Librarian and Secretary. Like his father, Paterson was a talented amateur photographer and amassed a considerable archive of images, recording locations, friends and family, which proved a clever catalogue of his own work. Only using photography as an aid to his art, the painter dismissed the ability of a photograph to render the true nature of the landscape; it could never rival the effect of a painting. The extensive Paterson photographic collection is now held at the University of Glasgow.

Triptych of enamelled plaques within electroplated stand, 27.5cm

c.1906

The Red Cross Knight

PHOEBE ANNA TRAQUAIR (1852–1936)

THIS BEAUTIFUL ENAMEL TRIPTYCH was created by leading light of the Arts and Crafts movement in Scotland, Phoebe Anna Traquair. A formidable designer and artist, her legacy can be seen in some of Edinburgh's most important public mural decorations, from the Song School of St Mary's Episcopal Cathedral to the magnificence of angels flying around the former Catholic Apostolic Church on Mansfield Place.

At the Dean Studio, a derelict church on Lynedoch Place at the West End, Traquair created an array of artistic gems from exquisite jewels to book covers, illustrations, embroidery and illuminated manuscripts. A busy mother with three young children, she was encouraged by Patrick Geddes and the Edinburgh Social Union to decorate public spaces to enhance the lives of the general public. During the 1880s and 1890s, with spiralling imagination, Traquair created a wealth of Arts and Crafts treasures for the Edinburgh people.

Illustrating one of her favourite themes, this rarely displayed piece demonstrates Traquair's expertise as an enamellist. It tells the Legend of the Red Cross Knight from Edmund Spenser's *The Faerie Queene*. Mirroring her illuminated manuscripts, the narrative scene is picked out in meticulous detail and jewel-like colour. The central panel shows the gallant knight killing the dragon for his love, Lady Una. An example of one of her stunning metalworks, this triptych was designed by her son, the architect Ramsay Traquair, and created by the silversmith J.M. Talbot. This is one of two enamel triptychs of this subject completed while she was working on an ambitious triptych tapestry of the same design. Traquair's artistic vision typically drew inspiration from romantic literature, the Pre-Raphaelites, her love of poetry and music, infused with her native Celtic symbolism. Themes of love, heartbreak and, in particular, the journey of the soul ripple through her allegorical and religious decorative work.

Originally from Dublin, Phoebe Anna Moss settled in Edinburgh after her marriage to Dr Ramsay Traquair, Keeper of Natural History at the Edinburgh Museum of Science and Art (National Museum of Scotland). Copying fossils and botanical specimens, Traquair's first works of art were detailed illustrations for her husband's research. At around the time this triptych was created, Traquair moved from her home at Dean Park Cresent to the historic village of Colinton. With a stunning view of the Pentlands from her beautiful garden, Edinburgh continued to inspire the wild Irish redhead.

Despite her tiny stature, Traquair's contribution to Scottish art was considerable. With an international reputation, she was the first woman to work as a professional artist and, in 1920, she was the first female to be admitted to the Royal Scottish Academy. Traquair created some of Edinburgh's most significant artistic treasures, as seen in this exquisite piece.

Oil on canvas, 127.5 × 160.0cm
European Room
Edinburgh City Chambers, Royal Mile
c.1909
Presented by the Society of High Constables of Edinburgh

Charles Edward Stuart at Holyrood
WILLIAM FERGUSSON BRASSEY HOLE (1846–1917)

ON 17 SEPTEMBER 1745, Charles Edward Stuart stormed through the doors of the Palace of Holyrood-house, declaring his capture of Edinburgh and proclaiming his father, King James VIII, the rightful King of Scotland. Victorious over the British army at Prestonpans, 'Bonnie Prince Charlie' occupied the palace of his ancestors for six weeks, celebrating with a grand ball in the Great Gallery. This triumphant moment of the Jacobite cause was painted by William Hole, a leader of the Edinburgh Arts and Crafts movement.

Painted between 1904 and 1910, this is one of nine large paintings commissioned by the Edinburgh Corporation to decorate the dining room of the City Chambers on the Royal Mile. Drawing on his unrivalled knowledge of Scottish history, William Hole handpicked a series of prominent episodes celebrating Edinburgh's eventful past from the *Coronation of James II at Holyrood* to the *State Entry of Queen Mary*. The final painting in the series, this study of the Young Pretender, was gifted by the High Constables of Edinburgh. A hidden artistic treasure, the City Council's 'European Room' remains one of the most ambitious decorative schemes in the city.

Hole grew up in his grandmother's house at 34 London Street. Despite showing artistic flair at school at the Royal Academy in Stockbridge, he was apprenticed as an engineer. Determined to be an artist, he enrolled at the Trustees' Academy and the Life School at the Royal Scottish Academy, supported by anatomical studies at Edinburgh University. With a passion for his nation's heritage, he began exhibiting historical paintings often with a Jacobite theme. Heralding his talents as an etcher and important printmaker, in 1884 he illustrated *Quasi Cursores*, a lively series of portraits of professors and officials for the tercentenary of the University of Edinburgh. Hole's historical scenes illustrated many Scottish books, including the works of J.M. Barrie and his lifelong friend, Robert Louis Stevenson.

In 1893, Hole moved from Saxe-Coburg Place to Inverleith Row, where he joined the congregation of St James The Less Episcopal Church. For his first experiment in mural decoration, Hole offered to decorate the chancel with a triptych, *Lord in Glory, St Michael and St George*. Impressed by his figural studies, love of Scottish history and historical accuracy, John Ritchie Findlay commissioned the artist to carry out the internal decorative scheme of his new Scottish National Portrait Gallery in 1889. Our Jacobite Pre-Raphaelite William Hole created in his decoration of the City Chambers a splendid tribute to his home town.

Oil on canvas, 91.4 × 124.4cm

1911

Presented by the Scottish Modern Arts Association, 1964

Cave Dwellers at Play

WILLIAM WALLS (1860–1942)

EXHIBITED AT THE ROYAL SCOTTISH ACADEMY IN 1911, this magnificent painting of some of Edinburgh's wildest residents was painted by Scotland's leading animal painter, William Walls.

Growing up in Harriebrae Mill in Dunfermline, William was the son of the grain mill master and Lord Provost, James Walls. Enrolling at Edinburgh's School of Art, he was convinced by fellow student Edward Hornel to study at the Antwerp Academy under the Professor of Painting, Charles Verlat, a famed animalier. Walls was greatly influenced by Verlat's animal-life classes, with their emphasis on vigorous brushwork and colour. As a student, Walls spent his spare time painting the animals at Antwerp Zoo. Writing home to his brother James in 1884, he revealed 'it requires a great deal of nerve to paint in the zoo . . . I have quite a crowd round me'.

Returning to Edinburgh, in 1890 Walls embarked on a six-month painting tour of the Highlands in a gypsy caravan with artists Robert Burns and William Stewart MacGeorge. On this trip he met fellow Dunfermline boy, the steel tycoon and philanthropist Andrew Carnegie from Skibo Castle. Carnegie became a close friend and patron, and often visited Walls at his summer studio at Spinningdale overlooking the Dornoch Firth.

To fuel his passion for drawing exotic animals, Walls, along with Edinburgh lawyer and keen naturalist Thomas Gillespie, decided to build a zoo. Walls was one of the original founders of the Royal Zoological Society of Scotland in 1909. Inspired by the open enclosures of Hamburg Zoo, Walls designed Scotland's first zoo with the help of Patrick Geddes, and with support from the City Corporation. Edinburgh Zoo was built upon the estate of Corstorphine Hill House and opened to the public in 1913. Walls moved to Kaimes Road in 1914, where the back windows of his house overlooked the zoo grounds, Corstorphine Hill and across to the Pentland Hills.

William Walls also taught at the newly established Edinburgh College of Art. Set up by the Council through the Scottish Education Department in 1908 as a central institution for art education, the College opened its doors on the site of the old Cattle Market on Lauriston Place in 1909. In a purpose-built animal studio, Walls often borrowed animals from the zoo for his animal-life classes. After almost twenty years, he retired from teaching in 1933 and spent most of his time painting his noisy neighbours. The large paintings of his beloved animals once covered the walls of the grand staircase of the zoo's Mansion House.

Walls was prolific. His animal subjects ranged from domestic pets to a menagerie of wild animals, but it is his large oils and watercolours of big cats in their dens that are his most ambitious. Here a leopardess cavorts with her cubs, brought to life with realistic movement and a confidence in colour that he shared with his brother-in-law, the artist Charles Hodge Mackie. This painting is a reminder of the legacy of one of Edinburgh's most respected artists, who, through his love of animals, helped to establish the city's zoo.

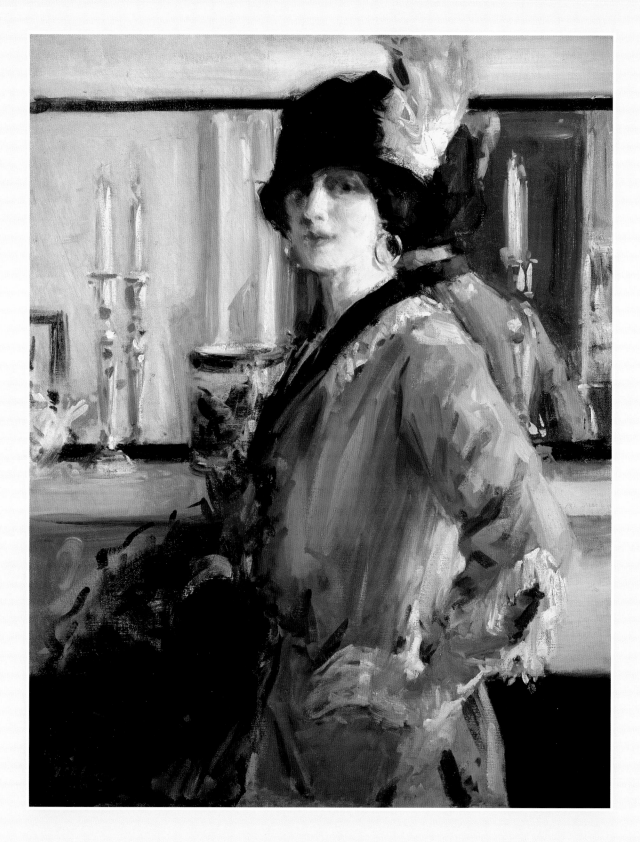

Oil on canvas, 107.0 × 84.5cm

1914

Presented by the Scottish Modern Arts Association, 1964

Edinburgh from the Castle
SIR JOHN LAVERY (1856–1941)

WITH HUES OF BLUE AND GREY, the haar floods over the Old Town as figures parade the esplanade below. From the ramparts of Edinburgh Castle, this romantic view was painted by Official War Artist John Lavery in 1917.

As London's leading society portraitist, John Lavery was assigned to the Royal Navy to paint the war effort at home. Based in Edinburgh, his visits to Leith, Rosyth Naval Base, North Queensferry Air Station, Granton Harbour and East Fortune Air Base were captured in a series of sweeping oil paintings. Along with many studies of the fleet on the Forth and the Forth Rail Bridge, Lavery painted the surrender of the German fleet at Rosyth in 1918. Returning to London, Lavery was knighted for his artistic efforts.

Indebted to his friend James McNeill Whistler, Lavery specialised in contemporary scenes and elegant portraits. Through the doors of his busy London studio, he welcomed a stream of eminent society figures. His many official portraits caught the likenesses of politicians, aristocracy, artists, royalty and stars of entertainment. He painted Anna Pavlova, Sir J.M. Barrie and, in 1913, King George V with his family at Buckingham Palace. However, none of his official portraits compared to his beautiful and elegant paintings of his wife, Hazel. Lavery travelled widely to France, Italy and North America, but his favourite spot was painting in his studio at Tangier in Morocco. In 1910 his achievement was celebrated at a one-man exhibition at the Venice Biennale, exhibiting his portraits, landscapes and contemporary scenes.

Orphaned as a child in Belfast, Lavery was sent to live in Glasgow and first gained work as an apprenticed photographer. Hailed as one of the Glasgow Boys, he fled to the ateliers of Paris and soon found himself one of the many artists attracted to the artistic commune of the nearby village of Grez-sur-Loing. There, he immersed himself in the idyllic surroundings and fell under the spell of the realist paintings of Jules Bastien-Lepage. Returning to Glasgow in 1885, infused with the radical spirit of French naturalism, he shot to fame with depictions of the wealthy inhabitants of Helensburgh, celebrated by his masterpiece, *The Tennis Party*, of 1886. In 1890, Lavery painted the *State Visit of Queen Victoria at the Glasgow Exhibition* of 1888. Working on the canvas for over two years, Lavery faithfully recreated over 200 portraits. It was this monumental painting that launched his career as a portraitist. Despite his move south to London, Lavery always remained a member of the Glasgow Art Club.

With the advance of the Second World War, Lavery returned to Kilkenny in Ireland, where he died at Rossenarra House in 1941.

Oil on panel, 35.5 × 24.1cm
Presented by the Edinburgh and District Water Trust

17 Heriot Row

ROBERT HOPE (1869–1936)

GLIMPSED THROUGH QUEEN STREET GARDENS, the stunning townhouse of No. 17 Heriot Row was home to the celebrated lighthouse engineer Thomas Stevenson. A haven of imagination for his only child, who loved to listen to his nannie's stories and daydream while staring at an old cabinet built by Deacon Brodie, this was the childhood home of the writer Robert Louis Stevenson.

A sickly child, Stevenson daydreamed at classes at Edinburgh Academy and Robert Thomson's Private School in Frederick Street. Following the family tradition, he studied engineering at Edinburgh University, but to the disappointment of his father he diverted to law with the intention of becoming a writer. When Stevenson qualified for the bar in 1875, his father added a brass plate to the house, 'R. L. Stevenson, Advocate'. The base for his many travels abroad, the house was Stevenson's home until he left Scotland. Painted by Edinburgh-born artist Robert Hope, this was originally owned by Stevenson's close friend, Lord Guthrie. Robert Hope painted all of Stevenson's residences, including 8 Howard Place and Swanston Cottage. It was behind the doors of 17 Heriot Row that Lord Guthrie was introduced to Stevenson's new American wife, Fanny Van de Grift Osbourne, at a dinner party in 1881. Hanging out with the Glasgow Boys, Stevenson fell in love at first sight with the dark-haired beauty while he was staying in the Hôtel Chevillon in the artistic village of Grez-sur-Loing near Paris in 1876.

Hope studied in Edinburgh and Paris. He specialised in portraits and landscapes and often ventured to paint the scenery of East Lothian. He was also a book illustrator and muralist, and decorated the apse vault of *Christ in Glory* at St Cuthbert's Church on Lothian Road. In 1910 he became President of the Society of Scottish Artists.

After years of travel, Stevenson finally found his haven on the island of Samoa in the South Pacific Ocean. Writing in the villa of Vailima, 'Tusitala' (the teller of tales) often recalled his childhood in this New Town house. Although once the haunt of lawyers, Heriot Row will be forever associated with Robert Louis Stevenson, who peered from its windows as a child.

> For we are very lucky, with a lamp before the door,
> And Leerie stops to light it as he lights so many more;
> And O! Before you hurry by with ladder and with light;
> O Leerie, see a little child and nod to him to-night!
> ROBERT LOUIS STEVENSON,
> *A Child's Garden of Verses and Underwoods*, 1906

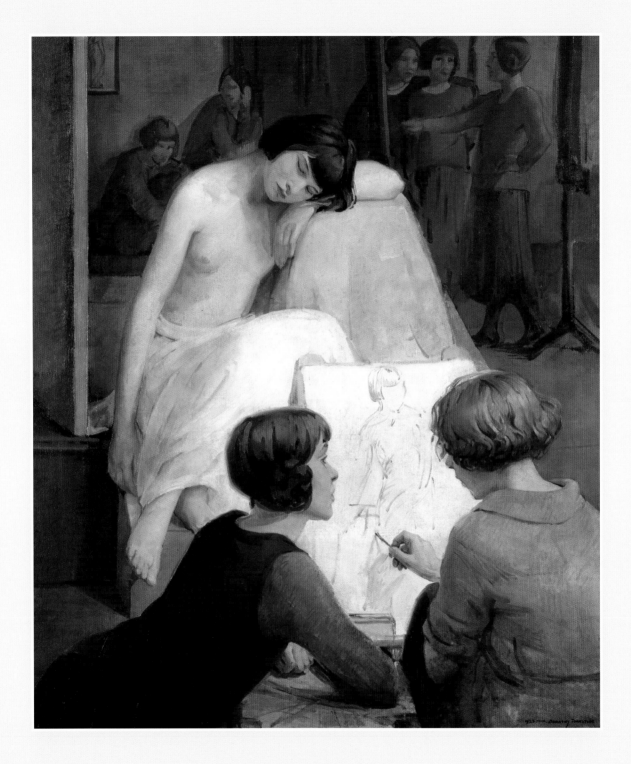

Oil on canvas 121.5 × 106.2cm
1923
Purchased from the artist (Jean F. Watson Bequest Fund
and government grant-in-aid), 1980

Rest Time in the Life Class

DOROTHY JOHNSTONE (1892–1980)

As A CHILD, Dorothy Johnstone grew up on Napier Road in Merchiston in the south side of Edinburgh in the shadow of the Gothic mansion Rockville House. Here the landscape artist George Whitton Johnstone encouraged the artistic talents of his beautiful daughter. With his early death in 1901, he did not live to see her enrol at Edinburgh College of Art, aged sixteen. In Ernest Lumsden's Life Class, her skilled draughtsmanship revealed her talents at informal portraiture, the genre for which she would become best known. In 1913, she exhibited the splendid *Marguerites,* a lively study of her nine-year-old sister, Rona, daydreaming on a chaise longue at the Royal Scottish Academy. As a portraitist, Johnstone's most sensitive work would be of her friends, family and children.

By 1914 Johnstone was teaching at Edinburgh College of Art. Painted at the height of her career and exhibited at the Royal Scottish Academy in 1923, this painting allows us a rare glimpse into her Life Class. As she advises in the background, we are drawn to her students, Kay Price and Belle Kilgour, sketching the model Poppy Lowe. With her signature flat brushwork, relaxed style and contrasting colour, this painting reveals Johnstone's talents as one of the leading figures of the Edinburgh Group.

The Group was a collective of progressive artists associated with Edinburgh College of Art. Dorothy Johnstone was a member, along with her close friends Cecile Walton and Mary Newberry. Re-formed after the war, the Group also included other prominent members such as Eric Robertson, Alick Sturrock and John Spence Smith. In 1924, in the same year that Johnstone and Walton staged a successful joint exhibition, Johnstone married her colleague and fellow group member David Macbeth Sutherland.

As a consequence of walking down the aisle, Johnstone, a respected and influential mentor, was forced to relinquish her teaching post and leave her students. With her husband's appointment as Head of Gray's School of Art in 1933, the Sutherlands left Edinburgh for Aberdeen. Johnstone kept ties to her hometown by continuing to exhibit her portraits and landscapes at the Royal Scottish Academy, for which she was finally elected an Associate in 1962. Johnstone's unique contribution to Scottish art is revealed in this intriguing self-portrait, a poignant memory of her teaching days at Edinburgh College of Art.

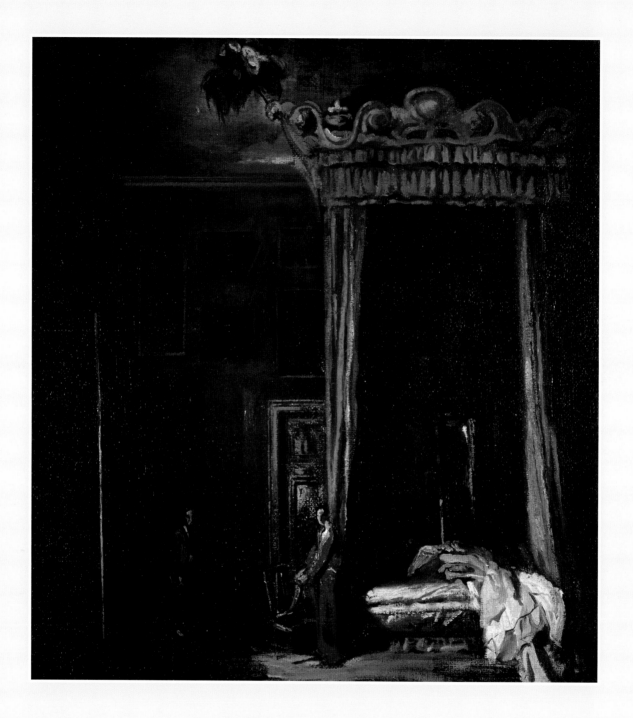

Oil on canvas, 68.0 × 62.9cm
Presented by the Scottish Modern Arts Association, 1964

The Red Bed

JAMES FERRIER PRYDE (1866–1941)

THE RED BED BELONGS TO A SERIES OF GOTHIC BEDCHAMBERS titled *The Human Comedy* by James Ferrier Pryde. Typical of these mysterious works, faceless characters linger in historic rooms dwarfed by a monumental four poster. Inspired by the lighting, drapery and dimension of the stage, this is a memory of Mary, Queen of Scots' bed chamber at the Palace of Holyroodhouse.

Pryde grew up in a townhouse at 10 Fettes Row in the New Town. His father, Dr David Pryde, an expert in Edinburgh history and lecturer in English literature, was Headmaster of Edinburgh Ladies College on Queen Street. The great nephew of Robert Scott Lauder, Pryde inherited an artistic legacy stretching back to Alexander Nasmyth through the Rev. John Thomson. As a student at the Royal Scottish Academy Life School, Pryde worked from a studio at Edinburgh's West End.

Pryde was deeply influenced by the dark side of Edinburgh's history. From the closes and tenements of the Old Town, he loved to sketch the dubious characters associated with the *Penny Gaff's*, the show booths on the Mound. Recalling his youth, he noted: 'I was very much impressed with the spirit of Holyrood, the Castle and the old houses and closes of the High Street. The spirit of them appears to have affected my later work.'

Although most of Pryde's professional life was based in London, echoes of his hometown were to remain on the canvas and in his imagination. They appear in his architectural imaginary visions, where looming buildings and elongated ruins overshadow their dubious figures. Within the muted colours and unsettling shadows can be found the columns and statues of the New Town juxtaposed with the strings of washing of the Old. A memory of the British Linen Bank on St Andrew Square appears ruined in Pryde's *The Shell*, c. 1908. Pryde's sister, Mabel, was also a talented artist; she eloped with a fellow student, the artist William Nicholson, while at the Herkomer Art School in Herfordshire. Collaborating under the pseudonym 'Beggarstaffs' between 1894 and 1899, Pryde and Nicholson designed a series of bold and modern advertising posters. In them they combined collage and silhouette to create some of the most innovative poster designs of the nineteenth century.

Pryde's obsession with the bed continued throughout his career. In 1930, he designed a giant four poster for the stage set of *Othello* at the Savoy Theatre in London. Ruined by years of poor health, Pryde languished on his thirteenth bed painting, *The Death of the Great Bed*, for over a decade. It remained unfinished on the death of this great British artist in 1941.

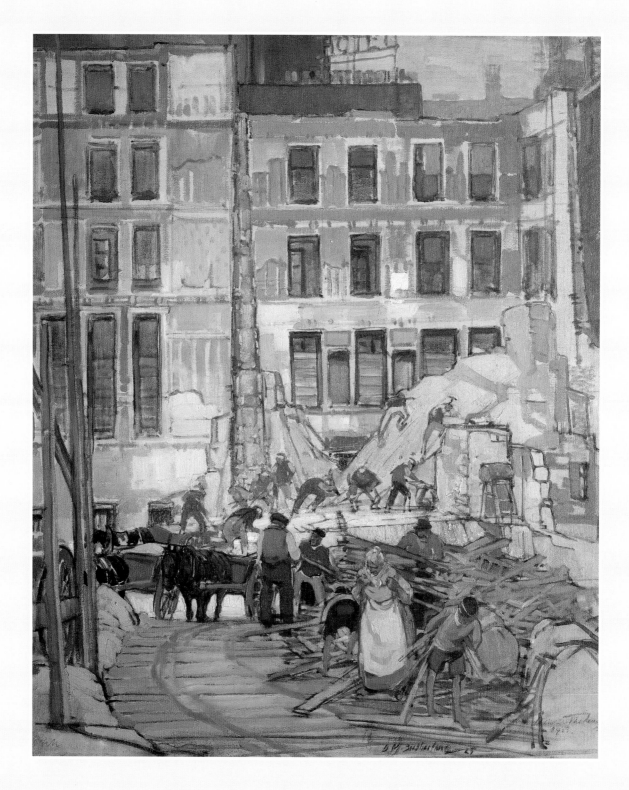

Oil on canvas, 81.3 × 66.3cm

1925

Purchased from the Fine Art Society, Edinburgh, 1982

The Demolition of the Crown Hotel, Edinburgh

DAVID MACBETH SUTHERLAND (1883–1973)

THIS VIEW OF THE RUINS OF THE CROWN HOTEL ON PRINCES STREET, demolished for the grand building of Woolworth & Co., was painted by Dorothy Johnstone's husband, David Macbeth Sutherland. A team of workers clear the rubble as an elderly lady and some boys help with the effort. With lightened palette and accents of broken colour, this is another painted gem from the Edinburgh Group.

Sutherland became an influential landscapist known for his Scottish coastal views and contemporary scenes. Escaping the boredom of the law office in Wick, Sutherland moved to the big city to make it as an artist. While attending evening classes at Heriot Watt College, he worked for a lithographic firm before enrolling at the Royal Institution School of Art and the Royal Scottish Academy Life Class. Here he was inspired by the teaching and experimental use of colour of tutor Charles Hodge Mackie. In 1911 the Royal Scottish Academy Carnegie Travelling Scholarship sent him to France, Spain and the Netherlands. A year later, he joined with Alick Sturrock, John Spence Smith, William Mervyn Glass, Eric Robertson, W.O. Hutchison and later A.B. Thomson to form the Edinburgh Group of young Scottish artists, sharing a studio at 21 Picardy Place. Awarded the Military Cross with the 16th Royal Scots during the First World War, Sutherland returned to reinvigorate the teaching at Edinburgh College of Art. Experimenting with the use of broken colour, he greatly influenced his students William Gillies and William MacTaggart. Sutherland left his home in Joppa to take up the Directorship of Gray's School of Art in Aberdeen in 1933. During the Second World War, he was appointed Official War Artist recording Newfoundland lumberjacks on Deeside. As Inspector of Art in the Highland Division, he continued to capture the landscapes of the north-west coast, Caithness, Wester Ross, Aberdeenshire and Plockton.

Gifted to the city by Mrs Dorothy Sutherland, this work was painted after recent travels to Brittany. Spending the summers of 1922 and 1923 in Concarneau, Sutherland painted a series of Breton scenes capturing the coast, ports, Celtic customs, glittering seas and evening *fest-noz* dances. Infused with Breton light and colour, this is one of Sutherland's most striking Edinburgh works.

'D.M.' was fondly remembered by his fellow student and colleague Adam Bruce Thomson in 1974:

> He was well acquainted with, and indeed had a
> lively interest in the changes manifested in painting.
> While appreciative of much, he was the last person
> to be diverted from his course by passing trends.

Oil on canvas, 71.1 × 92.0cm
1925
Presented by the Scottish Modern Arts Association, 1964

Maule's Corner after Rain

ROBERT EASTON STUART (1890–1940)

ROBERT MAULE & SON
WEST END EMPORIUM, EDINBURGH

ON A 'DREICH' EDINBURGH DAY, dressed in her coat and cloche hat, a woman escapes from the rain towards the gates of the Caledonian Station. This nostalgic view of Edinburgh's West End from the little-known Edinburgh artist Robert Easton Stuart stretches out across Shandwick Place over to St George's Church in Charlotte Square. Caught after a downpour, shoppers cross the glistening road as crowds wonder at the window displays of the magnificent department store, Maule's Emporium.

Robert Maule & Son was one of Edinburgh's best-loved department stores. To rival the grandeur of Jenners at the East End of Princes Street, the elaborate interiors boasted the finest tearooms and first-class departments ranging from chinaware, fashions and haberdashery to furniture; the store even had an electric lift. Maule's famous sales caused riots as the crowds swept through the floors in search of bargains galore. Previously the Osborne Hotel, then the Scottish Liberal Club, the store first opened in the 1900s. Famed for its ever-changing window displays, this prominent landmark of the West End later became Binns & Son in 1931 and was eventually taken over by House of Fraser in 1953.

Even before the addition of its famous clock in 1960, Maule's department store has always been known as one of Edinburgh's favourite meeting places.

> Let us suggest to STRANGERS and REMIND
> old visiting friends that the simplest and
> safest RENDEZVOUS, easy to say and IMPOS-
> SIBLE to forget, is . . . MEET ME AT MAULE'S

Pencil on paper, 27.7 × 40.0cm
1926
Purchased from Garton and Cooke (Jean F. Watson Bequest Fund
and with grant aid from the National Fund for Acquisitions), 1998

Edinburgh Castle in Snow
ERNEST LUMSDEN (1883–1948)

EDINBURGH WAS HOME to Ernest Lumsden, one of the leading printmakers of his generation. Born in London, Lumdsen studied at Reading School of Art before enrolling at the Académie Julian in Paris in 1903. A brilliant printmaker and another master of the Etching Revival, Lumsden was asked by Morley Fletcher, Director of Edinburgh College of Art, to teach at the newly opened Edinburgh College of Art in 1908. Documenting his worldwide travels through his Whistler-inspired topographical views, he was known for his views of the Orient and India, especially the Holy City of Benares. In 1910, Lumsden stopped off in Canada in pursuit of his great love, a young art teacher, Mabel Alington Royds. From here, he embarked on his first world tour, crossing the Pacific to Asia before returning to Edinburgh via the Trans-Siberian Railway. On the success of his souvenir prints, Lumsden resigned his post at Edinburgh College of Art and embarked on epic artistic adventures to Southern Asia, Burma and India in 1912. After serving with the Indian Army in 1917, Lumsden returned to Edinburgh in 1919 to resume his successful artistic career, before the market for etchings plummeted in the 1930s. With more than 300 plates, his prints included many fine studies of Edinburgh, from detailed views of industrial Leith and Canongate tenements to the Dean Village and the Forth Rail Bridge.

Despite hard times, Lumsden was dedicated to the promotion of arts and printmaking in Edinburgh. He preserved Scotland's heritage for printmaking through his Presidency of the Society of Artist Printmakers. As well as discovering the lost etchings of John Clerk of Eldin, in 1925 he published the influential book *The Art of Etching*. Organising his own Society of Eight, Lumsden exhibited portraits and landscapes alongside James Cowie, Josephine Miller, Mabel Royds, Fabian Ware and William Wilson.

This delicate drawing of the Castle caught in the winter of 1926 is one of a number of pencil drawings held by the City Collection to illustrate James Bone's book *The Perambulator in Edinburgh*. Through a series of accomplished and atmospheric studies, Lumsden's tour of the Old and New Towns provides a sensitive and detailed portrait of his adopted city during the 1920s.

> Stranger still in the white haar that steals up in wispy
> battalions from the North Sea, lingering about the closes,
> and dissolving the stories one after another into thin white
> air, in which even the Castle becomes a phantom.
> JAMES BONE, *The Perambulator in Edinburgh*, 1926

Oil on panel, 55.2 × 46.3cm

1929

Presented by the Scottish Modern Arts Association, 1964

View from the Mound, Edinburgh, Looking West

WILLIAM CROZIER (1893–1930)

BELOW THE FREE CHURCH COLLEGE, on a cold winter's day, a couple climb the winding Mound Place towards Ramsay Gardens and Edinburgh Castle. In subdued colour and catching the distinct fall of the Edinburgh light, this is a delightful view by the uniquely talented William Crozier.

William grew up in Oxford Street in Newington, the son of William Crozier, a printing press reader for publishers Thomas Nelson & Son. A haemophiliac, Crozier constantly struggled with his restrictive condition but always found refuge in his art. Giving up an apprenticeship at the North British Rubber Company, he enrolled at Edinburgh College of Art in 1916. His fellow students included Anne Redpath, William Gillies and William Geissler. At night classes, he was taught to etch by Adam Bruce Thomson, who always held a great affection for the artist. Awarded the Carnegie Travelling Prize from the Royal Scottish Academy in 1922, Crozier set off for Paris with his close friend William Gillies to study with the cubist painter André Lhote. Paris was followed by further travel in the sunlight and shadowed landscapes of Italy and the Netherlands.

Returning to Edinburgh, in his New Town studio at 45 Frederick Street, which he shared with fellow artist Sir William McTaggart, Crozier painted ambitious landscapes of Edinburgh derived from his experiences abroad. He created a series of etchings and paintings of Edinburgh influenced by Lhote's cubist geometrical approach that captured the mood of the landscape and displayed Crozier's signature bold design, painterly approach and sensitivity to light and shadows. Crozier's studies of Edinburgh from the late 1920s sealed his reputation as one of the leading figures of the Edinburgh School. The artists of the Edinburgh School of Painting were all associated with Edinburgh College of Art before and after the First World War. Although their styles and subjects varied, their works were connected through energetic brushwork, punchy colour and the influence of travels abroad, particularly in France and Italy.

Purchased from the Royal Scottish Academy exhibition in 1929 by the Scottish Modern Arts Association, this is considered one of the finest Edinburgh paintings. Following his election as an Associate of the Royal Scottish Academy in 1930, Crozier tragically died after a fall in his studio. One of his final works of art, this painting reflects his deep affection for his home city.

Oil on canvas, 86.5 × 101.6cm
Presented by Mrs Margaret Hunter,
daughter of the artist, 1980

Pachmann at the Usher Hall, Edinburgh

SIR STANLEY CURSITER (1887–1976)

WITHIN THE SPECTACULAR SURROUNDINGS OF THE USHER HALL, take a seat and listen to the extraordinary performance of Chopin from the great Vladimir von Pachmann. On one of his many European tours, the eccentric virtuoso pianist entertains the crowds in Edinburgh's famous concert hall. Flamboyant as ever, Pachmann addresses and taunts his captivated audience. From high up in the gods, Pachmann's commanding presence is celebrated in this painting by Stanley Cursiter.

The Usher Hall was built from funds donated by the Edinburgh whisky distiller Andrew Usher. The owner of the Edinburgh Distillery and a founder of the North British Distillery Company, in 1896 he gifted £100,000 for the provision of a world-class concert venue for the people of Edinburgh. From their headquarters at the Peartree House in West Nicholson Street, Andrew Usher & Co. perfected the first commercial blend and exported 'Old Vatted Glenlivet' across the world. Unfortunately Andrew Usher died before the completion of his generous gift. At the official opening on 6 March 1914, his widow Marion Blackwood Usher and Lord Provost Robert Kirk Inches unveiled the Andrew Usher memorial designed by the sculptor Henry Gamley.

Also a lover of music, Stanley Cursiter, Queen's Painter and Limner in Scotland, was one of Edinburgh's most influential artists. Moving from his beloved Orkney, Cursiter trained as a lithographer in the city before enrolling at Edinburgh College of Art. A dynamic artist and designer, his subjects ranged from portraiture and still life to salon interiors and windswept Orcadian landscapes. He was also a writer and curator, and was a noted campaigner of the arts in Edinburgh. Astonished by the first Futurist Exhibition in London in 1912, Cursiter experimented with Futurism in a series of dynamic views of the city. It was also Cursiter who brought to the Scottish Society of Artists, a year later, the first Post-Impressionist exhibition, including works by Gauguin, Cézanne and Matisse. He organised popular one-man shows on John Duncan and F.C.B. Cadell, but his lasting legacy, as the Director of the National Galleries of Scotland, was his lengthy campaign for the foundation of a gallery of modern art for Scotland. He was determined to establish an accessible and creative centre that would showcase Scottish design. His efforts eventually led to the establishment of the Gallery of Modern Art in 1960. Now housed in the Orphan Hospital and John Watson's Hospital, the Scottish National Gallery of Modern Art dominates the Dean.

Cursiter often enjoyed concerts at the Usher Hall accompanied by his wife Phylis Hourston, a violinist from Kirkwall. They also held soirées in their home in Royal Circus in the New Town. In this painting, now displayed within its original setting, in muted colours and thick dashes of paint, Cursiter has preserved Vladimir's performance to a captive audience.

Etching on paper, 32.0 × 21.8cm
Presented by Mrs Craig, 1957

Inner Shrine,
Scottish National War Memorial

ROBERT SMITH FORREST (1871–1943)

ST MICHAEL SOARS TO THE HEAVENS in this fine etching of the Inner Shrine of the Scottish National War Memorial, which lies within the protective walls of Edinburgh Castle. The collaborative effort of hundreds of Scottish artists and craftsmen, this masterpiece of art and architecture remains one of the most ambitious and important public artworks in Scotland.

Spearheaded by John Stewart-Murray, 8th Duke of Atholl, the Scottish National War Memorial was built upon the summit of the Castle Rock to remember the brave Scots lost in the First World War. Converted from an old barrack block and opened in 1927, it was designed by Edinburgh's eminent architect, Sir Robert Lorimer, as one of Britain's finest memorials to the Great War. Lorimer commissioned a team of more than 200 Scottish artists and craftsmen, who successfully fused architecture, sculpture and stained glass in a unified artistic expression of grief. Within the Hall of Honour, the Rolls list the names of those who perished in the First and Second World Wars, as well as more recent conflicts.

Glimpsed through Thomas Hadden's iron gates, the Gothic majesty of the Inner Shrine reveals its artistic treasures. The steel Casket of Honour, sculpted by Alice Meredith Williams, protects the 150,000 names of the lost. Guardian angels and the figures of St Andrew and St Margaret of Scotland protect the precious contents. The light of hope streaming through Douglas Strachan's magnificent stained-glass windows falls upon the carved bronze walls by Alice and Morris Meredith Williams. Based on Morris Meredith Williams' drawings from serving on the front in the First World War, this exquisite frieze is a highly detailed procession, recording different regiments, units, equipment and artillery. Carved with the profiles of servicemen and women, it is a highly personal tribute from a fellow soldier. Carved in oak by the Clough Brothers, the Archangel St Michael hovers above the Casket of Honour, heralding man's triumph over the atrocities of war and proclaiming the enduring survival of the human spirit.

In this etching the sanctity of the Inner Shrine has been caught by fellow artist Robert Smith Forrest, printmaker and studio photographer who lived at Raeburn House at 32 York Place. The gift of Sir Robert Lorimer to the nation, the Scottish National War Memorial remains a place of peace and reverence, a royal setting for some of the most moving examples of Scottish sculpture and stained glass to date from the late 1920s.

Colour woodcut on paper, 27.0 × 19.5cm
1920s
Purchased from the Open Eye Gallery (Jean F. Watson Bequest Fund
and with grant aid from the National Fund for Acquisitions), 1998

Edinburgh Castle

MABEL ALINGTON ROYDS (1874–1941)

IN ONE OF THE EVOCATIVE WOODCUTS by Mabel Alington Royds, girls wander along Johnstone Terrace below the cliff face of the Castle Rock. With its simplified design and colour contrasts, this impression of Edinburgh Castle was created by one of Edinburgh's great printmakers.

Born in Bedfordshire, the daughter of the Rev. Nathaniel Royds, Mabel Royds studied at London's Slade School of Art and the Parisian studio of Walter Sickert. A promising printmaker and teacher, she gained a teaching post at Havergal College for Girls in Toronto, far from home. It was here she was pursued by a love-struck artist from Edinburgh, Ernest Lumsden, during his first world tour. Lured back to Edinburgh, Royds began teaching with Lumsden at Edinburgh College of Art in 1911. Declaring their vows at Old St Paul's Church in 1913, they spent their honeymoon travelling across Europe to the Middle East and India. At the outbreak of war, Lumsden was rejected by the British army on medical grounds and the Lumsdens travelled to India in the hope of serving with the Indian army, with their less stringent medical rules. Rejected again, the Lumsdens ventured across the Himalayas, visiting the monasteries of Tibet. When Lumsden was finally accepted by the Indian Army Reserve Officers in 1917, Mabel left her husband in war service and returned to Edinburgh pregnant with their daughter Marjorie. Marjorie saw her father for the first time when he returned home in 1919.

Instrumental in introducing the art of Japanese woodblock printing from Paris, Royds was influenced by the Director of Edinburgh College of Art, Frank Morley Fletcher, who published his influential book *Wood-Block Printing* in 1916. Royd's prints of the 1920s record her travels to India and Tibet, followed by decorative, religious and floral studies of the 1930s. During periods of financial struggle, Royds was well known for using chopping boards from Woolworths instead of expensive woodblocks. Her most striking designs are of her young daughter Marjorie.

Pen and ink on paper, 28.1 × 36.9cm

1934

Presented by the Scottish Modern Arts Association, 1964

Edinburgh from Princes Street Gardens Looking North East Towards the Mound

WILLIAM WILSON (1905–1972)

IN THIS WINTER VIEW FROM THE GARDENS, the winding path leads us over the Mound, across to the Scott Monument and Balmoral Hotel, and on to the monuments of the Calton Hill. William Henry Playfair's neo-classical temples, the Royal Scottish Academy and the National Galleries of Scotland, take centre stage. This splendid Edinburgh view was drawn by the expressive hand of William Wilson, one of twentieth-century Scotland's finest landscapists and printmakers.

From Boroughmuir High School, Wilson attended evening classes at Edinburgh College of Art while apprenticed to the stained-glass company James Ballantine & Son. He was taught composition and etching by Adam Bruce Thomson, who encouraged his pupil to carry on the tradition of capturing the essence and mood of the landscape. Displaying his distinct and cursive style, this is one of a number of line drawings of Edinburgh that Wilson created in 1934, before he left full-time study and departed Edinburgh for travels to Spain and southern France. Wilson's powerful etchings of Scottish towns, harbours and the Highlands of the 1930s would establish his reputation as a formidable printmaker. Following his travels, Wilson went on to study engraving at the Royal College of Art and stained glass in Germany.

Leaving printmaking behind, Wilson returned to Edinburgh in 1937 to set up his stained-glass studio on Frederick Street. Inspired by the colours of Douglas Strachan's stained-glass designs at the Edinburgh War Memorial, Wilson became Scotland's leading contemporary stained-glass artist. Along with commissions for Canterbury and Brechin Cathedrals, he created more than 300 designs for stained-glass windows across Britain. Fusing his flair for contemporary design and his knowledge of traditional methods, Wilson pushed the medium to create highly innovative works. His contemporary visions glisten in his hometown, from the Caledonian Insurance Company on St Andrew Square to his staring figures at Morningside Parish Church. At one time art master at Fettes College, Wilson later worked in the studio of sculptor Phyllis Bone at Belford Mews. Awarded an OBE for services to the arts in 1961, his career was sadly cut short by failing eyesight. His very last window, created in 1965, was the impressive figure of St Columba that still protects the Abbey of Iona.

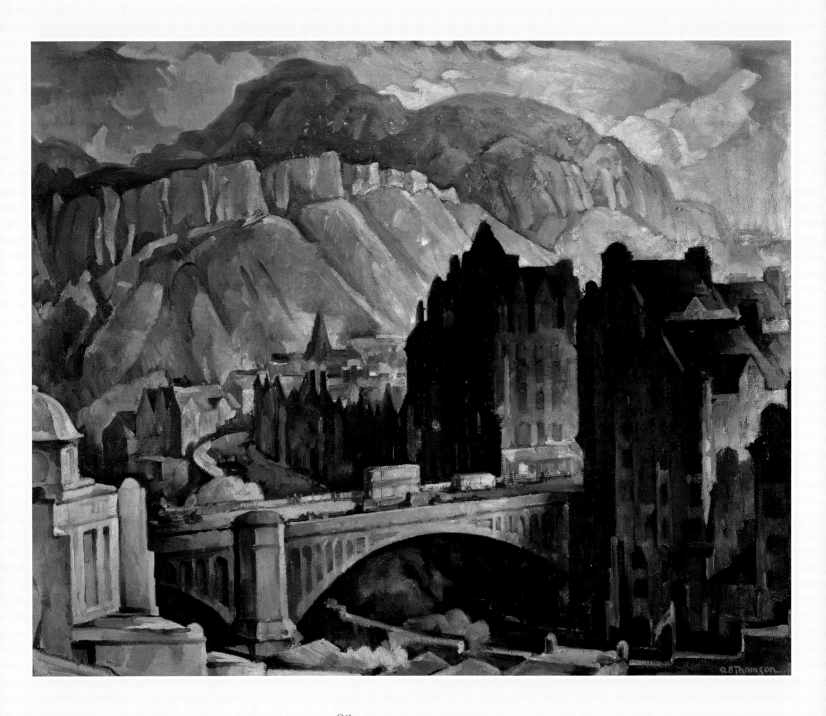

Oil on canvas, 109.2 × 137.1cm

1930s

Presented by the Scottish Society of Artists, 1935

North Bridge and Salisbury Crags, Edinburgh, from the North West

ADAM BRUCE THOMSON (1885–1976)

To PROMOTE THE CITY and to encourage a younger generation of artists, this iconic view of Arthur's Seat was presented by the Society of Scottish Artists to the City Council in 1935. One of his favourite views, it was painted by the gifted and influential landscapist Adam Bruce Thomson.

Edinburgh's geological and architectural splendour is conveyed in this stunning study of the city, brilliant in composition, with flattened surface and muted colours, the light rippling against the buildings. This is one of a series of ambitious paintings and etchings of Edinburgh that Thomson completed during the 1930s.

Born in Edinburgh, Adam Bruce Thomson enjoyed a long and prolific career. A respected tutor at Edinburgh College of Art, he influenced future generations of the Edinburgh School and championed the arts in the city. Growing up in Edinburgh, he was encouraged to become an artist through many trips to the city's galleries and museums. A pupil of William Walls, he was one of the first students to enrol at Edinburgh College of Art, having attended the last classes of the Life School of the Royal Scottish Academy. Thomson graduated with diplomas in Painting and Drawing and Architecture, as is apparent in his work. Following an architectural scholarship to Oxford, Cambridge and London, in 1909 he set off on travels to France, Spain and the Netherlands. After serving in the First World War, Thomson returned as an influential teacher of drawing and composition, and exhibited with the Edinburgh Group. He also taught colour theory to architectural students and ran evening classes in etching. He was the much-loved mentor of William Gillies, William Wilson and William Crozier. After his retirement in 1950, he always kept close ties with the College as an examiner and a Trustee. He was Treasurer of the Royal Scottish Academy, President of the Royal Scottish Society of Painters in Watercolour and President of the Society of Scottish Artists. In recognition of his long contribution to the promotion of arts in Scotland, Thomson was awarded an OBE in 1963.

Thomson travelled throughout Scotland, celebrating its unique scenery, as revealed in his oils and fluid watercolours, but was most inspired working in his home town. He loved to walk on Arthur's Seat and sketch from the Blackford Hills, the Scott Monument, the Dean Bridge and the village of Colinton. Racing out to catch a storm, he enthusiastically studied the distinct light, seasons and colour of Edinburgh. Still painting aged ninety-one, Thomson's last work was titled *Rising Moon, Arthur's Seat*, which was awarded the prize for Exceptional Merit for its expert use of light at the Royal Scottish Academy. 'Adam B' loved Edinburgh, and it shows in this enduring and much-loved masterpiece.

Woven wool, silk and gold thread, 122.0 × 193.0cm

1938

Gift of the Chart family, 2009

The Edinburgh Tapestry

LOUISA MARY CHART (1880–1963)/
KATHERINE CHART (1913–97) / JOHN CHART (1911–96)

PRESENTING THE BEST OF SCOTTISH TALENT at the Exhibition of British and Overseas Needlework in London in 1939, *The Royal Burgh of Edinburgh* was created by John and Louisa Chart in their tapestry studio at 29 George Square.

The daughter of Edwin Chart, the Clerk of Works at Hampton Court, Louisa Chart was born at the palace and grew up within the royal surroundings. She went on to train at the Royal School of Needlework and taught at Kingston School of Art. In 1906, she was a founding member of the Embroiderers' Guild of Great Britain. Four years later she helped to set up an historical tapestry repair workshop in her father's house with the Scottish tapestry historian William George Thomson, author of the influential *History of Tapestry* (1906). In 1911 Thomson returned to Scotland to become the first Director of the Dovecot tapestry studio in Corstorphine. Louisa Chart followed in 1913, to teach in the Embroidery Department of Edinburgh College of Art. Moving into a Georgian townhouse at 29 George Square, she set up her own tapestry studio specialising in the restoration of historical tapestries and creating military, heraldic and ecclesiastical works. Together with her nephew, John – who lived at her house whilst studying at Edinburgh College of Art, and who fell in love with one of her embroiderers, Katherine Dow – she undertook many commissions for HM Office of Works, as well as banners for the Scottish National War Memorial. Along with the Speaker's Faldstool at the House of Commons, in 1929 they decorated a couch for the Queen for Holyrood Palace. Louisa Chart also supervised the restoration of tapestries at Holyrood House, including the precious Oxburgh Hall embroideries of Mary, Queen of Scots. Through her teaching and studio, Chart influenced generations of female weavers. She was committed to raising the standard of tapestry, establishing the Modern Embroiders' Society of Edinburgh and the Needlework Development Scheme in 1934, which amassed a significant collection of over 900 items.

A showpiece of needlework and celebration of our historic town, *The Edinburgh Tapestry* presents a textile tour of landmarks and prominent characters. We can spot the outlines of Edinburgh College of Art, Edinburgh Castle, George Street, the Usher Hall, Princes Street, Holyrood Palace and George Square. Along with a group of City Fathers, the tapestry includes the portraits of 'the Fower Maries' and John Knox preaching. Represented in the lower medallion, Louisa Chart works away alongside her most trusted weavers, her daughter-in-law Katherine Chart and Miss Wetherhead. With his spyglass, John Chart inspects the excellent needlecraft.

An important artwork in Scotland's textile history, the tapestry was gifted by the Chart family to the City Collection. As a campaigner for the preservation of George Square, Louisa Chart would be pleased her studio is now housed by the Celtic and Scottish Studies Department of the University of Edinburgh.

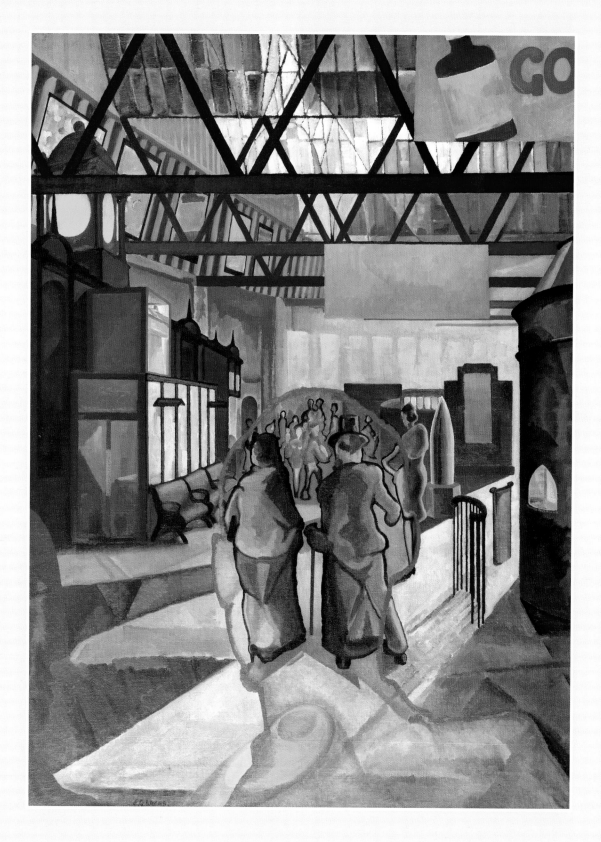

Oil on canvas, 99.0 × 73.7cm

1942

Presented by the artist, 1990

The Caley Station, 1942

EDWIN GEORGE LUCAS (1911–1990)

DURING RUSH HOUR, the crowds hurry past the circular ticket office of the Caley Station. Through the surreal frame of an artist's silhouette, step back in time to the grand Victorian interior of Princes Street Station.

After the original Princes Street Station burnt down on Lothian Road in 1890, in competition with Waverley Station, the Caledonian Railway Company built Scotland's largest railway station at the City's West End. Dominating the lower half of Lothian Road, built to the design of Peddie & Kinnear, the impressive building was built in distinctive red sandstone. The steam rose from its seven platforms, and the impressive interiors included opulent waiting rooms, shops and a refreshment bar. In 1903, the Caledonian Hotel was built next to the entrance. One of Scotland's grand Victorian railway hotels, it is still one of Edinburgh's prominent landmarks.

The Edinburgh artist Edwin Lucas knew this place well. It was the terminus for the line that ran through Juniper Green, where Edwin lived from 1917 to 1947. As he travelled to school and work, the view from his carriage window inspired many of his paintings. From the 1930s he began to paint watercolours of the Water of Leith valley, views of the Pentlands and the scenery around Juniper Green. Nephew of the Victorian artist Edward Handel Lucas, Edwin was a keen amateur painter. After education at George Heriot's School he worked for the Civil Service. On the outbreak of war, Lucas, a committed pacifist and conscientious objector, worked in hospitals for the duration of the war. In 1939, Lucas' visions changed when he began working in Wilhelmina Barns-Graham's former studio at 5 Alva Street. There surrealism made its mark and would remain an important part of his work. In the same year the 'New Era Group' held a surrealist exhibition at Gladstone's Land on the Royal Mile, including the work of William Gear. Innovative for the time, Lucas' experiments in surrealism represented some of the few encounters the movement had in Scottish art. With few opportunities to show his most innovative work, he received little attention from the arts establishment. He held two one-man shows at the New Gallery, Shandwick Place, in 1950 and 1951. His finest memory of Edinburgh, this painting was presented by the artist to the city in the year he died.

With the approach of nationalisation in 1945, the Caledonian Station was closed; it was demolished by 1970. Only the original concourse was left and incorporated into an elaborate art deco atrium. Afternoon tea and champagne cocktails are now served where passengers once queued for tickets. The original entrance to the hotel from the station is still emblazoned with the Caledonian Railway Company's heraldic logo, two unicorns rampant. Surviving the flames of a fire in 1890, the old Hamilton and Inches clock still ticks away five minutes ahead of schedule. Preserving its railway heritage, the hotel's 'Peacock Alley' survives as one of Edinburgh's most spectacular and luxurious interiors.

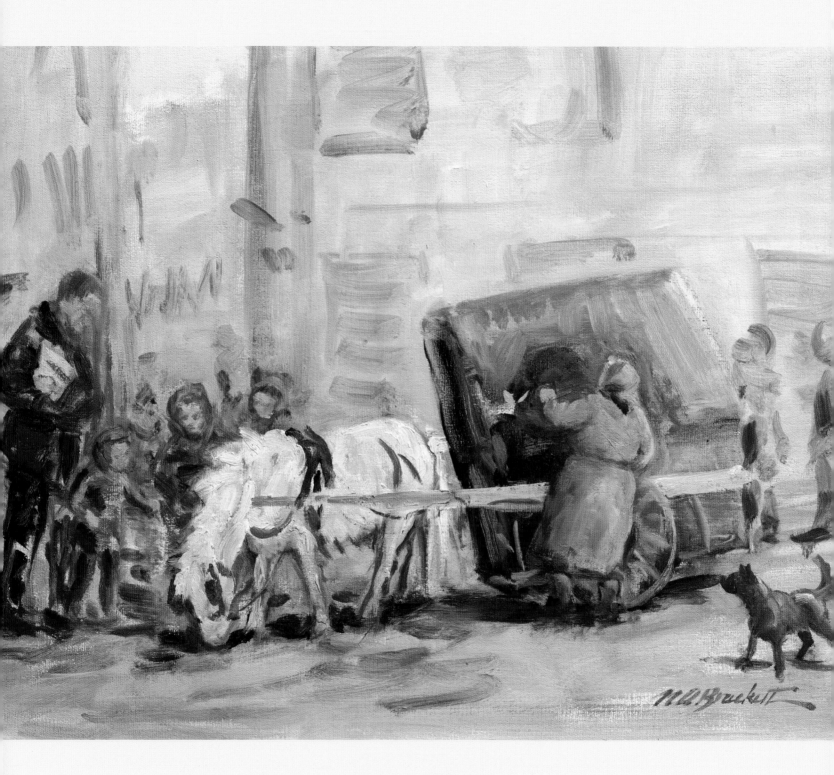

Oil on board, 35.6 × 45.7cm

1947–9
Presented by the artist to the Museum of Childhood

Mrs Dunlop and 'Smokey'

NANCY ALEXIS BRACKETT (1907–1984)

A LOVELY MEMORY FROM THE WEST END, this street scene shows Mrs Dunlop and her beloved pony Smokey entertaining the local kids. For more than thirty years, Mrs Dunlop filled the streets with Scottish airs from her old barrel organ. Smokey was a favourite subject of Edinburgh animal painter Nancy Brackett.

A student of William Walls at Edinburgh College of Art, Nancy developed a passion for painting horses that never diminished. With little interest in thoroughbreds, Nancy preferred instead to sketch the old nags of the gypsy camps in East Lothian, the ponies of the children's farm at Edinburgh Zoo, and the Clydesdales in the stables of the Edinburgh breweries. Her illustrations were included in *The Story of the Edinburgh Zoo* (1964).

Nancy was related to Robert Louis Stevenson through her mother, Johanna Jessie Dale, one of the Dale clan of farmers of East Lothian. Her father was Thomas Samuel Thomson, founder of the Edinburgh Stock Exchange, and her uncle was Patrick Thomson, owner of PT's, the famous department store on North Bridge. Nancy grew up in the family home of Gullane House at Gullane in East Lothian, where Robert Louis Stevenson would often come to read bedtime stories to Nancy's mother, Anna. Nancy's parents were Fellows and generous supporters of Edinburgh Zoo.

In 1932, Nancy married William Oliver Brackett, a pastor from Sherman, Texas. Moving to America, they settled at the First Presbyterian Church in Lake Forest, Illinois. After her husband's early death during the war, Nancy returned to Gullane with her three children. Moving to Great Stuart Street in the New Town, Nancy concentrated on her painting and work with the church; she was also active in the Society of Scottish Women Artists. Nancy was the first female elder of St Andrew's and St George's Parish Church on George Street, where she set up the first Christian Aid book sale in 1974. This annual sale of books, old prints and paintings continues to this day as Scotland's largest annual charity book fair.

Also an accomplished pianist, Nancy left this painting to the Museum of Childhood, where Mary Dunlop's mechanical piano is on permanent display. Together they are an enduring memory of one of Edinburgh's last and best-loved street performers.

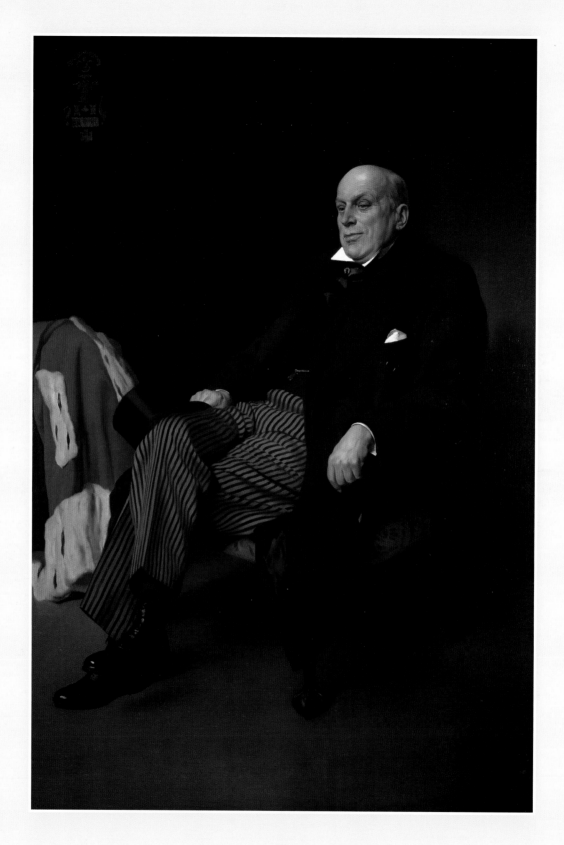

Oil on canvas, 198.2 × 137.2cm

c.1944

Commissioned from the artist

Sir William Young Darling

SIR HERBERT JAMES GUNN (1893–1964)

SIR HERBERT JAMES GUNN was the outstanding portraitist of his generation, as seen in this magnificent painting of Sir William Young Darling. Sombre and heavy, its visual impact rests on an earlier tradition of Edinburgh portraiture.

Growing up in Glasgow, the son of tailor Richard Gunn, the young artist escaped the chaos of his large family by sketching trips to the Kelvingrove Museum. Determined to be an artist, after a short stint at Glasgow School of Art he worked as a commercial artist designing lids for biscuit tins. He eventually joined Edinburgh College of Art in 1910, but following the tradition of the Glasgow School, he enrolled for lessons from the great academic history painter Jean Paul Laurens at the Académie Julian in Paris a year later. A gifted landscapist, in 1914 he was commissioned by the art dealer W.B. Paterson, the brother of artist James Paterson, to travel through Spain to North Africa. Paterson organised his first exhibition in Old Bond Street and T. & R. Annan & Sons in Glasgow. Gunn then turned to portraiture and gained attention with his first portrait of Edinburgh artist James Pryde, exhibited at the Royal Glasgow Institute in 1924. Bought by the Scottish Modern Arts Association, this fine portrait is now part of the City of Edinburgh's art collection.

In London, Gunn established himself as a leading society portrait painter, gaining an unrivalled reputation for a host of official portraits, from politicians and academics to writers and royalty. In 1938, he painted the Prime Minister, Neville Chamberlain, and in 1944 he travelled to France to paint Field Marshall Montgomery. This was followed by his portrait of King George VI in 1957. In the year of his appointment as President of the Royal Society of Portrait Painters, 1953, he was commissioned to paint the coronation portrait of Queen Elizabeth at Balmoral, which now hangs at Windsor Castle. Between 1923 and 1964, Gunn had 133 works hung at the Royal Academy, yet despite his prolific talent, he was only elected a member in 1961. This was followed by a knighthood in 1963.

Known for his realist, powerful portraits, Gunn's other notable works include *David Lindsay, 27th Earl of Crawford and Balcarres* (1939) and his *Conversation Piece (G. K. Chesterton, Maurice Baring, Hilaire Belloc)* (1932) at the National Portrait Gallery. Gunn was at his most elegant and informal painting the portraits of his second wife, the beautiful Pauline Miller. *Pauline in the Yellow Dress* was hailed as the *Mona Lisa* of 1944, followed by *Pauline in the McLeod Tartan* of 1946.

This portrait was exhibited to great acclaim at the Royal Academy in 1947. Sir William Young Darling, MP for Edinburgh South, was Lord Provost between 1941 and 1944. Here he is caught in deep contemplation by one of the most unique and modern of British painters.

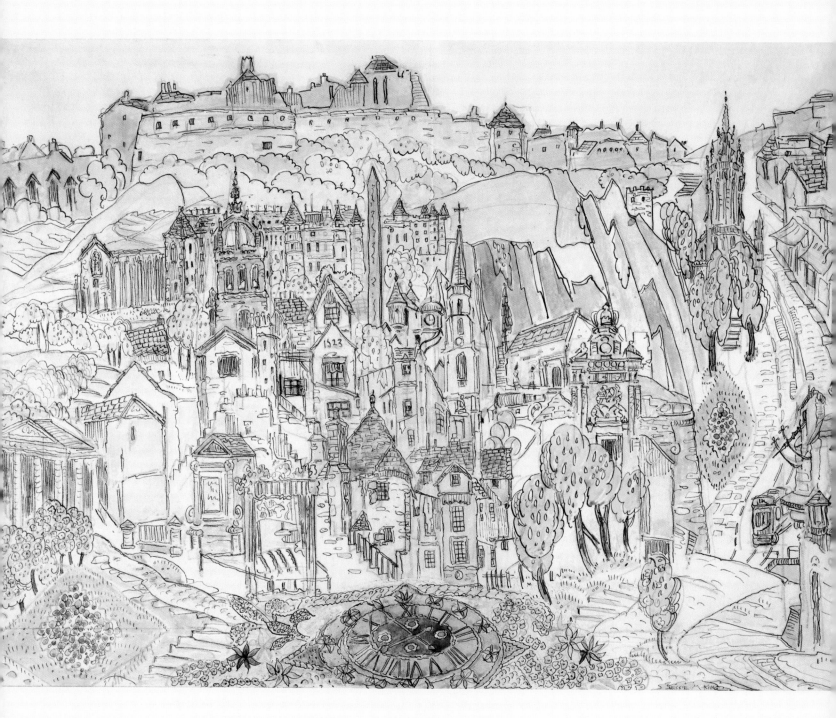

Watercolour and ink on vellum, 27.0 × 37.5 cm
1945
Purchased from the Scottish Gallery
(with Jean F. Watson Bequest Fund and
government grant-in-aid), 1977

The Enchanted Capital of Scotland

JESSIE MARION KING (1875–1949)

ONLY A GLASGOW GIRL could create this magical vision of Edinburgh. This is the original illustration to a child's fairytale set in the Old Town, *The Enchanted Capital of Scotland*. The Castle dominates this imaginary view from Princes Street Gardens looking up to a mass of architectural wonders pinned against the Castle Rock. Here we can see the outlines of Holyrood Palace, St Giles' Cathedral, the Scott Monument, the Floral Clock and Whitehorse Close. Always intrigued by Edinburgh's Old Town magic, an elderly lady known as the 'Raven' painted this in her studio in the Green Gate Close in Kirkcudbright. On the book's frontispiece, the artist's self-portrait depicts a witch on her broom casting magic from her wand, her paintbrush. This watercolour of Edinburgh was created by one of the leading illustrators of the twentieth century, Jessie M. King, an unrivalled artist of myth and legend.

Through the doors of Glasgow School of Art, King emerged as one of the leading stars of a group of young artists forging the Scottish Art Nouveau of the 1890s, the Glasgow Style. Infused with Pre-Raphaelite and Celtic symbolism, King's stylised pen and ink drawings covered many pages depicting fairytale, legend and poetry. While teaching Book Decoration at Glasgow School of Art, in 1902 King won a gold medal for her designs at the International Exhibition of Modern Decorative Art. Her inventive drawings sealed her international reputation as Scotland's leading illustrator. Loyal to the Arts and Crafts tradition, she worked in ceramics, jewellery, murals, book cover design and tapestry, as well as textiles and fabrics.

By 1911, King was running an art school in Montmartre in Paris with her husband, the artist Ernest Archibald Taylor. The Sheiling Atelier in the Rue de la Grande Chaumière was a creative force in the flourish of pre-war Paris that influenced the dawn of Art Deco. Looking up to the bright lights of the Moulin Rouge, King's imagination soared amid the vibrant, bohemian life of the city. As well as fellow Scots S.J. Peploe and J.D. Fergusson, King also met the American Frank Zimmerman, who introduced her to the Javanese technique of Batik textile printing. In 1908, King illustrated *The Grey City of the North*, a collection of drawings and paintings of Edinburgh's Old Town closes and buildings. This was followed by her beautiful Parisian architectural drawings.

With the outbreak of war the Taylors returned to Scotland and settled in the village of Kirkcudbright in Dumfriesshire. Establishing a thriving artistic community in studios of the Green Gate Close, King encouraged a younger generation of female artists. By 1945, the artistic lights of Kirkcudbright had waned, the summer school was gone and King was teaching at Kirkcudbright Academy and illustrating the occasional book. One of the last to be placed on her shelf, *The Enchanted Capital of Scotland* shows a change in style, but her distinctive flair for design shines through the bright colours and bold lines of Art Deco, Bakst and Batik. The illustrator of dreams, Jessie M. King never lost her magic, which she always saw in the Old Town of Edinburgh, so beautifully displayed in this delicate and ethereal water-colour.

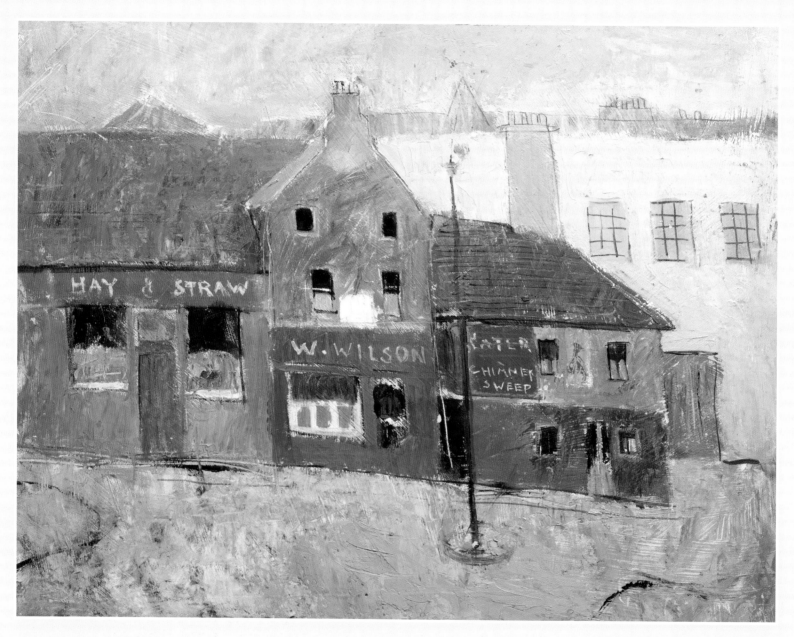

Oil on board, 48.3 × 58.4cm

c.1950

Purchased (with the assistance of the Jean F. Watson Bequest Fund
and government grant-in-aid), 1977

Causewayside

ANNE REDPATH (1895–1965)

WANDER PAST THE MERCHANT AND ANTIQUE SHOPS of Causewayside in Newington in this rare Edinburgh scene by the celebrated Scottish artist Anne Redpath, which was painted in honour of her artist friend, Willie Wilson. Near to her home at Mayfield Gardens, this was a well-known haunt for the artist, always on the hunt for antiques for her still lifes.

Having recently returned to Edinburgh after many years, Redpath had resumed her promising artistic career. Exhibiting landscapes of the south of France and Ireland, her first exhibition at the Scottish Gallery in 1950 was followed by much commercial success. At this period, Redpath created some of her most ambitious work and was acclaimed as one of Edinburgh's most vibrant contemporary artists. Inspired by the work of the post-Impressionists such as van Gogh, Gauguin and Matisse, she also continued the painterly tradition of the Scottish Colourists in her landscapes, interiors and sophisticated still lifes. President of the Scottish Society of Women Artists, in 1952 Redpath became the first female Academician of the Royal Scottish Academy; three years later she was awarded an OBE and an honorary Doctorate from the University of Edinburgh. After moving to her flat in London Street in the New Town, her home became an artistic hub, welcoming good friends such as Alick and Mary Newberry Sturrock, William Wilson, Sir William McTaggart, Sir Robin Philipson and the writers Compton Mackenzie and Sydney Goodsir Smith. Characterised by a bravura handling of paint, a confidence in bright colour and leaning towards the abstract, her later work continued to document her many travels abroad to Spain, France and Italy.

The daughter of a tweed designer, Redpath grew up in Hawick in the Borders before arriving as a student in 1913 at Edinburgh College of Art, where she was welcomed by the Head of Drawing and Painting, Robert Burns. A talented student, in 1919 she was invited to exhibit with the Edinburgh Group alongside Eric Robertson, Alick Sturrock, Mary Newberry and Dorothy Johnstone. A travelling scholarship sent her to Florence, Siena, Bruges and Paris, where she was captivated by the Italian Primitives and Early Renaissance artists. In 1920 she married the architect James Michie and settled in France. Returning to Scotland after almost fourteen years, she settled in Hawick, where she painted the landscapes and interiors of the Borders while bringing up her young children.

Reminiscent of her chalky palette of the 1930s, in this painting we glimpse the colours and textures of the tweed fabrics that often influenced her work. Always sensitive to the distinctive Edinburgh light, her treatment of the multicoloured shop fronts contrasts with her preferred palette of greys and whites. This nostalgic view of Causewayside from one of the leading artists of the Edinburgh School will bring back familiar memories for many.

Front Cover, Edinburgh International Festival programme, 1958, 29.5 × 21.0cm
Courtesy of Edinburgh Central Library

Edinburgh International Festival, 1958

SIR ROBIN PHILIPSON (1916–1992)

SILHOUETTED AGAINST THE SCOTT MONUMENT, a drummer boy heralds the beginning of one of the largest Arts festivals in the world. To stage a world-class cultural extravaganza uniting the arts of theatre, dance, music and art, the Edinburgh International Festival was established in 1947. Every summer the city still swells with colour and energy as artists and audiences flood into Edinburgh; the vibrancy is caught in this design for the front cover of the programme for the Festival in 1958 by one of the prominent members of the Edinburgh School, Sir Robin Philipson.

A lecturer at Edinburgh College of Art, Philipson held his second solo show at the Scottish Gallery to great acclaim in 1958. Having by then formed his distinctive style, influenced by American Abstract Expressionism, he shocked with his expressive, vibrant and semi-abstract visions of violent cockfights. Often on the monumental scale, with explosions of colour, Philipson's work is characterised by an energetic hand, heavy impasto and intense colour. Questioning human nature through darker undercurrents of sex and sacrifice, his still lifes, studio interiors and abstract triptychs are instantly recognisable. Throughout his career, he explored many themes, including lingering nudes, cathedral windows, the First World War, kings and queens, crucifixions and exotic animals. Despite his teaching responsibilities, Philipson was committed to painting; he was prolific.

Originally from Lancashire, Philipson grew up in Dumfries and headed to Edinburgh College of Art, where he was taken under the wings of influential tutors William Gillies and John Maxwell. Experiencing the horrors of conflict while serving in Burma during the Second World War, Philipson returned to teach at the college to form his distinctive and energetic style. Destined to be a major figure in Scottish art, Philipson took up the influential post as Head of Drawing and Painting at the College two years after designing this progamme. A President of the Royal Scottish Academy, he was knighted for his significant contribution to Scottish art in 1976.

In 1958 Philipson lived in a top flat in the West Bow overlooking the Grassmarket, where he watched the city come alive during the Festival. In 1967 he was elected a member of The Edinburgh Festival Society and in 1969 he sat on the Council. He was equally supportive of the Festival's world-class exhibitions, such as the Royal Scottish Academy's exhibition *From Cézanne to Picasso – The Maltzau Collection* and David Talbot Rice's *Masterpieces of Byzantine Art*.

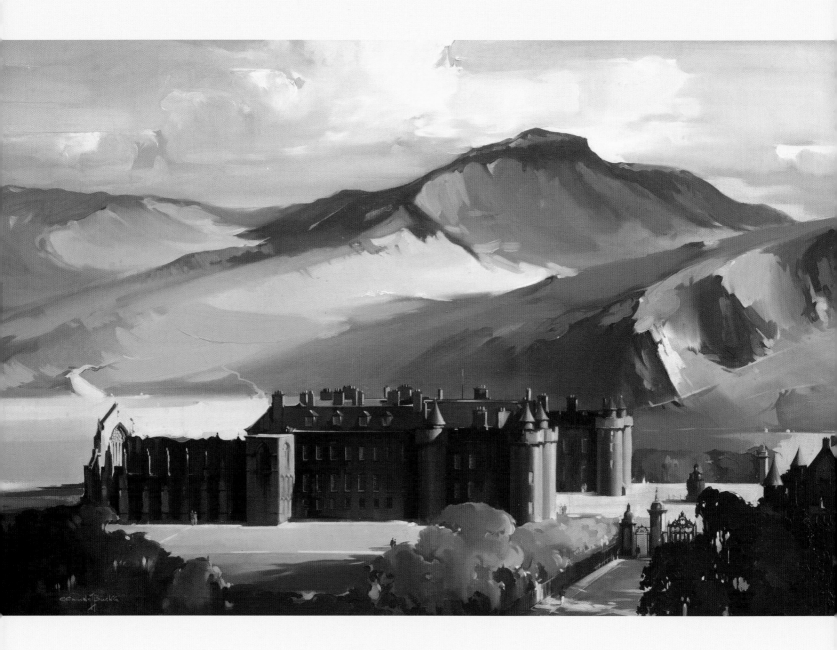

Oil on board, 79.0 × 120.5cm
1960
Donated by The British Railway Board (Residuary) Ltd, 2010

Glenogle Baths

JOHN BELLANY (1942–2013)

A MEMORY OF HIS EDINBURGH DAYS, John Bellany takes us back to the sixties with this strange scene in Glenogle Baths in Stockbridge. Confronted by the usual 'Glennies' crew, a group of locals stare, pose and stretch on the diving board inside the old Victorian baths.

From the fishing town of Port Seton in East Lothian, Bellany burst through the doors of Edinburgh College of Art in 1960. A driven and passionate student, his powers as a draughtsman amazed his tutors, the Principal William Gillies, Head of Painting Sir Robin Philipson, and John Houston. Hanging out in the pubs of Rose Street with fellow student Alexander Moffat and the lingering figure of the nationalist poet Hugh MacDiarmid, the young artists were encouraged to feed from their own experiences, surroundings and Scottish heritage. Against the tide, they turned their backs on the fashionable Pop Art and Abstract Expressionist style to monumental figurative works. With his sketchbook, Bellany frequently stalked the heroic figures staring down from the walls of the Scottish National Gallery. A year before this was painted, Bellany and Moffat had visited Paris. In the Louvre they were amazed at the monumental Romantic works of Delacroix and Géricault, and the stark socialist realism of Gustav Courbet. Back at College, Bellany began creating the monumental expressionist works based on his local scene. Drawing on the strict Calvinist roots of a traditional fishing port, Bellany painted a bold and gutsy portrait of his local community. In a series of ambitious large-scale works, he would capture the customs, superstitions and characters of the east coast fishing communities.

In 1963, the City Council granted Bellany and Moffat a street traders' licence to display their paintings on the railings of Castle Terrace during the Edinburgh International Festival. This work dates from 1964, the same year they tied their paintings to the railings of the Royal Scottish Academy and the National Gallery of Scotland on the Mound. Demonstrating that art should be accessible, it was Bellany and Moffat who brought the art to the people in a rebellious and inspiring act of defiance.

Awarded a postgraduate scholarship in 1965, Bellany left Edinburgh to study at the Royal College of Art in London. The city where he forged his style, Edinburgh remained a special place for Bellany and he often returned to his flat in the New Town. Although he broke the mould, Bellany very much belongs to the Scottish tradition, as seen in flicking through the pages of this book. Bellany was always supportive of the work of the City Art Centre, and it is fitting to include this early work, a rare Edinburgh view, from the painter of the people.

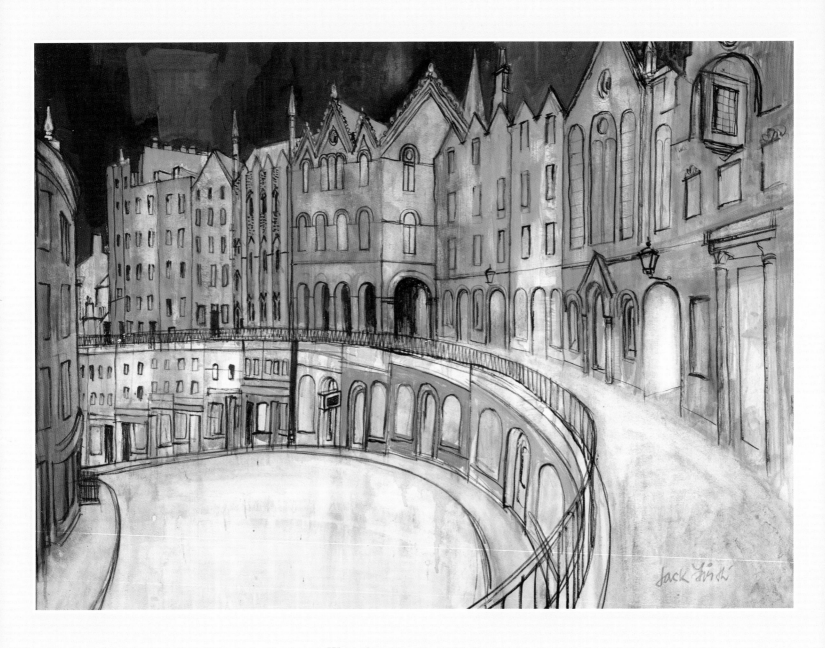

Watercolour on paper, 55.9 × 76.2cm
1968
Purchased (Jean F. Watson Bequest Fund), 1968

Nostalgic Recollection
(Victoria Street, Edinburgh)

JACK FIRTH (1917–2010)

FROM GEORGE IV BRIDGE, gaze upon the striking architecture and many colours of Victoria Street. Constructed in the nineteenth century to create access from the Grassmarket, the tall buildings of Victoria Terrace loom over the multicoloured antique and craft shops below. The lively charm of Victoria Street appealed to one of Scotland's leading watercolourists, Jack Firth.

Jack Firth frequently wandered up Victoria Street from Heriot's School to copy the masterpieces of the National Gallery on the Mound. In 1935, he enrolled at Edinburgh College of Art and trained under William Gillies, John Maxwell, Sir William MacTaggart and Adam Bruce Thomson. After wartime service, Firth returned to teach in Edinburgh schools. From Head of Department at Forrester High School, he was appointed Art advisor to the Edinburgh Education Department in 1963. Committed to promoting the accessibility of art to children, he placed specialist art teachers in every primary school and built up the Schools Art Collection, now held within the City Collection.

Between 1950 and 1970, Firth also lectured part time in Drawing at Edinburgh College of Art and gave many talks as the travelling lecturer for the Scottish Arts Council. Despite teaching commitments, Firth continued to paint in his studio in Corstorphine. A master of watercolour, he was known for his fluid watercolours celebrating the Scottish landscape, in particular coastal scenes and picturesque ports. He loved St. Monans and Crail in the East Neuk of Fife, and also ventured up to Morayshire and over to the west coast on family summer holidays to Ardnamurchan and Arran. Firth was a versatile artist who also painted interiors and still lifes reminiscent of his dear friend Sir Robin Philipson. In addition to esteemed titles such as Vice-President of the Royal Scottish Society of Painters in Watercolours and President of the Scottish Arts Club, for over ten years Firth was also resident artist at Edinburgh Zoo.

Reminiscing of my own nostalgic recollections of one of Edinburgh's most beautiful streets, it's fitting to include a painting from a collection that Jack Firth helped to promote.

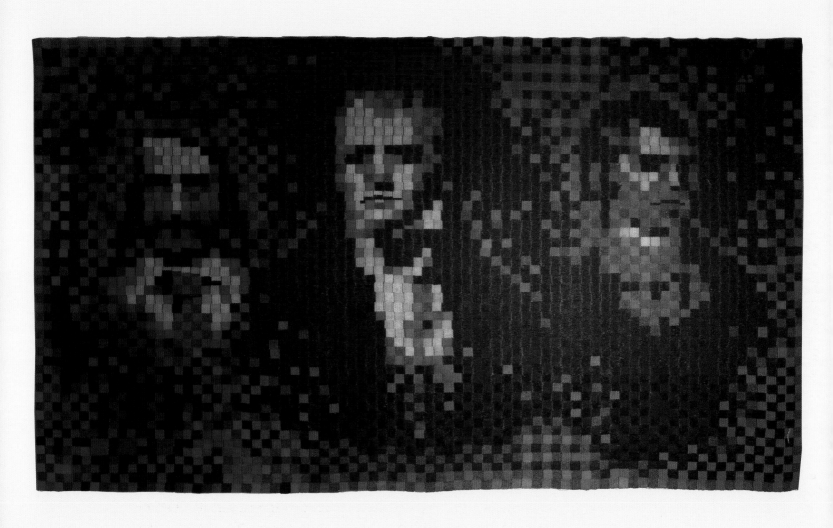

Tapestry
The Writers' Museum, Lady Stair's House
1971
Commissioned from the artist

Stevenson–Scott–Burns

ARCHIE BRENNAN (B. 1931)

THE PORTRAITS OF SCOTLAND'S GREAT WRITERS are woven into this tapestry commissioned by the City Museums from master weaver Archie Brennan in 1971. Hanging upon the scarlet walls of the Writers' Museum in Lady Stair's House, this is one of the modern tapestries created in the historical Dovecot Studios in Corstorphine, Britain's oldest surviving tapestry workshop.

Born in Roslin, Brennan's enthusiasm for art was nurtured by many trips to Edinburgh's art galleries and museums. While at Boroughmuir High School, Brennan attended night classes at Edinburgh College of Art, where he met apprentices from the Dovecot Studios. In 1948, he took up his own apprenticeship at the studios now known as the Edinburgh Tapestry Company. Set within the grounds of Corstophine Castle, the looms stood in the purpose-built studios beside the fifteenth-century 'beehive' Dovecot. The studios were established in 1912, when John Crichton-Stuart, 4th Marquess of Bute, invited weavers from William Morris' Merton Abbey workshops in London to come to Edinburgh. The first traditional tapestries to hit the looms were monumental works for the Marquess' Gothic Revival mansion of Mount Stuart on the Isle of Bute. This first set of tapestries established the studio as an international centre for weaving. From these traditional designs, over the years the Dovecot has heralded tapestry as a contemporary and exciting medium. It continues its work in new premises in a Victorian swimming bath at Royal Infirmary Street.

Brennan was the progressive Director of the Dovecot for over fifteen years from 1963. In a highly creative period of experimentation, he continued to collaborate with leading artists while working on his own designs. From 1962 to 1973, Brennan established the Graduate and Postgraduate Department of Tapestry and Fibre Arts at Edinburgh College of Art. This tapestry was commissioned before Brennan left Scotland in 1975 on worldwide travels with his loom. For the Australian National University, Brennan helped to establish the Victorian Tapestry Workshop in Melbourne. He helped to establish the Victorian Tapestry Workshop in Hawaii, and taught at the National Arts School in Papua New Guinea. After ten years of living in Hawaii, he settled in New York in 1993. Here in his studio he continues to work; he weaves every day and promotes the ancient art of tapestry by travelling and teaching across the world.

Originally commissioned for Huntly House Museum in the Canongate, this tapestry was designed by Brennan to be viewed from a distance, dissolving in pixilated form. It displays his fascination with the close relationship between digital imagery and tapestry, a theme he had explored in his famous portraits of the boxer Mohammad Ali. Rescuing the 'Scott' section of an earlier tapestry from the London studio of his friend Eduardo Paolozzi, Brennan reworked the theme for this stunning work of art. Drawing on Edinburgh's artistic past, bolstered by the presence of Stevenson, Scott, Burns, Raeburn and Nasmyth, this is one of the finest tapestries to come off the looms of the Dovecot. Now displayed above the artefacts and personal belongings of our literary statesmen, this tapestry has found its perfect home.

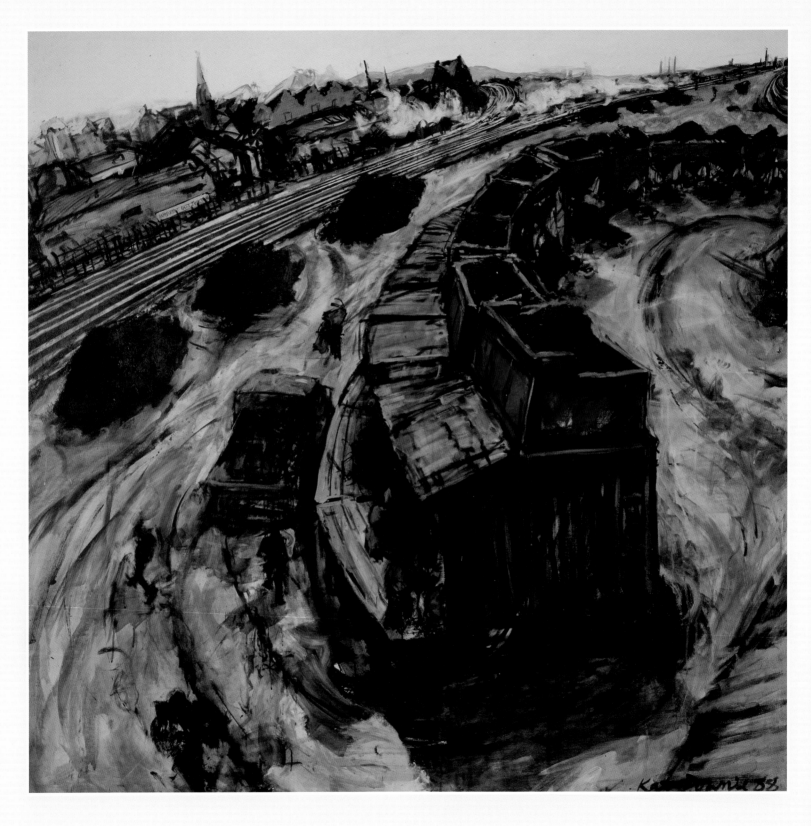

Acrylic and coal dust on canvas, 170.0 × 177.5 cm
1988
Commissioned from the artist, 1988

The Coal Yard

KATE DOWNIE (B.1958)

ON THE SITE OF BRUCE LINDSAY WALDIE'S RAIL COAL YARD, this view of Haymarket Station is now no more. Workers linger as a truck refills from one of the many bothies. In the background, the massed buildings of Haymarket lie below the Pentland Hills. Caught in paint and coal dust, with great spontaneity and expression, this gritty view is a prized industrial urban landscape from leading contemporary artist Kate Downie. As early as 1784, Haymarket was the traditional site of the city's coal offices and was utilised as a coal depot for many years. In 1842 Haymarket Station opened as the original terminus for the Edinburgh and Glasgow Railway. To preserve the scene before redevelopment, *The Coal Yard* was commissioned from the artist as part of a project intended to reflect the changing face of Edinburgh and its people. It was exhibited at the City Art Centre's exhibition *Should Auld Acquaintance Be Forgot* in 1989.

Originally from North Carolina, Downie grew up in Aberdeen and studied at Gray's School of Art. Familiar with the wild and rugged coastline of Aberdeenshire, the talented landscapist moved to Edinburgh, where she continues to work and document the city. Shortly after the creation of this work, Downie left for Paris, where her performance piece, *La Circulation*, of 1989, sparked an interest in road junctions and crossroads. In Downie's urban views she constantly investigates the interaction between people and spaces, and loves to explore the less attractive spots, forgotten places, bridges and edges. Her detailed and complicated urban studies, reminiscent of the industrial scenes of Muirhead Bone, contrast with her quieter and atmospheric coastal views. From Edinburgh, Downie has travelled and exhibited all over the world. She has held artist's residencies in the USA, Amsterdam, Paris, Corsica and Norway, and most recently China, where she recorded industrial landscapes influenced by the work of traditional Chinese ink painters. Her more unusual residences include hospitals, a brewery, a maternity hospital and an oil rig. Working in a range of media, all her work displays effortless draughtsmanship, and Downie is brilliant in her rapid, edgeless panoramas of urban landscapes.

The Coal Yard is one of Downie's many Edinburgh urban explorations; she has also painted the docks of Leith, hectic panoramic city junctions and dramatic representations of the Forth Rail Bridge. One of the busiest crossroads in the city, the view of Haymarket has again changed considerably since 1988, with the addition of a new station and the arrival of the trams. This painting provides us with a glimpse into the past. A postcard of Edinburgh industry, this is also a memory of the workers that used to linger on the rails of Old Haymarket.

Bronze foot, ankle and hand
Picardy Place
1991

The Manuscript of Montecassino

SIR EDUARDO LUIGI PAOLOZZI (1924–2005)

EDINBURGH'S 'BIG FOOT' STANDS ITS GROUND outside St Mary's Roman Catholic Cathedral at the top of Leith Walk. Strewn on the ground alongside a palm and a severed limb, these are the torn fragments of *The Manuscript of Montecassino*.

Echoing the Roman remains of the *Colossus of Constantine* at the Capitoline Museum in Rome, this monumental three-part sculpture was created by the Italian Scot Eduardo Paolozzi. Born in Leith, the son of Italian immigrants, Paolozzi grew up in his parent's sweet shop down the road at 10 Albert Street. Paolozzi briefly studied at Edinburgh College of Art before leaving for London; here he would emerge as one of the most inventive and forceful British artists of the post-war era. In 1986, Paolozzi was honoured as Her Majesty's Sculptor in Ordinary for Scotland.

A founder of the Independent Group in 1952, Paolozzi was the first to launch Pop Art in Britain through his surrealist collages and screenprints of the 1950s. Ahead of the game, Paolozzi was the first artist to include the word 'Pop' in his famous poster of 1947, *I was a Rich Man's Plaything*. An influential teacher, designer and innovative graphic artist, Paolozzi was also a giant of monumental sculpture. Impressed with technological imagery, this work shows Paolozzi's fascination with combining the human body with elements of machinery, and his obsession with technology and robotics.

Take a closer look at one of Paolozzi's most personal statements, situated outside his parish church, a prayer cast in bronze. In honour of his family and Italian heritage, the sculpture is inscribed with a Latin poem by Paulus Diaconus, an eighth-century monk from the Benedictine Abbey of Montecassino. Set high in the hills, the famed scriptorium of this ancient monastery guarded its precious hoard of illuminated medieval manuscripts. On the morning of 15 February 1944, centuries of heritage and tradition were shattered when the Abbey was obliterated by Allied bombers in the Battle of Montecassino during the Second World War. Although Paolozzi's parents had left the nearby town of Viticuso for a new life in Edinburgh, the family did not escape the devastation of war. With Italy's declaration of war on Britain in 1940, Italian immigrants in Edinburgh were rounded up and interred at various locations in the city. They included sixteen-year-old Paolozzi, who was sent to Saughton Prison. Tragically, as his father, grandfather and uncle were being transported along with 400 other Italians to Canada onboard the ss *Arandora Star*, they drowned when the boat was torpedoed by a German U-boat.

> Edinburgh, with its fine historic architecture must be complemented with works of suitable grandeur, with sculpture of the right scale and material on a theme that reflects the everlasting inspiration that the city has drawn upon from classical models ... The foot can be considered to be inspired (or re-invented) by the foot of Constantine in Campidoglio in Rome.
>
> On the site I can see these very parts of the landscape that were the back-cloth to my childhood. A great deal has disappeared, which makes it a privilege to add something signifi-cant to what might have become an urban gap ...
> SIR EDUARDO PAOLOZZI, *The Manuscript of Montecassino*

Linocut with collage, 57.0 × 38.2cm

1992

Purchased from Edinburgh Printmakers Workshop
(Jean F. Watson Bequest Fund and with grant aid
from the National Fund for Aquisitions), 1992

East Haar

JANE HYSLOP (B.1967)

PROTECTED BY ITS CASTLE, Arthur's Seat and ancient city walls, medieval Edinburgh huddles below St Giles' Cathedral. Bridging the centuries across the valley to the New Town, here the old city ports block the wide streets with their ornamental gardens. As the haar from the Forth lingers above, this contemporary view harks back to Edinburgh's architectural and geological past.

From Dalkeith, Jane Hyslop's distinctive and stylised city prints capture the character and architectural splendour of Edinburgh. Accentuating the city's prominent features, her diagrammatic views echo ancient maps, chapbooks and engravings. As a student at Edinburgh College of Art, Hyslop caught her native Midlothian in a version of the oldest medieval map, a source of constant inspiration, the *Hereford Mappa Mundi.*

Captivated by the contrast of the congested streets of the Old Town with the classical layout of the New, Hyslop's prints reflect her passion and knowledge of the city's evolving geological and architectural richness. Her brilliant works recall old prints and childhood memories of trips to the Brass Rubbing Centre, the Royal Botanical Garden and Craigmillar Castle. Like the artists and mapmakers of long ago, from Kirkwood's plans of the New Town to the comical caricatures of John Kay, her prints record the city at a particular point in time. They stand as documents of change and progress, precious native views from one of the city's leading printmakers. Her modern cartography is described in her own words: 'Being someone who tries to understand a place by drawing it and untangle it through mapping, Edinburgh offers such rich source material. It also has such an imposing geology and offers views both to the sea and to the hills. Its position ensures an ever changing backdrop in terms of the weather which can alter its atmosphere and character so fundamentally.'

This print was commissioned for the Edinburgh Printmaker Workshop's *Edinburgh Suite* in 1992. Hyslop created this impression of her hometown after an artistic residency at the historic Traquair House in Peeblesshire. Inspired by an old panorama of Edinburgh hanging on the stair, this image also took form while Hyslop's imagination was lost in one of her favourite books, James Hogg's *The Private Memoirs and Confessions of a Justified Sinner.* As every Edinburgh resident knows, flooding in from the Forth, the ghostly haar can transform the city in an instant. Hyslop suggests the seizing Edinburgh mist with the addition of some Japanese paper.

The Royal Mile

WILLIAM HIGHET (B. 1934)

THIS PANORAMIC PAINTING OF THE ROYAL MILE, revealed in all its glory, invites us to take a closer look. The architect William Highet has captured in exact detail the south side of the Royal Mile. From St Mary's Street to the Castle Esplanade, the artist has set the original boundaries of the 'Royal Burgh of Edinburgh' founded by David I in AD 1130.

It took over two years to record and create this fascinating architectural study, built to scale over six panels, with painstaking precision. This painting, concentrating on one of the most historic sections, is a precise record of Edinburgh's most famous street at a particular point in time. It emphasises the eclectic mix of architecture and styles of the various buildings.

Born in Glasgow, William Highet studied at Glasgow School of Architecture before setting up an architectural practice in Inverness. Concentrating on his painting during his retirement, he was drawn to recording the magnificence of the Royal Mile. With architectural expertise and artistic flair, he decided to record it for posterity; in his own words, 'It started as a challenge . . . a challenge to record part of our nation's history pictorially, focussing on a small section of the capital city of Edinburgh, where the age and variety of buildings illustrates a mixture of activities – religion, government, commerce and family

Acrylic on board, in six sections, total measurement 100.0 × 883.5cm
Purchased from the artist (Jean F. Watson Bequest Fund and with
grant aid from the National Fund for Acquisitions), 2009

life – all contained in one "living" street.' In this unique work we can see prominent buildings and landmarks, from the Museum of Childhood, the Tron Church, St Giles' Cathedral, Parliament Square, up towards the Lawnmarket and the Gothic spire of St John's Church on Castlehill.

Still clinging to its medieval past, the tall lands tower above the cobbled streets and narrow archways of the old closes. With the courts, shops, offices, apartments, ancient mansions, cathedrals and hidden courts, underground closes and ghosts, the Royal Mile is still the hub of the town that always comes alive during the Festival. Encouraged by Slezer, Allan and Bruce James Home, we must still protect this vein of Scottish history, the centre of the World Heritage Site. Amazingly, we can still visit many of the landmarks that Slezer drew centuries ago.

Connecting a Castle to a Palace over one Scots mile of centuries of architecture, the old High Street is an architect's dream. A treasure trove of history, the survivor of fire, plague and war, the Royal Mile will always rival the grandeur of the New Town. Rediscovering its magic, a wander down the old High Street will linger long in the memory.

Bronze

2004

Commissioned from the artist by the Friends of Robert Fergusson

Robert Fergusson

DAVID ANNAND (B.1948)

CLUTCHING HIS LATEST EDITION OF POEMS and penning his next couple of lines, Robert Fergusson hurries past the Canongate Kirk on his way from his publishers to the Cape Club in Craig's Close. This glimpse into the past pays tribute to the Scots poet of the Enlightenment, the celebrity of his day, our Edinburgh makar Robert Fergusson.

Born in the Cap and Feather Close off the Royal Mile in 1750, Fergusson attended Edinburgh High School followed by study at St Andrews University. Returning to Edinburgh to work as a legal copyist for the Commissary Office, Fergusson's first poems were published by Walter Ruddiman in the *Weekly Magazine*, followed by his first collection of poetry in 1773. He was an unrivalled Scotto-Latinist and, along with pastorals in Scots and English, it was Fergusson's Edinburgh poems that first brought national attention. Master of Scots, Fergusson again raised the old words to describe Edinburgh in a series of sympathetic and satirical poems inspired by the city's history, architecture, traditions and peculiarities of the Edinburgh townsfolk. Within a couple of years, Fergusson had produced more than fifty poems in English and thirty-three in Scots. This was a considerable achievement for such a young writer, but his fortunes were soon to change.

After too many nights drinking with his artist friends at the Cape Club, Fergusson was soon lost in a downward spiral of drink and depression. Haunted by morbid thoughts, he took to compulsive reading of the Bible for respite. Following a serious head injury, Fergusson was thrown into the Edinburgh Bedlam, never to see the light of day again. He died alone in his cell and was buried in an unmarked pauper's grave in the Canongate Kirkyard. When Robert Burns arrived in the city in 1786, he paid for a memorial stone to the poet who had inspired his own work; it is carved with his words, 'This simple Stone directs Pale Scotia's way, To pour her Sorrows o'er her Poets Dust.'

Given to the 'Guid Fouk o' Edinburgh' by the Friends of Robert Fergusson, David Annand's sculpture was unveiled by Lord Provost Lesley Hinds on 17 October 2004. Despite the lapse in time, Annand's sculpture moulds naturally into its historic setting. Displaying the power of a sculpture to remind and remain, Fergusson still walks among the people, no longer a forgotten figure.

As this epic tour comes to a close, take a leaf out of Fergusson's book and delight in this city of antiquity. With such a rich and important *History of Art*, remember the artists; they are part of the story.

> Auld Reekie! wale o ilka toun
> That Scotland kens beneath the moon,
> Where couthy chiels at e'ening meet,
> Their bizzing craigs and mous to weet.
> ROBERT FERGUSSON, 'Auld Reekie', 1773

Bibliography

GENERAL

Creech, William, *Edinburgh Fugitive Pieces: With Letters, Containing a comparative View*, 1791

Creech, William, *An Account of the trial of William Brodie and George Smith, before the High Court of Justiciary, on the 27th and 28th of August, 1788; for breaking into, and robbing, the General Excise Office of Scotland*, 1788

Catalogue of Paintings, Drawings and Sculpture in the City of Edinburgh Collection, Vol.3 , Acquisitions: 1979–1992

Cumming Elizabeth, *Catalogue of Paintings, Drawings and Sculpture in the City of Edinburgh Collection*, Vol. 1 & Vol. 2, 1979

Gray, James, *Poems of Robert Fergusson*, Edinburgh, 1821

Harris, Paul & Julian Halsby, *The Dictionary of Scottish Painters 1600 to the present*, Edinburgh, 2000

Jamieson, John, *Theatrum Scotiae, A New Edition*, Edinburgh, 1814

Macmillan, Duncan, *Scottish Art 1460–1990*, Edinburgh, 1990

Macmillan, Duncan, *Painting in the Golden Age*, Edinburgh, 1986

Raspe, Rudolf Erich, *A descriptive catalogue of a general collection of ancient and modern engraved gems, cameos as well as intaglios, taken from the most celebrated cabinets in Europe*, James Tassie, No. 20 Leicester-Fields, London, 1791

LOCAL

Bone, James, *The Perambulator in Edinburgh,* , London, 1926

Cockburn, Henry, *Memorials of his Time,* Edinburgh, 1856

Chambers, Robert, *Traditions of Edinburgh,* W. & C. Tait, 1825

Elton, Mary Stewart, *Four panoramic views of the city of Edinburgh, taken from the Calton Hill, by Lady Elton,* 1823

Gibson, Patrick, *Select views in Edinburgh: consisting chiefly of prospects that have presented themselves, and public buildings that have been erected in the course of the recent improvements of the city,* Edinburgh, 1818

Grant, James, *Cassell's Old and New Edinburgh,* 1880

Harris, Stuart, *The Place Names of Edinburgh; their origins and History,* Edinburgh 2002

Home, Bruce James, *Old Houses in Edinburgh,* William J. Hay at John Knox's House, Edinburgh, 1905

Lauder, Sir Thomas Dick, *Etchings Illustrative of Scottish Character and Scenery,* Edinburgh, 1885

Paterson, James, *A Series of Original Portraits and Caricature Etchings by the late John Kay,* 1838

Stevenson Robert Louis, *Edinburgh Picturesque Notes,* London, 1878

Smith, Jane Stewart, *Historic stones and stories of bygone Edinburgh/written and illustrated with pen, pencil, and camera,* Edinburgh, 1924

Steele, I *The Enchanted Capital of Scotland* (illustrations by J.M King), Edinburgh, 1945

Scott, Sir Walter, *Provincial antiquities and picturesque scenery of Scotland: with descriptive illustrations,* Edinburgh, 1826

Youngson, A.Y., *The Making of Classical Edinburgh,* Edinburgh, 1966

SCOTTISH ART

Baird William, *John Thomson of Duddingston, pastor and painter: a memoir,* Edinburgh, 1895

Ballatine, *James Life of David Roberts, RA*, 1866, Edinburgh

Baker, Michael, *The Doyle Diary: The Last Great Conan Doyle Mystery – with a Holmesian Investigation into the Strange and Curious Case of Charles Altamont Doyle*, New York and London, 1978

Beasant, Pamela, *Stanley Cursiter: a life of the artist*, Orkney, 2007

Bertram, Geoffrey, *The Etchings of John Clerk of Eldin*, Enterprise Editions, 2012

Blaikie, Walter Biggar, *William Hole, RSA* (reprinted from the 'Edinburgh Academy Chronicle', December 1917), Edinburgh, 1917

Bone, Sylvester, *Sir Muirhead Bone: artist and patron*, London 2009

Bonnar, Thomas, *Biographical Sketch of George Meikle Kemp, Architect of the Scott Monument*, Edinburgh, 1892

Boulet, Roger, *Ernest Lumsden*, Visual Arts Burnaby, BC, Canada, 2003

Bourne, Patrick, *Anne Redpath 1895–1965*, Edinburgh, 2004

Cavers, Keith, *A vision of Scotland: the nation observed by John Slezer 1671–1717*, HMSO in association with National Library of Scotland

Cousland, C.J, *Honoured in Scotland's Capital*, C.J. Cousland & Sons Ltd, Edinburgh, 1946

Cumming, Elizabeth, *Phoebe Anna Traquair: (1852–1936)*, Edinburgh, 2005

Cumming, Elizabeth, *Hand, Heart and Soul: the Arts and Crafts Movement in Scotland*, Birlinn, Edinburgh, 2006

Clouston, R.S, *Sir Henry Raeburn*, London, New York, 1907

Durand, A.D., *The man who loved to draw horses, James Howe 1780–1836*, Aberdeen, 1986

Forbes, William, *Memoirs of a Banking House*, as quoted in Richardson, Ralph, *Coutts & Co, bankers, Edinburgh and London: being the memoirs of a family distinguished for its public services in England and Scotland*, London, 1901

Ford, Patrick J., *'Interior paintings' by Patrick William Adam*, Glasgow, 1920

Francis John Collins, *Notes by the Way, with Memoirs of Joseph Knight and Rev Joseph Woodfall Ebsworth*, London, 1909

James Craig, 1744–1795, ed. Cruft, Kitty and Fraser, Andrew, Edinburgh, 1995

Geddes, Patrick, Thomson, Arthur, Duncan, John, *Interpretation of the Paintings in the Lounge of Ramsay Lodge*, Lloyds and Scottish Staff College, Edinburgh, 1979

Geikie, Rev. Archibald, *A Brief sketch of the life of Walter Geikie, Esq. RAS, Edinburgh, Scotland*, American Annals of the Deaf, Vol. 7 (4), 1855

Gillespie, T.H, *The Story of the Edinburgh Zoo*, Slains Publishing, 1964

Gilpin, Sidney, *Sam Bough, RSA: some account of his life and works*, London, 1905

Sir James Gunn, 1893–1964, Scottish National Portrait Gallery, 1994

Holloway, James, *James Tassie (1725–1799)*, Edinburgh, 1986

Hudson, Derek, *James Pryde: 1866-1941*, London, 1949

Huhtamo, Erkki, *The Roll Medium: The Origins and Development of the Moving Panorama until the 1860s*, Berkeley, 2010

Hyde, Ralph, *Panoramania!: The Art and Entertainment of the "all-embracing" view*, Barbican Art Gallery, 1988

Kelman, Rev. John, *Memories of William Hole, R.S.A* (With an introduction by his wife), London and Edinburgh, 1920

Kemplay, John, *The Paintings of John Duncan, A Scottish Symbolist*, Pomegranate Artbooks, San Francisco, 2009

Lindsay, Maurice, *Robin Philipson, (Modern Scottish Painters, Number Six)*, Edinburgh, 1976

Low, James, *Notes on the Coutts Family*, Montrose, 1892

MacWhirter, John, *Sketches from Nature*, London, 1913

McBey, James, ed. Barker, Nicolas, *The Early Life of James McBey, An Autobiography, 1883–1911*, Oxford, 1977

Melville, Jennifer, *Manhattan to Marrakech: the art and lives if James and Marguerite McBey*, Aberdeen, 2001

Nasmyth, James, *An Autobiography*, London, 1883

Patrick, Andrew McIntosh, *James McBey, 1883–1959*, The James McBey Centenary Exhibition, Aberdeen Art Gallery and The Fine Art Society, Edinburgh, 1983

Pearson, Fiona, *William Wilson, 1905-1972*, Scottish Masters, National Galleries of Scotland, 1994

Salaman, Malcolm, *James McBey 1883-1959, Modern Masters of Etching, no.2*, 1924

Scott, William, ed. Minto, W, *Autobiographical Notes of the Life of William Bell Scott; and Notices of his Artistic and Poetic Circle of Friends, 1830 to 1882*, London, 1892

Stevenson, Sara, *Facing the Light, the Photography of Hill and Adamson,* Scottish National Portrait Gallery, Edinburgh, 2002

Smith, Gordon W., *Philipson: A Biography of Sir Robin Philipson,* Edinburgh 1995

D.M. Sutherland (1883–1973) Exhibition Catalogue, Aberdeen Art Gallery, City Art Centre, Edinburgh, Dick Institute, 1975

Adam Bruce Thomson OBE, RSA, HRSW (1885–1976): Paintings from the Artist's Studio: a centenary exhibition.

Adam Bruce Thomson: Painting the Century, 6–30 November 2013, Scottish Gallery, Edinburgh

White, Colin, *The Enchanted World of Jessie M. King*, Edinburgh 1989

ARCHIVE/WEBSITES

The National Library of Scotland (www.nls.uk)

James Paterson Museum Archive, University of Glasgow
http://www.gla.ac.uk/services/specialcollections/collectionsa-z/jamespatersonmuseumarchive/

Classical Art Research Centre, and the Beazley Archive, University of Oxford (James Tassie)
http://www.beazley.ox.ac.uk/gems/tassie/default.htm

Peter Stubbs, History of Photography in Edinburgh (www.edinphoto.org.uk)

Mapping the Practice and Profession of Sculpture in Britain and Ireland 1851–1951
www.sculpture.gla.ac.uk/

The Dictionary of Scottish Architects (1840–1980) (www.scottisharchitects.org.uk)

Edinburgh Book Shelf (www.edinburghbookshelf.org.uk)

Edinburgh World Heritage (www.ewht.org.uk)

Letter from William Walls to James Walls, 1884, National Library of Scotland, Acc. 10448

Letter to JYS from William Brodie, (Jan 8th 1866), Simpson Collection, Library Archive, The Royal College of Surgeons of Edinburgh (1479)

ARTISTS' WEBSITES

David Annand (www.davidannand.com)

John Bellany (www.bellany.com)

Archie Brennan (www.brennan-maffei.com)

Claude Buckle (www.claudebuckle.co.uk)

Kate Downie (www.katedownie.com)

Jane Hyslop (www.janehyslop.com)

William Highet (www.highetfineart.co.uk)

George Edwin Lucas (www.edwinglucas.com)

Acknowledgements

I would like to thank all who helped with this ambitious project. I would like to thank my publishers, Birlinn, for taking on the challenge and especially editorial manager Andrew Simmons for his constant encouragement. Many thanks to David Patterson for agreeing to this unique collaboration, his kind support, and commitment to safeguarding one of Scotland's great art collections. A special thanks to all relatives of artists who very kindly provided information and gifted permission for artworks to be reproduced. Finally, to *all* Edinburgh artists for providing centuries of inspiration – what a view!

The City of Edinburgh's art collection is housed at the City Art Centre, 2 Market Street, Edinburgh, EH1 1DE. For more information about the collection, opening hours, exhibitions or related events, please visit: www.edinburghmuseums.org.uk.

RECOGNISED

The City's Scottish art collection is a 'Recognised' collection. 'Recognised' status is awarded by the Scottish Government to collections of National Significance.

FRIENDS OF THE CITY ART CENTRE AND MUSEUMS

Join the Friends of the City Art Centre and Museums, and enjoy a varied programme of visits, talks and special events. The Friends also assist in raising money towards the purchase of items for the City's collections.

Download an application form from http://www.edinburghmuseums.org.uk/Support-Us and send to: The Membership Secretary, Friends of the City Art Centre and Museums, 2 Market Street, Edinburgh, EH1 1DE.

Photography